A Certain Slant of Light

A Certain Slant of Light

THE FIRST HUNDRED YEARS OF NEW ENGLAND PHOTOGRAPHY

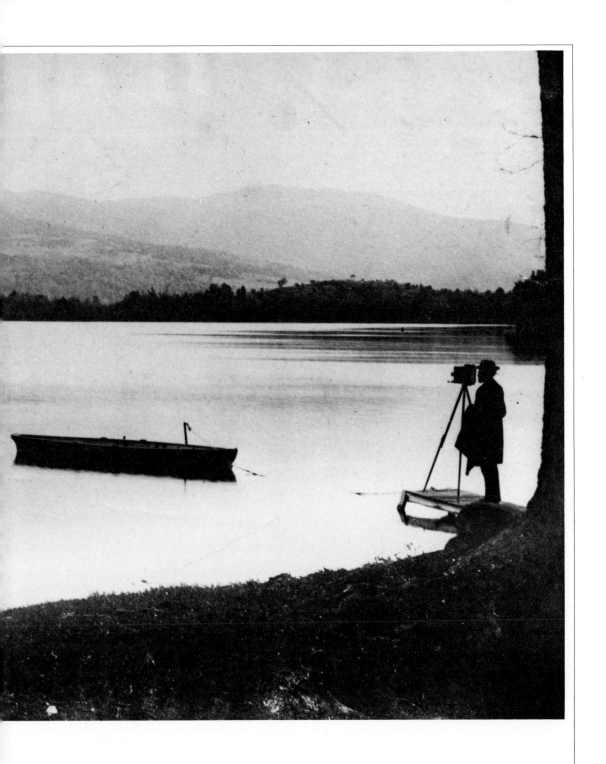

William F. Robinson

NEW YORK GRAPHIC SOCIETY BOSTON

For Anne, Ben, and Philip

First Edition

The poem on page v is printed by permission of the publishers and the Trustees of Amherst College from *The Poems of Emily Dickinson,* edited by Thomas H. Johnson, Cambridge, Mass.: The Belknap Press of Harvard University Press, Copyright © 1951, 1955 by the President and Fellows of Harvard College.

LIBRARY OF CONGRESS CATALOGING IN PUBLICATION DATA

Robinson, William F 1946–
 A certain slant of light.

 Bibliography: p.
 Includes index.
 1. Photography—New England—History.
1. New York Graphic Society. II. Title.
TR23.15.R62 770′974 80-15916
ISBN 0-8212-0752-0

Designed by Janis Capone

New York Graphic Society books are published by Little, Brown and Company.

Published simultaneously in Canada by Little, Brown and Company (Canada) Limited.

PRINTED IN THE UNITED STATES OF AMERICA

There's a certain slant of light,
Winter afternoons,
That oppresses, like the heft
Of cathedral tunes.

Heavenly hurt it gives us;
We can find no scar,
But internal difference
Where the meanings are.

None may teach it - any -
'Tis the seal despair -
An imperial affliction
Sent us of the air.

When it comes, the landscape listens,
Shadows hold their breath;
When it goes, 'tis like the distance
On the look of death.

— Emily Dickinson

Acknowledgments

I would like to thank the following for their kind suggestions and assistance: Ann Barry, Connecticut State Library; Elsie Barstow, Mystic, Conn.; Peter C. Bunnell, Princeton University Art Museum; Bobbi Carrey, Massachusetts General Hospital; Marcia Conroy, M.I.T. Historical Archives; Harold E. Edgerton, Cambridge, Mass.; David Gunnery, Warren Anatomical Collection, Boston, Mass.; Ernst Halberstadt, Onset, Mass.; John Hill, Bethany, Conn.; Frances Hoxie, Connecticut Historical Society; Art Liebenguth, Connecticut Antiquarian and Landmarks Society; Donald Lokuta, Union, N.J.; Barbara McDonnell, Phillips Academy, Andover, Mass.; Weston J. Naef, The Metropolitan Museum of Art; John Page, New Hampshire Historical Society; Marius Péladeau, Rockland, Me.; Polly Pierce, Stockbridge, Mass., Library; Roland W. Robbins, Lincoln, Mass.; David Rodd, Boston Camera Club; Page Savery, Stowe-Day Foundation; Ralph Steiner, Thetford, Vt.; William Warren, Fitzwilliam, N.H.; and Eugene Zep, Boston Public Library.

I would especially like to thank Melancthon W. Jacobus, Connecticut Historical Society; Jack Jackson, The Boston Athenaeum; Richard Wolfe, Countway Medical Library, Boston; and my father, Cedric L. Robinson, for sharing with me their extensive knowledge of New England and its photographic history.

I would like to thank Robin Bledsoe, my editor at New York Graphic Society, for her great efforts in assisting with the completion of this book.

Introduction

A Certain Slant of Light is an historical survey of the photographer's craft in New
England. The book begins in 1839 with the introduction of practical photographic
processes from England and France, and traces how a century of New Englanders
used the medium to create forceful, innovative, and often beautiful images.

While this work attempts to document and illustrate the region's photographic
highlights, it will also depict the overall art and craft of photography as it existed
at various stages. Photographers themselves, the photographic business, technical
developments, the changing relationship between photography and other fields of
study, and the continuing discovery of new uses for the photographic image are
among the subjects covered. Various changes in style, technique, and subject matter
will be examined in terms of the ideals and expectations of the individual photogra-
phers, the photographic community, and the public at large.

The images chosen as illustrations reflect this preoccupation with the broader as-
pects of New England photography; they range from atypical images by reclusive
geniuses, as well as classic examples of the art as it was generally practiced, to more
modest pictures whose style and content best reflect a specific kind of photographic
work.

Much of the flavor of New England's photography can be attributed to the char-
acter of the region's people and environment. Lacking the grand vistas of the
American West or the architectural magnificence of Europe, New England instead
provided a homey, rural countryside with colonial homes, tree-edged fields, and
rock-strewn brooks. Its cities and towns busied photographers with commissions to
photograph their people and expanding industries. Its scenic wonders, such as Bar
Harbor, the White Mountains, Cape Cod, or the Berkshires, provided subjects to
be depicted for the popular taste.

At the same time, new and intriguing subjects for the camera were being created
by New England's inventors and backroom tinkerers. These figures worked, over
the years, at improving the photographic process and adapting it to new, usually
practical, ends. Above all else, this has been the region's strongest contribution to

the craft of photography. Here, for much of its history, photography was never an isolated craft. Rather it reached into other areas of thought: art, science, and mechanical invention. Writers, painters, doctors, scientists, inventors, explorers — all made use of photography. In doing so, they added to the great vault of work that is New England's photographic heritage. In many cases photography served as the common ground for these figures to exchange information.

In contrast to this loose-knit fraternity, the region also contained a number of solitary figures who took up the craft of photography for the purpose of producing images depicting their own (or, less often, illustrating someone else's) personal vision. These photographers, following the intellectual tradition of Henry David Thoreau, Nathaniel Hawthorne, and Emily Dickinson, often worked indifferent to fame and almost always unrecognized by the surrounding community.

In drawing together these varied aspects of New England photography into a cohesive study, the writer has chosen to weigh equally artistic style, technical innovation, and photographic subject to determine a chapter sequence that provides, as much as possible, a chronological order to this history. In many cases chapters will overlap, or the narrative will skip in time in order to juxtapose similar works. All this is done to present an orderly overview of what must always be considered a field of unique, individual efforts of a multitude of artists, linked by regional influences and their choice of the photographic medium.

Contents

A Certain Slant of Light

1 "One of the most beautiful discoveries of the age"

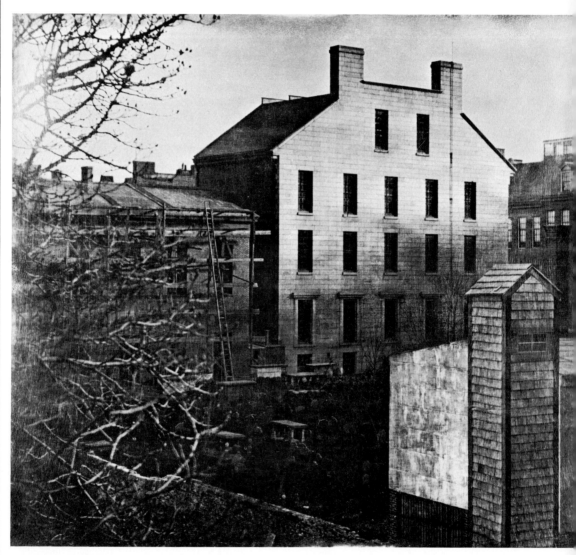

King's Chapel Burying Ground, Boston, April 19, 1840. Samuel Bemis. The earliest documented daguerreotype made in New England still in existence, 6½ × 8½ inches. Bemis carefully recorded the pertinent information for this, his first daguerreotype, on a piece of paper pasted to its back: "... Iodizing process 25 mts. [minutes] (apparatus new), Camera process 40 mts. — Wind N.W. Sky clear, air dry and very cold for the season. Lens meniscus. Daguerr's apparatus. Time 4.50 to 5.30 P.M. N.Y. Plate, ordinary." Bemis's record of the weather conditions arose from a then current ignorance as to whether the daguerreotype's chemical process was affected by temperature and relative humidity. Like most daguerreotypes, this image is reversed. International Museum of Photography at George Eastman House, Rochester, N.Y.

The story of practical photography in New England begins, as it does for the rest of the world, in the spring of 1839. Scattered newspaper accounts publish discoveries made in England and France. A Frenchman, one Louis Jacques Mandé Daguerre (1787–1851), can insert a specially treated plate into a camera obscura,* and after proper exposure and further chemical treatment, a "perfect copy from Nature may be produced." [1] In England, a man named William Henry Fox Talbot (1800–1877) experiments with a different procedure: using a camera obscura, he first obtains an image that is a tonal reversal of the original subject — blacks are white and whites black — then in a second step re-reverses the image to produce a positive print.

> The French call this instrument by the name of its inventor, the *Daguero-scope*. It is also called, in poetical language, the *Pencil of Nature*. Mr. Talbot calls the process *the art of Photogenic Drawing*. But whatever it may be called, it is certainly one of the most wonderful inventions in this inventive age. Henceforward, travellers who have never taken lessons in drawing may bring home the most finished and accurate sketches. They may even multiply them on the spot to an indefinite extent. Henceforward, every man may be his own draughtsman. [2]

Yet with these early words of the new art of photography to reach the public came reports of a conflict over who should be credited with its invention.

> It appears that Mr. Talbot has for some years devoted much labor and attention to the perfection of this invention, and having brought it to a point deserving the notice of the scientific world, and while actually engaged in drawing up an account of it to be presented to the Royal Society, the same

* *Camera obscura:* a common tracing apparatus of the day comprised of a box with a lens set in one end which threw an image of the subject on a ground glass at the other end. With a piece of paper placed over the ground glass, the subject could be easily traced.

invention has been announced by M. Daguerre in France! Who is entitled
to the honor of the original discovery, is a grave question to be answered
by scientific men.[3]

In France, Daguerre's invention was officially announced to the world in January
of 1839, but Daguerre jealously guarded its secrets, in the hope of receiving an
award from his government for its disclosure. In England, however, a paper by
Talbot was read to the Royal Society on February 30, 1839, giving full particulars
of his process. For this reason, it was the first to be tried in New England: by
March Talbot's information had crossed the Atlantic in British scientific journals.

In Boston, the son of the publisher of the *Boston Daily Advertiser* had learned
of the process through his father's news connections and was hard at work in his
dormitory room at Harvard College trying to make photographs. The young man
was Edward Everett Hale (1822–1909), later to write *The Man Without a
Country*. He was assisted by classmate Samuel Longfellow (1819–1892), brother
of the famous poet. Recalled Hale over fifty years later,

> Mr. Samuel Longfellow . . . and I were intimate friends, in Massachusetts
> Hall in Cambridge. We . . . followed Talbot's directions as closely as possi-
> ble. With these directions, and with an artist's camera, which I have still,[4]
> I took a picture of the windows opposite, in Harvard Hall. In especial,
> there was a bust of Apollo in the window, which came out very well, black
> on white ground, the bust being itself white on the black of the room be-
> yond. I thought at the time, and I think now, that this was the first experi-
> ment in a Talbotype, which was made in this country.[5]

Hale could not remember the exact date of the experiment, except that it was
probably in May 1839 (and definitely before he and Longfellow graduated that
June). The little dark brown image was unfortunately lost long before Hale real-
ized its historical value.

Over the next few years, other Bostonians dabbled with the talbotype. One of
them was Josiah Parsons Cooke (1827–1894). As a child, Cooke was a frail lad
who spent his time reading and tinkering with chemical apparatus. In 1842, at
age fifteen, he produced talbotype images of a number of Boston buildings. Two
years later he entered Harvard and made pictures of the campus as well. But he
soon put aside photography for other pursuits. At age twenty-three he became a
Harvard professor and almost single-handedly developed the college's departments
of chemistry and mineralogy. Today Harvard still holds these earliest surviving
American talbotype negatives.

Another Bostonian who experimented with Talbot's discoveries was William

Old Merchants Bank Building, State Street, Boston, 1842. *Josiah Parsons Cooke. Modern print from a talbotype negative, approximately 5 × 6 inches. As a Harvard undergraduate in the early 1840s, Cooke experimented with this early two-step negative and print process. The negative consisted of writing paper soaked in appropriate chemicals. Since the light had to pass through the paper negative to make a print, the image produced was characteristically soft-edged and muted. By permission of the Houghton Library, Harvard University.*

Francis Channing (1820–1901), who in 1842 produced talbotypes by an improved method he had devised, by which "one minute is sufficient for a building on which the February sun is shining, four or five minutes for general views." [6] None of Channing's images is known to have survived. He soon abandoned his interest in photography and went on to invent a "magnetic electrical fire alarm telegraph for cities" and a ship-railway for interocean transport.

While Talbot's was the first technical information on photographic processes to reach America, his discovery did not ultimately prove as popular as that of the Frenchman Daguerre, for two main reasons. The talbotype negatives were not the clear films of today; rather, they were simply pieces of writing paper permeated with photographic chemicals. Printing with these paper negatives produced a fuzzy-edged image, as the light had to pass through the paper itself before reaching the actual printing paper. Moreover, Talbot quickly patented his process and vigorously prosecuted anyone using it for financial gain. It was for this last reason that only amateurs and experimenters dabbled with it.

While these few people were trying out Talbot's "photogenic drawing" in the spring of 1839, news of the discoveries of Daguerre was spreading to America. On April 23, the *Hartford Daily Courant* reprinted an extract from a personal letter of Professor Samuel F. B. Morse to his brother, Sidney Edwards Morse, editor of the *New York Observer*, dated Paris, March 9.

> You have perhaps heard of the Daguerreotipe, so called from the discoverer, M. Daguerre. It is one of the most beautiful discoveries of the age. . . .
> A few days ago I addressed a note to Mr. D. requesting as a stranger, the favor to see his results, and inviting him in turn to see my Telegraph. . . . [The daguerreotypes] are produced on a metallic surface, the principal pieces about 7 inches by 5, and they resemble aquatint engravings . . . the exquisite minuteness of the lineation cannot be conceived. No painting or engraving ever approached it. . . .

Morse's report of a discovery that promised sharp, two-dimensional copies of the infinitely detailed natural world created a ground swell of excitement as it was reprinted in newspapers throughout America.

At the end of Morse's letter Sidney Morse added:

> With what delight will the eye dwell on the panoramas of Jerusalem, Thebes, Constantinople, Rome, and other cities of the old world, delineated with the unerring fidelity of the Daguerreotipe? With what interest shall we visit the gallery of portraits of distinguished men of all countries, drawn not with man's feeble, false and flattering pencil, but with the power and truth of light from heaven! It may not be long before we shall witness in this city the exhibition of such panoramas and such portraits.[7]

These predictions, however, were made before details of Daguerre's process were released, especially the fact that it took an exposure of from fifteen to thirty minutes to obtain an image. For this reason Daguerre himself thought that portraits taken by his method would never be feasible. Yet in the next decade hundreds of experimenters, many of them New England Yankee tinkerers, would streamline and modify it to reduce exposure times to a matter of seconds.

Not until the early fall of 1839 did the exact step-by-step procedure for making a daguerreotype reach America. Daguerre had accepted an annuity from the French government in return for the full disclosure of his discoveries, and on August 19, 1839, a demonstration was given to the French Academy of Sciences and the Academy of Fine Arts.

In simple terms, Daguerre began with a copper sheet that had been thinly coated on one side with silver and then brightly polished. The sheet was then exposed to light-sensitive iodine vapor which settled on the silver. The sheet was kept in the dark until put into the camera just before the picture was taken. To bring out the image, the metal plate was suspended in a closed box over a bowl of heated mercury. As the mercury molecules adhered to the silver, the picture appeared in direct proportion to the amount of light that had struck each part of the plate, in much the same manner as condensation from a person's breath mists a window — showing up fingerprints and smudge marks. The plate was then made permanent by immersion in a photographic fixer.

While more complicated than Talbot's process, daguerreotypy produced a quite beautiful image. Since the process worked on the molecular level, it was virtually grainless. The image could be magnified literally a thousand times over and still show detail. Only the quality of the lens itself limited the sharpness of a daguerreotype. Its only drawbacks were the delicacy of the mercury image — mercury is a liquid at room temperature — and the shiny, reflective silver surface beneath,

making it hard to see the image unless the daguerreotype was viewed at just the right angle of light. This second characteristic caused the daguerreotype to be dubbed "The Mirror with a Memory" by Bostonian Oliver Wendell Holmes in 1859.[8]

As soon as Daguerre's instructions were made public, they quickly made their way across the Atlantic. In Boston, Edward Everett Hale was one of the first to learn of the report, which appeared in his father's *Boston Daily Advertiser* of September 25, 1839. From this description Hale and his cousin Francis A. Durivage (1814–1881), later an eminent journalist and essayist, built the necessary apparatus. Their attempts apparently proved unsuccessful since they produced no images at this time.

According to one report, the first New Englanders to successfully produce a daguerreotype were Robert Grant and a Mr. Davis, who did so in Boston within three days of the first publication of Daguerre's account in that city's papers.[9] The daguerreotype has not survived and little else is known of this photographic first. Robert Grant was a scientist-inventor best known for his study of the uses for "calcium light," or limelight (an intense light source produced by directing an oxyhydrogen flame on a piece of lime). A searchlight perfected by Grant in the 1860s was used by Union gunboats for night river patrol during the Civil War.

The Mr. Davis referred to was most likely Daniel Davis, Jr. (1813–1887), who, with his brothers Ari and Asahel, produced "magnetic and philosophical instruments" for scientific experimenters. Within the next few years the Davis brothers became a primary force in improving the daguerreotype process and spreading its use across America. In 1842 Daniel Davis obtained the third U.S. patent in the field of photography, for a method of coloring daguerreotype portraits.

Aside from Hale and Durivage's failures, and Grant and Davis's success, little is known about photographic activities in New England during the fall and winter of 1839. Since numerous articles explaining daguerreotypy appeared in the national press during this time, it is very likely that a legion of isolated experimenters were cutting holes in cigar boxes to put in an eyeglass or magnifying lens and trying their luck.

In March 1840, New England's would-be daguerreotypists received a great assist with the arrival from New York City of Frenchman François Gouraud (d. ca. 1848). Billing himself as "friend and pupil of Mr. Daguerre," Gouraud set up a series of private showings and public lectures on the daguerreotype and how to make it.

Gouraud and his collection of daguerreotypes did much to dispel a feeling on the part of many Bostonians that the idea of a photographic process was simply a sham. Yankee skepticism had been aroused by a hoax pulled off a few years

before, in 1835, by the *New York Sun* in an attempt to expand sales. The paper reported with all seriousness that a new telescope then being set up in South Africa was able to see the back side of the moon, a side inhabited by winged man-like creatures. The report was so detailed and so blatantly incredible that the "learned" of the day assumed it must be true or it would not have been printed.

Four years later there was enough egg left on the face of America's intellectual community to make them avoid Daguerre's and Talbot's discoveries as another "moon hoax." Twice shy, they left the new craft to young experimenters like Edward Everett Hale. With the arrival of Gouraud this attitude softened. He exhibited daguerreotypes, showed how they were made, and put doubts to rest. In doing so he brought Boston's scientific community squarely behind the development and improvement of the photographic process at a very early date.

Gouraud came to New York from France in November 1839. He first set up shop in New York City but soon left for Boston after squabbles with other New York daguerreotypists, especially Samuel F. B. Morse. Very much the opportunist, Gouraud was quick to take credit for the success of anyone who came in contact with him, success that Morse and others achieved often despite the instructions of Gouraud.

"François Gouraud came to Boston," Edward Everett Hale relates,

> and brought letters [of introduction] to my father. Mr. Francis Colby Gray, a leader in affairs of art in Boston, one of the directors of Harvard College, interested himself greatly in Gouraud, and arranged for him a class which met in the sacred precincts of the Massachusetts Historical Society. To say this in the Boston of that day, was as if you said the class met in the queen's private apartments at Windsor. Gouraud imported the apparatus and sold it. He had specimens of Daguerre's work, two of which, I believe, I still own. He arranged, I think, in Connecticut, for the manufacture of plates.
>
> Mr. Gouraud was impecunious, and I suspect that my father used to lend him money. I wish now that he had bought apparatus instead. Instead of that, we youngsters had to make our apparatus, and did.[10]

After these private showings to Boston's elite, Gouraud gave a series of four public lectures at the city's Masonic Temple beginning on March 24, 1840. About five hundred men and women from Boston and surrounding towns attended each lecture. They examined the daguerreotypes hanging in the entrance hall and on the walls of the lecture room. According to one report, the pictures showed docks, warehouses, and shipping activities. Gouraud summarized the daguerreotype process and then took a picture.

Still Life of Plaster Casts. *François Gouraud. Boston, 1840. Daguerreotype, approximately 5⅝ × 7⅝ inches on a 6½ × 8½ inch plate. Gouraud, a daguerreotype promoter, toured America around 1840 lecturing and selling equipment. He exhibited this or a similar picture in Providence, his next stop after Boston. A reporter for the* Providence Journal *attended Gouraud's exhibit and reported: "The most beautiful of the views are several large pictures of statuary, paintings, drapery, etc., arranged purposely to be taken; the transparency of the crystal vases, the relief of the sculpture, and the light and shade of the paintings, show at a glance the nature and material of every object. But they must be seen and examined to be understood."* (Providence Journal, May 23, 1840, p. 2.) *Courtesy Museum of Fine Arts, Boston. Gift of Mrs. Joyce Cushing Brandsma in memory of Bradford Cushing Edmands.*

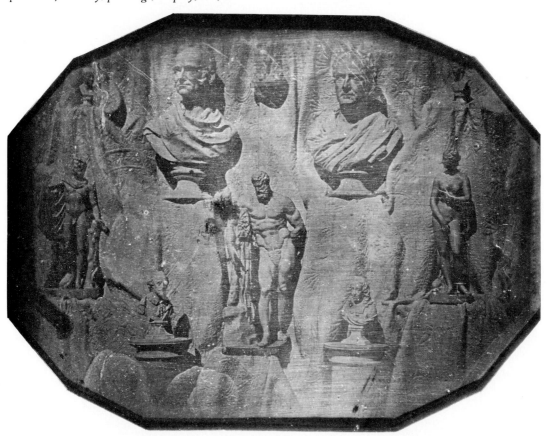

During his lecture Mr. Gouraud prepared a plate, describing the mode of operation as he proceeded, which when finished, was placed in the camera obscura, and the whole apparatus being then set on a window of the hall commanding a view of Park Street from the Church to Beacon Street, including a portion of the Common — a most beautiful and perfect picture was produced in *ten minutes,* to the delight and astonishment of the spectators.[11]

Among those in Gouraud's audience were Edward Everett Hale, now a schoolteacher; Samuel Bemis, a Boston dentist and jeweler; Albert Sands Southworth, a young druggist from what is today Chicopee, Massachusetts; Josiah Johnson Hawes, an itinerant portrait painter and sometime lecturer on electricity; and Dan-

iel Davis, Jr., the instrument maker. All these men were soon to make their mark on the course of photography in New England and America.

While enthusiastic about the daguerreotype's possibilities, many who came to the lecture were openly skeptical of Gouraud's own abilities. It was a misty day when Southworth attended the lecture, with intermittent snow and rain. According to him, Gouraud aimed his camera out the window as usual but because of the bad weather produced

a dimmed and foggy plate instead of the architectural detail of buildings, and the definite lines and forms of street objects. . . . The Professor [Gouraud had by now dubbed himself Professor and Doctor, using the terms interchangeably] appeared highly elated, and exhibited his picture with great apparent satisfaction, that he had it in his power to copy the very smoke and mist of the atmosphere in a stormy day.[12]

Whatever Gouraud's skill or lack of it, his lectures created a legion of aspiring daguerreotypists. One Andrew Simpson of 147 East Merrimack Street, Lowell, Massachusetts, rushed out afterward to an optician's shop to buy a small lens. With it he returned home to Lowell and made a small box modeled after the one he had just seen. This became his camera and lens. He then hunted up the necessary paraphernalia called for in Gouraud's directions:

The camera obscura, with its lens;
the iodine box, with its wooden dish;
the substance box;
mercury box, with its grooved boards;
a moveable camera sash, with its plate board;
the plate box;
the travelling box;
two rinsing pans;
a washing pan, with a cork at the corner;
a phial containing olive oil;
some very finely carded cotton;
some impalpable pumice powder, tripoli, or other polishing substance, tied
 up in a bag of muslin, sufficiently thin to allow the powder to pass
 through when the bag is shaken;
a phial of nitric acid, at 40 degrees, diluted with water, in the proportion
 of one liquor glass to sixteen of the same of distilled water;
a small furnace;
one spirit lamp;
a phial of mercury;
four metallic bands or cramps, the same substance as the plate;
six wooden wedges;
one glass funnel;
a phial of iodine;
a bottle of hyposulphate of soda;
a tea kettle;
a vessel for distilling water;
a little box of nails;

a pair of iron pincers;
a candlestick;
chemical matches;
the daguerreotype plates.[13]

Simpson's next step was to convince his wife to sit for a portrait. However, because of her husband's seemingly incomprehensible enthusiasm and madcap travels to collect the necessary equipment, compounded by her own doubts about the very idea of producing a picture by mechanical means, Mrs. Simpson found herself breaking into fits of giggling while she was supposed to be sitting immobile for the quarter-hour exposure. This would not do at all, and Mrs. Simpson was quickly replaced by her sister, Mrs. Maria Lowerre, who was no less skeptical of the venture but apparently could keep herself more composed. After the exposure the plate was developed, and Mrs. Lowerre became the first person to be daguerreotyped in Lowell, then New England's second largest city. The daguerreotype is unfortunately now lost.

Back in Boston, Edward Everett Hale and his cousin Francis Durivage built two sets of equipment based on Gouraud's. Their first successful daguerreotype was made on April 15, 1840.

> After school I went to Mr. Gouraud's and got a daguerreotype plate to experiment upon. Carried it to Francis's, and having gone through the preparatory processes, took a view . . . with which I was highly delighted. It had several defects, but was nevertheless admirable.[14]

> It is of the church at the South End nearly opposite the head of Orange St. . . . and is quite equal to some of the worst of Mr. Gouraud's, which I think quite encouraging for the first. It is very much like the one he had of Quincy Market. . . . I stood to be taken in it, Francis opening and shutting the camera, but unfortunately I stood against a dark background so that nothing but my legs which come against the white stone of the steps, and my face and shirt bosom are visible. It was in the camera twelve minutes, apparently just the right time for the light.[15]

Another attempt by Hale was a self-portrait:

> I sat with a mirror in my hands, in full sunshine. The mirror threw up the sun from below to abate the shadows. I sat in this light *five minutes*. The picture came out a capital portrait of my hair, ears, and *chin*. Alas! I had tipped my head too far back, and all that appeared were my projecting eyebrows and the orifices of both nostrils (no mouth, alas!) and the chin from below taking its place.[16]

Landscape (*most likely North Conway/Intervale, N.H. locale*). *Samuel Bemis, ca. 1840. Daguerreotype, 6½ × 8½ inches. Bemis summered each year in the White Mountains — one of the first to realize the area's potential as a summer resort. An affluent jeweler and dentist, he owned a large tract* in Crawford Notch, and it is likely he brought his camera with him in the summer of 1840 to continue his daguerreotype experiments. International Museum of Photography at George Eastman House, Rochester, N.Y.

All these pictures taken by Hale have long since disappeared. He was then a schoolteacher and could little afford to keep buying 6½ × 8½ inch daguerreotype plates from Gouraud at two dollars a plate. Instead he simply rubbed out the old image from the plate with pumice stone and used the plate over again. In early days the silver coating on the plate was quite thick and could be used up to forty times before wearing through.

While Hale may have been a penny-wise schoolteacher, other Bostonians could afford to buy a daguerreotype plate for each exposure, as did Samuel Bemis (1789–1881), a well-to-do jeweler and dentist. Bemis attended Gouraud's lectures and then purchased a complete outfit of apparatus from him. The whole of it is preserved, packing cases and all, at the International Museum of Photography at George Eastman House in Rochester. The accompanying sales slip shows that Bemis bought it on April 15, 1840, for $51.

On the afternoon of April 19, after closing his office at 32 School Street for the day, Bemis set up the camera facing out what was most probably his office window toward the King's Chapel Burying Ground. With the late afternoon sunlight raking across the rooftops, he opened the lens at 4:50 and closed it at 5:30.

His attempt was successful; the picture is the earliest documented daguerreotype taken in New England still in existence (page 2).

Bemis made a number of views from the same location showing the Burying Ground in different seasons. Another subject for his camera was the White Mountains region of New Hampshire. Since 1827 he had spent his summers there, setting up a home at the foot of Mount Crawford in Crawford Notch. Around 1840 he built the still standing Gray Stone Inn to which he later retired. In the summer of 1840 he brought his equipment up with him from Boston and photographed the local landscape, taking what are probably the earliest views of the area. Bemis apparently soon lost interest in daguerreotyping, as all his works date from around 1840. He lived to a ripe old age, dying rich and eccentric in 1881.

François Gouraud spent only a few months in Boston lecturing and selling equipment — March, April, and May of 1840. By mid-May he had moved on to Providence to lecture there.

THE DAGUERREOTYPE IN PROVIDENCE.

M. GOURAUD'S splendid Daguerreotype Exhibition of the wonderful Drawing produced by the light of the Sun will be open in this city on Saturday next, the 23rd inst. at UNION HALL, in rear of the Universalist Chapel, from 9 a.m. to 7 p.m. to be closed positively on Friday afternoon, the 29th inst.

Price of admittance 25 cents, children half price.

NOTICE — For the satisfaction of those who should wish to be fully initiated to the theory and practice of that new and beautiful art of Drawing which may be learnt in less than one hour, Mr. Gouraud will give a public lecture, or rather a practical demonstration of the process, on the last day of the Exhibition, at 4 o'clock p.m. precisely, in the same building.

Tickets for the lecture 25 cents.

The view, which will be a perfect one, will be taken during the lecture, and will be drawn for by lot, and delivered to the holder of the fortunate ticket without any charge.[17]

As in Boston, Gouraud's lecture and exhibition fascinated Rhode Islanders. His week-long exhibit included views of Paris, reportedly made by Daguerre himself, as well as Gouraud's own views of New York and Boston. Prominently exhibited was that "dimmed and foggy plate" of Boston during a storm that Southworth referred to so disparagingly. The people of Providence, however, were more impressed. Wrote a reporter for the *Providence Journal* on May 23, 1840: "In nothing is the power of the instrument more seen than in views of water and sky, and of different states of the atmosphere. The fog in one of the views seems material

and palpable, and nothing can exceed the truth to nature with which a snow storm is represented."

After the week in Providence Gouraud took his exhibit to Buffalo and then south before abandoning his lectures for other ventures. His collection of daguerreotypes, except for those left behind in lieu of unpaid bills, was apparently destroyed in a fire in New Orleans on the night of January 29, 1843.[18]

Gouraud's legacy to daguerreotypists was a book of instructions on the daguerreotype process, the first one written in America: *Description of the Daguerreotype Process . . . with a Description of a Provisory Method for Taking Human Portraits* (Boston, 1840). The sixteen-page work consisted of a condensation of Daguerre's original French manual, plus a reprint of an article on portraiture and portrait studio construction that Gouraud originally wrote for the March 26, 1840, issue of the *Boston Patriot and Daily Advertiser*. A second early New England manual was *The Photographer's Guide: In Which the Daguerrian Art Is Familiarly Explained* (Lowell, 1842), written by Gilman and Mower, daguerreotypists with a studio at 35 Merrimack Street, Lowell.

Outside the greater Boston and Providence areas, little is known of early daguerreotype experiments in New England. Most assuredly there were those who read the articles in national journals, or who, like Albert Sands Southworth, made the trip into Boston for Gouraud's lectures, yet they will remain forever anonymous.

On August 19, 1840, Samuel F. B. Morse, who had sparked America's interest in daguerreotyping with his letter about a visit to Daguerre, came to Yale for the reunion of his class of 1810. He lined up his eighteen classmates and took the first known daguerreotype of a college class (now lost). He took two exposures at 8 A.M. in the yard just north of the college president's house. That evening he exhibited the finished product, which he neatly mounted and framed. Apparently not overly impressed, the class secretary recorded, "The likenesses were most of them very distinct and good." [19]

In addition to the early photographic experimenters themselves, the New England region contributed from an early date to the production of photographic materials. Instrument makers, opticians, and cabinet makers constructed cameras and "darkroom equipment" modeled after those demonstrated by Gouraud.

The first daguerreotype plates were imported from France. Within a few years of 1839, however, Americans were producing them as well. At first the plates were poor imitations of the European items; they usually were sold by lecturers modeling themselves after Gouraud, or in the new galleries now springing up. "American plate is very imperfect, the silver abounds with perforations which appear like black dots in the design," [20] complained Gilman and Mower in their photo manual.

The Scovill Company, a brass manufacturer in Waterbury, Connecticut, began

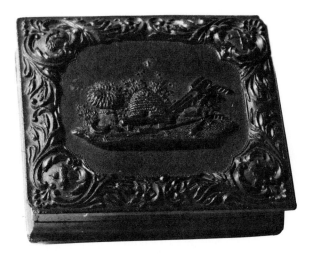

Daguerreotype case: *"Beehive of Industry."*
Alfred P. Critchlow. Florence, Mass., ca.
1850s. Ornate cases such as these were made
by forcing plastic-like pellets into a heated
mold. Case manufacturers vied with each
other to produce artistic cases, which often
outshone the drab portrait within. Private
collection.

to make daguerreotype plates in 1842 that were "considered better than the English and nearly as good as the French." [21] Around the same time the company hired Joseph Pennell, Southworth's partner from his Chicopee studio, to supervise the production of daguerreotype plates. Over the ensuing years, Scovill was quick to adapt any improvements in daguerreotypy to the manufacture of its plates. By 1848 their output exceeded one thousand daguerreotype plates a day.

In the early 1850s a second Waterbury brassworks, Holmes, Booth and Haydens, acquired a man once employed by Daguerre and set him to directing daguerreotype plate production. By this time Pemberton and Co. of Connecticut and Benjamin French of Boston were also selling daguerreotype plates, as well as other photographic items which they either manufactured or imported.

In 1854 daguerreotypist Samuel Peck of New Haven patented a way to heat pellets of gutta-percha (a sap exuded from certain Malaysian trees in the manner of rubber and chicle) and force them into molds to form highly ornate "Union" cases to hold finished daguerreotypes. The company he founded to make these cases was later bought out by Scovill. Another case manufacturer was Alfred P. Critchlow of Florence, Massachusetts. Critchlow began producing cases in 1852 and apparently contested Peck's patent. In 1858 his firm became Littlefield, Parsons and Co., later the Florence Manufacturing Co., and finally the present-day Pro-Phy-Lac-Tic Brush Co.

These gutta-percha cases were often finely designed with decorative borders and reliefs of patriotic or sentimental scenes, such as Washington crossing the Delaware or the young bride grieving at her husband's grave. Unfortunately, these designs

contributed to the wholesale destruction of many old daguerreotypes at the turn of the century. By the 1890s people were junking the once treasured daguerreotypes to use the beautiful cases for cigarette boxes, jewel cases, and pretty bureau-top containers for odds and ends. The case manufacturers themselves contributed to this practice with a last ditch effort to survive the demise of the daguerreotype; they turned out wooden collar boxes, playing card cases, and the like, topped with the ornate covers of the old Union cases.

2 "Pictures taken...
except small children"

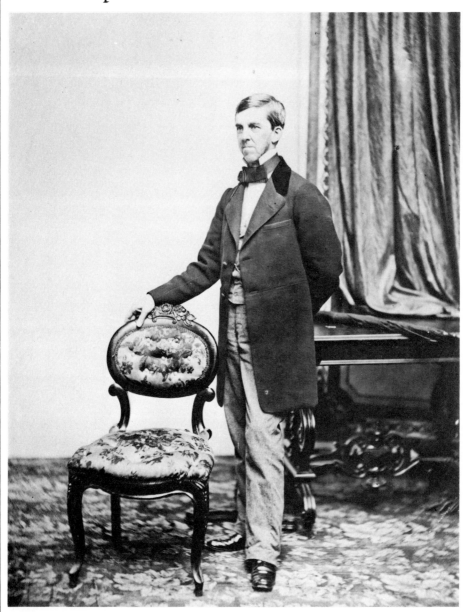

Oliver Wendell Holmes. *Daguerreotypist unknown. Boston, ca. 1845. Late nineteenth-century photographic print from a daguerreotype. Probably one of the earliest pictures of the man who was to do much to promote photography among the general public. It was taken when Holmes was an up-and-coming doctor, sometime between his publication of a study in 1843 on the possibility of doctors' transmitting contagious diseases from one patient to another, and his appointment to the Harvard Medical School in 1847. Countway Library of Medicine, Boston.*

Within a few years of Daguerre's announcements in 1839, Americans were turning the craft of daguerreotypy into a commercial venture. The high-contrast daguerreotype image was too harsh for general use outdoors in bright sunlight and dark shade, but in a softly lit studio it brought out minute differences in shading to produce a clean, sharp picture that was ideal for portraiture. Perhaps a sitter might object to remaining motionless for an exposure measured in the tens of minutes, but people were working to solve that problem.

Daguerrean galleries, as they were called, first appeared in the larger American cities, like New York, Philadelphia, and Boston, around 1840. By the close of 1841 galleries were operating in New England in Hartford (S. M. Ensign), Lowell (B. R. Stevens), and Boston (Henry I. Abel, C. E. Hale, Marcus Ormsbee, John Plumbe, Jr., Southworth and Co., and E. A. Smith). By 1850 virtually every New England city had from two to a dozen or more galleries competing for the public's favor, and in a village of any size one could usually find someone making portraits on a part-time basis.

One reason for the spread of daguerreotypy in America was the financial crisis of the early 1840s, created by the economic chaos accompanying the Andrew Jackson administration during the 1830s. Many people who in better times might have been otherwise employed turned to daguerreotypy, attracted by the possibility of a steady income with only a small outlay for equipment.

In New England, a second reason for the growth of daguerreotypy was the Yankee love for mechanical contrivances. The craft was ready made for the inveterate tinkerer, and even better, its pseudo-artistic nature allowed him to elevate himself to the position of "daguerrean artist." Albert Sands Southworth reminisced about his early days in the business:

> Into the practice of no other business or art was there ever such an absurd, blind, and pell-mell rush. From the accustomed labors of agriculture and the machine shop, from the factory and [store] counter, from the restau-

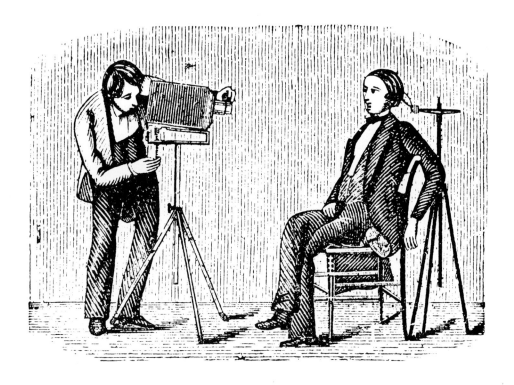

rant, the coach-box, and the forecastle, representatives . . . appeared to per-
form the work for which a life-apprenticeship could hardly be sufficient.[1]

Southworth himself had been a small-town pharmacist before his trip to Boston to
hear Gouraud lecture. His partner, Josiah Johnson Hawes, had been a carpenter,
miniature painter, and itinerant lecturer on the subjects of electricity and magnetism.

The daguerreotype appeared in an era of national restlessness. New fields of
science and technology were just opening, inventions were coming fast and furi-
ously — the telegraph, sewing machine, and other devices. Nathaniel Hawthorne
made a daguerreotypist a main character in *The House of the Seven Gables* (1851).
Mr. Holgrave is not simply a daguerreotypist, however; he represents a typical
personality of his day. Hawthorne speaks of him as having been, by age twenty, a
country schoolmaster, salesman in a village store, political editor of a rural news-
paper, itinerant peddler, part-time dentist, sailor, and lecturer on mesmerism. "His
present phase, as a daguerreotypist, was of no more importance in his view, nor
likely to be permanent, than any preceding ones." [2]

Despite these undisciplined early wanderings, many of these young and ambi-
tious men ultimately became great masters in the art. Nor was the trade restricted
to young white males. In Hartford, for example, one studio was run by Mrs.

Mary A. Parker; another by Augustus Washington, a black who had taken up daguerreotyping to finance his way through Dartmouth College. Washington later packed his equipment and left for Liberia in 1855. While the daguerreotypist himself, termed the "daguerreian operator," was usually male, women worked as assistants, posing the customers and advising women sitters on makeup and dress. Southworth and Hawes employed two women in this capacity, one of whom was Hawes's sister, Nancy (later Southworth's wife). More often than not these anonymous women were responsible for the success of a sitting. Their eye for composition and pose, and their flattering attention to the sitter brought out the best in a customer and guaranteed a beautiful final product.

Not everyone was enthusiastic about the daguerrean art, however. Although many painters of the day, like Samuel F. B. Morse himself, hailed the idea, others scoffed. In a letter, the great Hudson River School painter Thomas Cole commented in early 1840:

> I suppose you have read a great deal about the Daguerreotype. If you believe everything the papers say, (which by-the-by, would require an enormous bump of marvelousness,) you would be led to suppose that the poor craft of painting was knocked in the head by this new machinery for making Nature take her own likeness, and we [painters] nothing to do but to give up the ghost.... But I was saying something about Daguerreotype matters — this is the conclusion: that the art of painting is as [much] a creative as an imitative art, and is in no danger of being superseded by any mechanical contrivance.[3]

But Cole was wrong. Portrait painters suffered greatly from the establishment of daguerreotype portrait studios. Previously, someone wanting a likeness usually employed the services of an itinerant painter called a limner. These artists went from town to town trading their artistic skill on canvas for a modest subsistence. For the most part the limner's work was ill-proportioned, flat, wooden, and devoid of life. Today we grace these rudimentary efforts with the classification American Primitive. In their day they were less esteemed. In 1861 Oliver Wendell Holmes hailed their demise, calling their makers

> wandering Thugs of Art whose murderous doings with the brush used frequently to involve whole families; who passed from one country tavern to another, eating and painting their way, — feeding a week upon the landlord, another week upon the landlady, and two or three days apiece upon the children; as the walls of those hospitable edifices too frequently testify even to the present day.[4]

With competition such as this it was no wonder that the daguerreotype, no matter its shortcomings, quickly gained the public's favor. What was a few dollars and ten minutes' sitting, compared to the bed and board of the limner and hours of posing for a lifeless canvas? The early daguerreotype portraits may have been little better, but at least they were easier on the customer and his pocketbook.

Many itinerant painters, seeing the handwriting on the wall, switched from brush to lens and adopted the daguerrean trade. Josiah Johnson Hawes abandoned his painted miniatures. William Hazen Kimball (1817–1892) did likewise in 1844. He later moved from his home in Lowell to Concord, New Hampshire, to begin a business that was carried on by his children and grandchildren well into the twentieth century.

Other men combined painting and daguerreotypy. J. W. Stock and O. H. Cooley, who opened the first "Portrait and Daguerreotype Rooms" in Springfield, Massachusetts, in May 1844, advertised "accurate and beautiful likenesses" on the daguerreotype plate and miniature paintings on "terms low to suit the times." [5] Those wishing a portrait painted simply sat for a daguerreotype, and this was then used in place of the customer's sittings.

One early New England gallery was the Boston studio of John Plumbe, Jr. (1809–1857). Plumbe, a Welshman, came to America in 1821 and in the 1830s was a railroad construction supervisor. A born operator, he had convinced Congress to grant him money to survey new rail routes. Later, in the face of Congress's reluctance to supply further funds, he was "obliged to resort to taking Daguerreotype likenesses, in order to keep up the soul of our undertaking by supporting our body." [6]

In the first months of 1841 Plumbe arrived in Boston to open his "United States Photographic Institute," a title that even P. T. Barnum might have been proud of. He operated as his own daguerreotypist until he could afford to hire an assistant. He soon worked up a franchise system, selling the right for others to set up studios in various cities under the name "Plumbe National Daguerrian Gallery and Photographers' Furnishings Depot." There were fourteen galleries in all, including Newport, New York City, and two in Boston. The public had great enthusiasm for his work, not so much for its artistic merit as for the fact that Plumbe kept up with, and adapted to, new innovations in daguerreotypy. The public felt assured of getting a "state of the art" picture from a Plumbe gallery.

In his search for better methods — shorter exposures, brighter images, more attractive framing, tinted images — Plumbe employed Boston's Davis brothers: Ari, Asahel, and Daniel, Jr. They devised many improvements which later became identified with Plumbe's name. Daniel, an early experimenter with electricity, developed a way to apply the daguerreotype plate's silver surface by electroplating. He

also patented and sold Plumbe the rights to one of the first successful techniques for hand coloring daguerreotype portraits. Asahel toured the countryside lecturing on the "Plumbe system" before setting up a gallery under the Plumbe name in Philadelphia. The Davises also made equipment which Plumbe sold through his galleries. After the departure of Gouraud, many of the early daguerreotypists in New England learned their trade from Plumbe, who gave lessons on the operation of the equipment he sold, advertising

> the security and independence in a profession as honorable, interesting and agreeable as any other . . . by the expenditure of a mere trifle and [a] few days application. Can any other pursuit in life present the same advantage in furnishing the means of gentlemanly support, not to say fortune? [7]

Many New Englanders and others journeyed to New York City to study the art at the studio of Samuel F. B. Morse, then America's most famous daguerreotypist. In the early days of the trade, when the public knew so little about it, the advertisement of a name everyone recognized proved a profitable calling card.

> DAGUERREOTYPE PORTRAITS, by S.M. ENSIGN, Pupil of Prof. S.F.B. Morse, of New York, taken with or without Sunlight, from 10 o'clock A.M. until dark, every day, at *Kellogg's Building,* Main Street. Portraits can be taken equally well in *cloudy* and even *stormy* weather, requiring only a few seconds, and in clear weather can be taken in less than a *second of time,*[8]

read the advertisement for Hartford's first studio. J. D. Willard, Hartford's second daguerreotypist, as well as Albert Sands Southworth and Joseph Pennell of Chicopee, all took lessons from Morse. When Southworth and Pennell moved to Boston in 1841, they prominently displayed Morse's name on their business cards.

By the mid-1840s virtually every studio ran a sideline of providing lessons. Those without funds for lessons often worked as apprentices, later going off on their own or amassing enough money to buy out an ailing studio in the hope of doing better than their former employer. Elias Howe of sewing machine fame worked for Plumbe and the Davis brothers before overhearing a discussion of the need for a mechanical stitching device while working in the shop. For a short time Howe later had his own studio in Cambridgeport, Massachusetts. James Wallace Black was an apprentice for Boston daguerreotypist John Leroy, who also worked to develop the sewing machine. "I remember thinking how impossible it must be to sew by machinery, and I as little thought of the wide range photography would eventually

take," [9] reminisced Black, the man who was to take America's first successful aerial photographs (see chapter 3).

Yet the business was not all smooth profits and expansion. Throughout the 1840s, unpredictable results from a general ignorance of the actual chemical and mechanical actions that produced the daguerreotype image, as well as the financial burden of purchasing new equipment to keep up with improvements in the process, plagued the daguerreotype studios. Added to this, many would-be daguerreotypists believed the extravagant claims of easy success made by those selling equipment or giving lessons. Many a studio was set up that never made a profit, and many passed from owner to owner, often because the proprietor was "necessitated to leave the city":

> RARE CHANCE — The undersigned designing to leave the city in the course of two or three weeks, offer for sale the DAGUERREOTYPE AP-PARATUS and FIXTURES, the whole in perfect order for operation. Any person wishing to embark in a good business will do well to embrace the present opportunity. For particulars enquire at 136 Main Street (up stairs).
>
> <div align="right">HOVEY & GROSVENOR.[10]</div>

The daguerreotype studios of the 1840s and 1850s varied from an open space in the back of a rural store, where one could find a camera focused on a chair and a woolen blanket tacked on the wall behind, to big city multistoried establishments with waiting rooms, art galleries, dressing rooms, developing rooms, and skylighted "operating rooms," where the pictures were taken. In locales without even a back-room daguerreotypist one found the itinerants with their horse-drawn wagons — fully equipped, self-contained studios and darkrooms. They were common sights in the rural areas of New England in the middle of the nineteenth century. "One may not infrequently see a photographic *ambulance* standing at the wayside upon some vacant lot where it can squat unchallenged . . . , or making a long halt in the middle of a common by special permission of the 'Selectman,' " [11] observed Oliver Wendell Holmes.

The traveling wagons, the back-room studios, and the big city galleries all aspired toward the same gaudy opulence. An 1857 advertisement for the "Boston Gallery of Art" of James A. Cutting and Austin A. Turner shows a chandelier-hung salon where well-dressed customers sit on velvety couches or stand marveling upon rows and rows of ornately framed pictures entirely covering the walls. A client entering the gallery of Boston daguerreotypist Luther Holman Hale in 1851 encountered

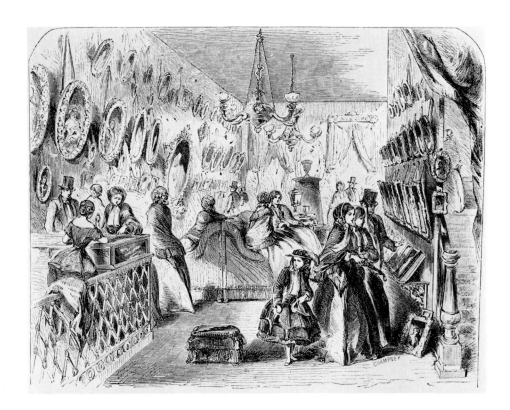

the pianoforte, the music box, the singing of birds; the elegant drapery; the beautiful pictures; the expensive gallery of portraits; the struggling sunbeam peering through doors of stained glass; statuary, engravings; all, all seem to impress the visitor with the ideal of palace-like magnificence, and serve to soothe the troubled spirit, and calm the anxious brow, preparatory to the obtaining of a good picture.[12]

One wonders how many customers' first impression was confusion that they had wandered off course and mistakenly walked into a high-class bordello. It would seem that the only difference between the two establishments was that in the daguerreotype gallery the figures framed on the walls were fully clothed.

In fact, the bordello and the daguerreotype gallery were decorated with similar aims. The clientele often came in bunches and there was a need to keep them relaxed and occupied while awaiting their turn upstairs. Before the days of electric flood lamps, or even magnesium flash powder, the studio photographer was entirely dependent on the weather for sufficient sunlight to obtain a good picture. There were no reservations made for a sitting in daguerreotype days, and the customer simply dropped in on a sunny day. So did everyone else with the same idea. Mon-

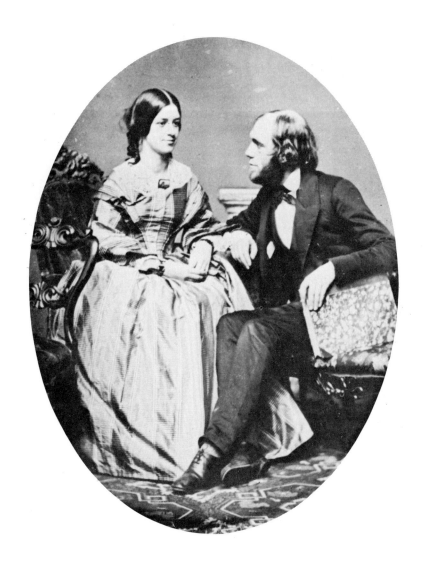

day was always a busy day, no matter the weather. With a six-day workweek, serious courtship was reserved for Sunday evenings. Come Monday morning, the daguerretoypist had a waiting room full of young men and women who had agreed to exchange daguerreotypes the previous evening.

To keep the customers from becoming bored and irritable — and ultimately immortalizing this expression in a daguerreotype likeness — the studio operator brought in what he could to keep everyone entertained. Ornithologist-daguerreotypist Andrew Wemple Van Alstin (1811–1857) of Worcester filled his waiting room with stuffed birds. Elderly daguerreotypist Anson Clark of West Stockbridge, Massachusetts, jokingly boasted of "specimens of minerals . . . models of machines

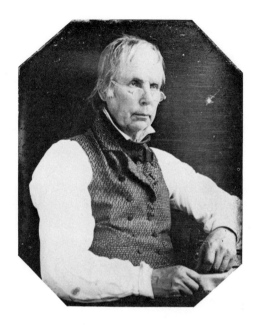

Portrait, *believed to be a self-portrait by Anson Clark. Daguerreotype, 2⅞ × 3¼ inches. Anson Clark (1783–1847) of West Stockbridge, Mass., took up the daguerreotype trade after a varied career as experimenter, inventor, instrument maker, and religious freethinker. Historical Room, Stockbridge Library, Stockbridge, Mass.*

. . . pictures of all the heathen Gods and Goddesses . . . eggs of various kinds of birds . . . shells . . . the cane that kill'd Abel and one of the Ram horns that brought down the walls of Jericho." [13]

Once a customer's turn came, he was ushered into the "operating room." Here at one end stood the camera, a mahogany box or brass cannon-shaped object. The sitter was posed in a chair before a plain backdrop at the other end of the room. A head clamp was fitted behind to prevent motion of the head, and the sitter stared straight ahead at the camera. At this point the daguerreotypist might call for some temporary cosmetic surgery — perhaps some cotton wadding to plump out hollow cheeks or sticking wax to flatten bat-wing ears. A few words would be said to calm the sitter's nerves, the lens cap removed, the proper time counted off, the cap replaced, and the sitter returned to the waiting room for the five to ten minutes' time it took to develop the daguerreotype plate. The finished picture was then delivered in a covered case, framed in wood, encased in a locket, or set in a ring — whatever the customer desired.

The image itself might range from a mere pasty-faced "likeness" to a realistic masterpiece of portraiture, although it usually tended toward the former.

> There was a charm about reproducing an object by this means that brought many persons to practice it who were perfectly ignorant of the first principles of light and shade. Consequently, the results were only a faint likeness, without any pretension of artistic merit,

wrote James Wallace Black, confessing that he himself at first simply

> used a common window side light, with a large mirror for reflecting light,
> the object being to get a fair outline with the face as white as possible, and
> also the shirt front.[14]

In the matter of lighting the subject, the average daguerreotypist was faced with
a choice of two evils: either flood the room with strong sunlight to shorten exposure
time, and in doing so produce an image of a half-blinded, squinting customer; or
use less light, thereby lengthening the exposure and producing a picture with parts
of the body "enlarged" — hands, cheeks, and chest all fuzzy and slightly oversized
from nervous motions and breathing during the exposure. For the twenty years that
the daguerreotype held prominence (ca. 1840–1860), many studio daguerreotypists
worked as diligently trying to discover a means of making shorter exposures with
less light as they did actually posing their subjects.

In one phase of the business prolonged exposures presented few problems: taking
likenesses of the deceased. It was quite common for a funeral procession to make a
call at the local daguerrean gallery on its way to the cemetery. For the more discreet,
J. S. Miller of the Excelsior Daguerrian Gallery of Nashua advertised in 1853:
"Likenesses taken of invalids and deceased persons, at their residences, if desired." [15]
J. S. Miller was, within certain limits, also ready to take on younger and healthier
specimens: "Pictures taken cloudy *as well* as fine weather, except small children." [16]
Only bright, sunny days allowed the exposure to be short enough to capture the
image of a fidgeting child.

Daguerreotypists usually blanched when screaming children entered their gal-
leries, often ushered in by parents whose own apprehension over the daguerreotype
process instilled in the child a fear no less terrible than that of an impending dental
appointment. Yet there was ready money for the person who could satisfy doting
parents. Daguerreotypists often advertised themselves as adept child portraitists —
sometimes using the hard-sell approach:

TO PARENTS.

> In the DAGUERREOTYPE ART, nothing is so difficult as to succeed in
> the PORTRAITS OF CHILDREN.
> To this branch the subscriber has given particular attention, and can guar-
> antee an accurate Likeness of a Child often when other operators have en-
> tirely failed in the attempt. Those Parents who desire Pictures of their little
> ones — (and who does not!) when they remember the uncertainty of life,

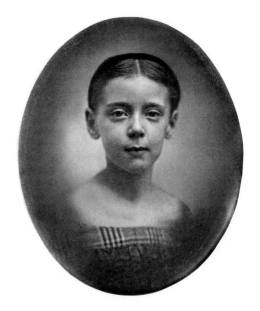

Elizabeth Bradley Jewell (1850–1897). *Photographer unknown (New Hampshire locale), ca. 1860. Daguerreotype, 2⅞ × 3⅜ inches. While most daguerreotype images are sharp and hard-edged, this portrait of a young girl shows a soft, ethereal quality. New Hampshire Historical Society, Concord.*

and the suddenness with which the graceful bud is *often* plucked by the stern Reaper, would do well to call at the original
DAGUERREOTYPE GALLERY,
EXCHANGE PLACE, WATERBURY,
and bring their children with them.
ALSO, ADULTS TAKEN IN A SUPERIOR STYLE.
WM. H. JONES.[17]

Public reaction to the daguerreotype ranged from amused tolerance to aboriginal dread. In *The House of the Seven Gables* Hawthorne has one character muse on the "hard and stern" expressions on the mirror-surfaced daguerreotypes, and on the problem of getting the right angle of light by which to see the image, concluding: "They [sitters] are conscious of looking very unamiable, I suppose, and therefore hate to be seen." "No wonder so many daguerreotypes have a strange, surprised look," observed contemporary essayist T. S. Arthur, noting that sitters complained of "magnetic attractions," "prickly sensations," "drafts of air," or a "sense of suffocation," while being daguerreotyped.[18]

Nevertheless, there were few people who, by the late 1850s, had not been daguerreotyped a half-dozen times or did not boast of a mantelpiece collection of daguerreotyped loved ones. The mid-1850s was the peak era of daguerreotype production. In 1857 the annual output of daguerreotype portraits was estimated at three

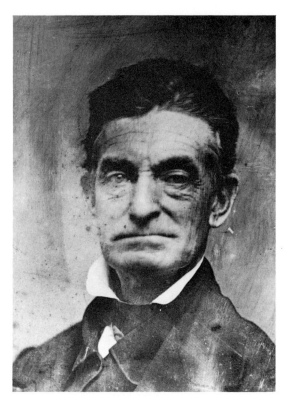

John Brown. *Whipple and Black. Boston, late 1856–early 1857. Daguerreotype, 4¼ × 6¼ inches. Brown, the violent abolitionist, had recently returned from Missouri, where this "instrument of God's will" led a free-soil band in a massacre of pro-slavery settlers. In 1859 he was hanged for his deeds at Harper's Ferry. The Boston Athenaeum.*

million for the United States; in New England, hundreds upon hundreds of galleries advertised their calling.

The finest daguerreotypists in America, and perhaps the world, could be found at this time in Boston. Here resided artists, experimenters, and innovators; here were made some of the greatest images ever to be preserved on the daguerreotype plate. By 1850 the city boasted twenty-five major galleries along Tremont Row and Washington Street. Here ex–New Hampshireman James Wallace Black (1825–1896) excelled at making becoming portraits. "The natural courtesy and gentlemanly attention which he unaffectedly pays visitors," wrote an acquaintance, served to "call out the loveliest and best mood of his sitters." [19] Before organizing his own studio in the late 1850s, Black worked his way up from apprentice to full partner of another Boston great, John Adams Whipple (1822–1891). Whipple was more the innovator and experimenter, while Black was the artist. Originally a chemist, Whipple devised many techniques to improve the daguerreotype process, as steam engines replaced the laborious hand work necessary to give a high polish to the daguerreotype plates.

Another Boston inventor was Luther Holman Hale (1821–1855), who had risen to prominence as a camera "operator" for Benjamin French. Hale's ingenuity apparently was equalled by his love for a practical joke. When a small-town daguerreotypist tried to wheedle the well-kept secret of how Hale produced the most brilliant images (rotary buffing machines for polishing, and a high temperature under the mercury vaporizer), Hale swore it was his ability to keep the chemicals cool. He went into a rambling discussion of the ability of a hot potato to keep its heat, then

confided that he kept cold potatoes in his chemical trays. This explanation satisfied the small-town daguerreotypist, to Hale's great delight.[20]

Another time a customer came quite late in the day, when the sunlight was already fading. Despite Hale's warnings that it would take an extremely long exposure, the customer insisted upon sitting for a picture. Hale and his assistants meticulously posed the sitter, removed the lens cap of the camera, and told the person not to move on any account. They then tiptoed out the door and left for a leisurely supper. Finally returning to the studio, Hale was surprised to find the man still rigidly seated in the posing chair. Carrying the joke along, Hale pretended to develop the picture and presented the man with a very bad likeness that he had fished out of the reject pile. The reaction of the customer to all this was, unfortunately, unrecorded.[21]

Of all the Boston studios, the most famous was that of Southworth and Hawes. Like Whipple and Black, Southworth and Hawes were an artist/inventor partnership. Albert Sands Southworth (1811–1894) was a born tinkerer, prone to flights of fancy with get-rich-quick schemes. Josiah Johnson Hawes (1808–1901) was a keen-minded artist with a strong will that balanced Southworth's vagaries. Together they brought the daguerreotype image to a quality never surpassed.

Unlike their contemporaries, Southworth and Hawes pushed the medium to its limit. Their portraits, often unconventionally posed, were brilliantly lit with faces sometimes swathed in deep shadow, and were always powerful and penetrating. James Wallace Black wrote of the two men:

> The first to practically show us that we must know something of composition and light and shade was the firm of Southworth & Hawes. They certainly, at the time, took the lead, and made some of the most exquisite results — only the profession had not the cultivation to appreciate them. I have known those men to devote days to producing what they considered a good likeness, and many of their productions are today unequalled.[22]

From the earliest days of daguerreotypy, its practitioners complained that the results were simply too contrasty to contain detail in both the brightly sunlit and dark shadow portions of the image. Early experimenters suggested that

> it is best to choose a time when the sky is partly clouded; and if, during a part of the operation [exposure], you are fortunate to have an occasional glimpse of sunshine, the impression will be very harmonious; the shades produced [i.e., the shadow area], instead of being of a dull black tone, will be perfectly transparent, for the details will have time to be formed in them by the diffused light, and the sun's rays will give the most brilliant touches.

To reproduce this effect in the studio, it was suggested that a gauze canopy be suspended between the sitter and the sunlight. When the exposure was nearly completed, the daguerreotypist was advised to "take away the gauze and allow the sun's light to give the finishing touch to the lights of the pictures." [23] Though fine for still-life compositions, the distracting movement of the gauze was bound to produce eye motion, or more, in a sitter, and resulted in a blurred image.

Southworth and Hawes solved the problem with a combination of artistic eye and scientific precision. "Have a room where you can *control* your light thoroughly and perfectly," advised Southworth.

> Have a room where you can give as much diffused light on the face, without making it one particle more on one side than on the other than the eye can bear comfortably. . . . Then open your sky-light just as you want it, to give the right light on the nose and the forehead, giving the shadows as they ought to come, and you have your light right for the subject; and for the different lights, change your subject around the room, and if the nose happens to be a short one, you have got to manage it, or if it is very long, and if there are wrinkles your diffused light lights them up. [24]

According to Southworth, they opened the skylight so that light shone down on the sitter at a raking 45-degree angle. "The reason is, that I want to show the lines of the brow, the lines of the nostrils. I want the shadows falling off to this direction so as to give the shape of the nostrils." [25]

The studio itself was large, and the skylight high. "Now I want to go twenty-four feet from the sitter, and I want to lower the instrument one foot. . . . I want the largest lens that you can possibly give me . . . no less than five inches in diameter." [26] Portrait daguerreotypists were constantly warned by the experienced to avoid lowering the camera so much that it caused distortions, making the lower part of the body seem larger in proportion than the head, much the same as a wide-angle close-up does today. Yet Southworth and Hawes were able to get a feeling of looking *up* into the sitter's eyes by getting much farther back than the usual half-dozen feet from sitter to camera, and thus avoiding perspective distortions.

Once the equipment and lights had been set, the artistic eye took over.

> I bring them into the light-room that their eyes may be accustomed to the light in which they are going to sit. You go around into the room, and show them the objects of interest; view their faces in the different lights, and get familiar with their countenances, and endeavor to call out their ideas. [27]

Lemuel Shaw. *Southworth and Hawes. Boston, 1851. Daguerreotype, 4¼ × 6¼ inches. As chief justice of the Massachusetts Supreme Court, Shaw (1781–1861) gained national fame the year this picture was taken by refusing to release a fugitive slave on a writ of habeas corpus. Shaw's homeliness was almost as well known as his stand against* *slavery, prompting Massachusetts Senator Rufus Choate to remark, "I always approach Judge Shaw as a savage approaches his fetish, knowing that he is ugly, but feeling that he is great." The Metropolitan Museum of Art, Gift of Edward S., Alice M., and Marion A. Hawes, 1938.*

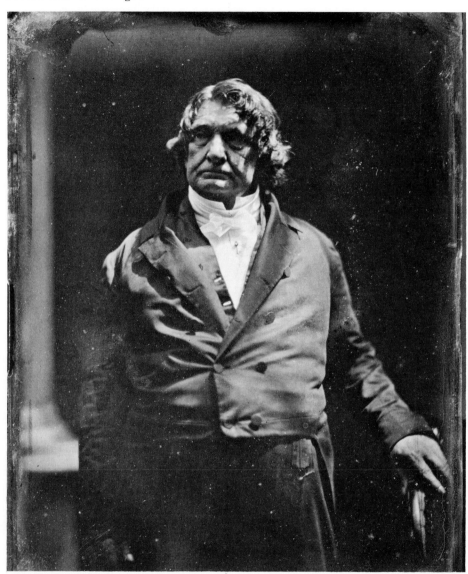

The striking portrait of Massachusetts Supreme Court Chief Justice Lemuel Shaw was obtained in this manner. A newspaper reporter interviewing Hawes in 1888 wrote that "Chief Justice Shaw came to sit, and while waiting for the preparation of the plate, he happened to stand under the skylight in such a manner that his rugged features were brought out with striking power. They begged him to remain as he was, and hurrying for plate and camera, they secured the great portrait."[28]

While Shaw's eyes are bathed in shadow in this image, Southworth and Hawes were usually quite adamant that their sitter's eyes be clearly visible and focused into the distance. They felt that eyes crossed to look at something close by robbed the face of character. They also made sure that the lighting was such that a spot of light was reflected from the eye of the sitter, again to give life and character to the face. In their advertisements they decried others who, instead of imparting one small spot or highlight in each eye, allowed the whole pupil to become a blotch of white, "giving it a wild, unnatural gaze, or destroying its lively appearance." [29]

The efforts of Southworth and Hawes to produce the best daguerreotypes possible made them well known throughout the country. For the famous and notable of the 1840s and 1850s, a visit to Boston meant a climb up three flights of winding stairs to the top two floors of 5½ Tremont Street. At the door they were met by Southworth, who put them at ease with conversation and a tour of the studio. The scrupulous concern for the sitter and the individuality of the final image did not come without charge. Southworth and Hawes's prices were more than double their competitors'. "No cheap work is done, we shall spend no time in bantering about prices," warned one of their advertisements. [30] The high price was necessary to defray the cost of the artists themselves composing and taking each picture. Most galleries had a number of "taking rooms" where the customer was set in a stock pose and his or her picture taken by a hired camera operator. Southworth and Hawes also went to the additional expense of taking a number of pictures from which the customer could choose his favorite. The partners often profited from these rejected images. If the daguerreotype was of a famous personality, there were periodicals (especially *Gleason's Pictorial* of Boston) willing to pay for its use in making an engraving for their magazine. Southworth and Hawes also made daguerreotype copies of the original to sell to the public. In fact, a good portion of Hawes's income in the latter half of the century came from the reproduction and sale of photographic prints copied from daguerreotype portraits he and Southworth made in the 1840s and 1850s.

The greatest of Southworth and Hawes's work are their three-quarter to full-body portraits of craggy-faced men. Not only are the faces remarkable, but the figures all bear individualized gestures and poses. "Barring the modern costume, it looks as if an ancient statue had been exhumed and reproduced by the photographic art," [31] wrote one reporter of the Lemuel Shaw portrait. The partners virtually never repeated a pose; rather, they let the physical appearance of the sitter dictate the final arrangement. This departed from the usual practice of setting the customer in one of a number of stock poses in order to produce a flattering, pleasant, but characterless image.

In their own way, Southworth and Hawes used a sitter's physical peculiarities to

represent inner character. For this reason their best work is of subjects with some-what awkward features, ones that "make beauty in a face seem almost contempti-ble." [32] They discarded smooth handsomeness for lined faces whose images ex-pressed "great power, splendid intellect, and mighty will." [33]

The demise of the daguerreotype portrait industry came in the late 1850s. New processes now made the old metal-plate daguerreotype out of fashion. These in-cluded the ambrotype,* perfected by James A. Cutting of Boston, and the photo-graph, popularized in the early 1850s by John Adams Whipple of Boston: the now conventional technique of producing a negative from a camera exposure and print-ing it on photographic paper. Photographs printed on paper took the forefront in the late 1850s. Previously, the negative and print process, like the earliest daguerreo-types in the 1840s, required too long an exposure to be practical for portraiture, but by the late 1850s this problem was overcome. In 1859 the carte-de-visite style arrived from Europe and caught the American public's attention (see chapter 5). Cartes de visite were small photographs pasted on cardboard and left as calling cards or collected in albums. Their low cost and ease of duplication soon edged out the daguerreotype.

In 1861, almost as a death knell of the daguerreotype, Southworth retired from his partnership with Hawes. Perhaps he realized that their greatness lay only in the medium of the daguerreotype. The early paper photographs they produced around 1860 support this possibility. They are lifeless, with little contrast or vibrancy, and only the names of Southworth and Hawes, or later Hawes alone, link them to the noble images of America's great.

* An ambrotype was a faintly exposed glass negative mounted over a darker material, such as black paper, cloth, or paint. Where the silver deposits on the negative were thin (correspond-ing to the dark areas in the subject photographed), the light would pass through and show up the dark material beneath. Where the silver deposits were thick (corresponding to the light areas in the subject), the light would reflect back and seem lighter than the dark layer beneath. In this way a positive image was produced from a negative. Since it used the original negative, the ambrotype was a one-of-a-kind picture like the daguerreotype. Also, since the subject was exposed directly on smooth glass, the ambrotype approached the daguerreotype in sharpness of image.

3 The Heavens from Earth and Earth from the Heavens

The Moon. *John Adams Whipple. Harvard College observatory, August 6, 1851. Daguerreotype, 3¼ × 4¼ inches. One of the best surviving originals of Whipple's moon daguerreotypes taken at the observatory between 1849 and 1852. Donald P. Lokuta Collection.*

APPLYING THE CAMERA TO NEW USES

1840s–1860s

While most photographers of the mid-nineteenth century spent their time in studios making portraits, others were searching out different uses for the medium.

The photographic picture became the new way of recording the universe. Soon no place was exempt from the camera's lens. The photographer entered the precincts of the doctor's office and operating room, cameras were attached to telescopes focused on the heavens, cameras immortalized historical events, provided irrefutable proof of scientific discoveries, and soon hung from balloons floating thousands of feet above the earth.

One of the earliest problems in the application of photography was how to transfer an image to the printed page. With the unique daguerreotype, the most common solution was for an artist to redraw the picture onto an engraver's block for printing. This interpretation, however, robbed the daguerrean image of much of its character and, if the artist was not of the highest caliber, much of its quality as well. Popular periodicals of the day, such as *Gleason's Pictorial* of Boston, had staffs of accomplished engravers, and many of the portrait cuts in *Gleason's* were based on Southworth and Hawes's daguerreotypes.

Less successful as engravings were pictures whose force depended on their photographic quality. In 1844 abolitionist Jonathan Walker, of Harwich, Massachusetts, sailed south to help slaves escape their plantation masters. He was caught and imprisoned at Pensacola. In 1845 the court there, wanting to give a dire warning to all who might aid escaped blacks, ordered that the palm of Jonathan Walker's hand be branded with the letters *SS*, for slave stealer. Instead of intimidating the abolitionists, Walker's branded hand became a rallying point for the antislavery movement. Later that year Walker was released and returned to Massachusetts, where he wrote a chronicle of his trials.[1] He had a daguerreotype made of himself by Southworth and Hawes, which artist J. Andrews used as the basis for an engraved portrait frontispiece to the book. Southworth and Hawes also daguerreotyped Walker's branded hand, and this picture appears in Walker's book as a rough woodcut: the outline of a hand with the letters *SS* appearing in their proper

The Branded Hand of Jonathan Walker. *South-worth and Hawes, ca. 1845. Daguerreotype, ap-proximately 3½ × 2¾ inches. Walker was apprehended off Florida's Gulf Coast as he was helping slaves escape to the West Indies. After a sensational trial at Pensacola, he was found guilty and his hand was branded with an SS for slave stealer. As the picture which forms in a camera is always reversed, the letters appear backward. (In* our modern two-step negative and print procedure, *the reversed image of the negative is re-reversed onto the print to give the correct orientation.) The line drawing is a cut, made from the daguerreo-type, which appeared on the title page of Walker's memoirs of his experiences,* The Branded Hand. *Daguerreotype courtesy of the Massachusetts His-torical Society, Boston; illustration, private collec-tion.*

place on the heel of the palm. Yet this crude woodcut was unable to achieve the effect of the actual daguerreotype. In its perfect representation of a human hand —with all its lines, scars, and fingerprints—strangely marred by two branded letters, the daguerreotype has virtually the same curious and awe-inspiring effect produced by Walker when, as he addressed an abolitionist audience, he took the podium, paused, then raised his hand to show the slavemasters' mark of warning.

Around the same time that Southworth and Hawes daguerreotyped Walker's hand, they took part in another project, which attempted to take advantage of the camera's objective eye. In 1843 the painter Washington Allston died leaving a great amount of unfinished work, which ranged from quick sketches on small scraps of paper to large, partially finished canvases. The trustees of Allston's estate hired Southworth and Hawes to copy this collection, informing the daguerreo-typists that it was to be published in a book and that they wanted the pictures all to be 16 × 16 inches. Southworth and Hawes's first problem was one of optics, as the rudimentary lenses of the day produced too many distortions to copy straight lines accurately. Hawes solved this by assembling a three-lens system that elimi-nated much of this distortion.

The next problem was to eliminate changes introduced by the engraver as he copied the daguerreotypes onto the blocks. The idea of the whole project was, above all, to reproduce the spirit of Allston's works, not the interpretations of an intermediary artist. Southworth and Hawes took blank engraver's plates, 16 × 16 inches, and prepared them as they would copper daguerreotype plates. They then copied all of Allston's collection onto these plates. Afterward, in 1848 and 1849,

the brothers Seth and John Cheney, both accomplished artists, laboriously traced with engraver's tools the lines of Allston's work as they appeared on the silvered surface of the daguerreotypes. In 1850 the plates were printed in Boston and published as *Outlines and Sketches*. Although *Outlines and Sketches* pioneered a novel means of reproducing the daguerrean image directly onto the printed page, few other books followed its example because of the extensive labor involved.

As a footnote to this early copy work, Southworth in 1857 began the practice of photographing undocumented handwriting and enlarging it to compare with known examples to resolve legal disputes. After retiring from partnership with Hawes in 1861, Southworth took up the profession of handwriting expert, and by the 1870s he was a recognized authority in the field.

While Southworth and Hawes found unique uses for daguerreotypy, most of the images produced in mid-nineteenth-century New England that were not studio portraits (the great majority of the business) were pictures taken of business establishments and homes. These were done on commission, and the framed image was then hung on the parlor wall or in the company president's office.

Daguerreotypists developed special techniques to deal with the problems inherent in this outdoor work. For one, the daguerreotype plate reacted very differently to different colors of light. Blues showed up quickly on the plate, but an extended exposure was needed to record a green of the same brightness. Typically, this created pictures with washed out white skies and almost black foliage. Leaves reflecting glare off their surface contrasted with the dark shades of the evenly lit vegetation to make the trees look sprinkled with snow.

Another problem arose from the extreme contrast of the daguerreotype image: it was impossible to produce a good image of a new, whitewashed building standing next to an old, soot-covered one. An exposure that was correct for the new building would show the old one as a dark, featureless shape; likewise, an exposure designed to catch the detail in the old building would depict the new one as simply a square extension of the white sky.

Outdoor daguerreotypists worked on blue, overcast, hazy days, or at dawn and dusk when blue skylight, rather than the sun, lit their subjects. The even illumination by bluish light allowed a shorter exposure because of the blue sensitivity of the daguerreotype plate. This eliminated the strong light and shadow produced by direct sunlight, resulting in a picture "far more beautiful than the spotted productions which ordinarily result from the practice of operating when the sun is shining brightly on the object."[2]

Timed exposures revealed that the sky was recorded six times faster than a white wall illuminated by it. To get clouds into the picture, a daguerreotypist used

a curtain of black velvet, nailed to the upper part of the camera. . . . I first unveil the whole view by completely raising the curtain, and, when one-sixth of the time of the presumed exposition [exposure] has passed, I lower the curtain in a slanting roof-like position so as to make [the curtain's] lower extremity coincide with a line joining the center of the object glass with the horizon.[3]

The daguerreotypist would keep the curtain's edge moving slightly so as not to produce a noticeable light/dark line in the picture, "by this means the sky and mountains remain luminous, and the vault of heaven present transparency and depth."[4] Other daguerreotypists found that a portion of the image could be accentuated if it lay beneath the delicate shadows of bare tree branches.

Perspective was another problem for the daguerreotypists. A person looking up at a tall building from close by actually sees the face of the building wider at the bottom than at the top. While this distortion is corrected automatically by the brain when viewing natural objects in three dimensions, it seems strange when seen in a two-dimensional picture.

To compensate for this "keystone effect," early photographers followed one of

Middle Street, Portland, Maine. *Marcus Ormsbee, 1847 or 1848. Daguerreotype. Engine Company Casco No. 1 is turned out for a fire. The domed building is the Exchange Building (burned January 8, 1854). Ormsbee opened one of Boston's* *earliest daguerreotype studios in 1841, moved to Portland for a few years in the late 1840s, then returned to Boston. From the collections of the Maine Historical Society, Portland.*

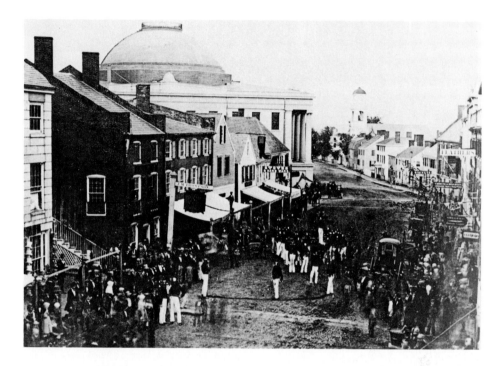

two basic guidelines. Either they set up the camera at least twice the distance from the building as its height to make the distortion negligible; or if, as in a city, other buildings kept them from getting too far back, they hung the camera from a window about one-third the height of the building.

For Southworth and Hawes's architectural work, Hawes devised a special camera. Since the keystone effect was caused by not having the daguerreotype plate in the camera perfectly vertical and parallel to the building facade (the camera had to be tilted upward in order to include all of the building), Hawes built a camera that allowed the back section containing the plate holder to be positioned straight up and down even though the rest of the camera was aimed upward. This eliminated the perspective distortions and made the likeness of the building appear as the eye sees it.

The partners also produced excellent interior pictures. One image, a classroom of young women at the Emerson School in Boston, demonstrates quite well their technique for interiors. In his writings Southworth constantly stressed the use of the biggest lens possible in order to get the most light, thus allowing shorter exposures. He advocated a quick exposure with a large, poor quality lens over a sharp, high-quality, but small lens, believing that a long exposure with its loss of spontaneity and inevitable blurred movement was more damaging to the final image than was lack of sharpness from the lens itself.

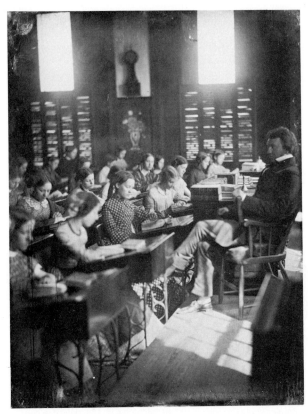

Classroom of the Emerson School. *Southworth and Hawes. Boston, ca. 1855. Daguerreotype, 6½ × 8½ inches. The Metropolitan Museum of Art, Gift of I. N. Phelps Stokes, Edward S. Hawes, Alice Mary Hawes, Marion Augusta Hawes, 1937.*

In the Emerson School picture both background and foreground are vastly out of focus; only a fifth of the students' faces are actually clearly focused. The glare of the light coming in through the windows washes out a large section of the picture. Despite all this, the general effect is casual, with no stiffness of pose by the students. One has the impression that this is not an exposure taking up a a good portion of a minute, but rather a split-second one, just after the teacher has asked a question, as the students are pausing to think before raising their hands to answer.

Southworth and Hawes also tried daguerreotyping the heavens. In the spring of 1846 they borrowed parts of a telescope to try to capture a solar eclipse, and in 1850 Hawes devised a solar camera with a 12-inch lens and movable reflector. At neither time did they produce any images of importance.

Attempts at astronomical photography such as these were common from the earliest days of photography. In 1840 a daguerreotype of the moon was made by John W. Draper of Philadelphia, but it was of poor quality. It required a twenty-minute exposure and showed vague splotches where the maria, or seas, were found on the lunar surface. In 1843 a report came from Rome of the daguerreotyping of stars and nebulas, but little information confirms this. Two French astronomer-physicists, J. B. L. Foucault and Armand Hippolyte Louis Fizeau (who in the early 1840s had done much to improve Daguerre's process), successfully daguerreotyped the sun in 1845. There were other "firsts" during this time but usually, on inspection, the results were quite dismal.

The basic problem was the poor quality of photographic optics of the day. "There is not, nor has there ever been made any set of lenses for the camera, which, if the same in value were arranged for the telescope, would be worth using,"[5] wrote Southworth in 1871. Around 1850 the cost of a good camera lens was $75, while a telescope lens of comparable size was priced in the tens of thousands of dollars.

Bostonian John Adams Whipple began daguerreotyping the skies in the late 1840s, using a small reflecting telescope with a 7-inch mirror and 5-foot focus (comparable in size to the typical amateur astronomer's telescope of today). His first subject was the moon:

> By putting the prepared [daguerreotype] plate directly in the focus of the reflector, and giving it an exposure of from three to five seconds, I obtained quite distinct impressions; but owing to the smallness of the image, which was only about five-eighths of an inch in diameter, and the want of a clockwork to regulate the motion of the telescope [to keep it centered on the object as the earth's motion moved it across the sky], the results were very far from satisfactory.[6]

Whipple realized he had the ability but not the equipment. He then approached William Cranch Bond, the first director of Harvard College Observatory. The reappearance of Halley's Comet in 1835 had stirred an interest in astronomy both in scientific circles and among the general public. This enthusiasm had helped Bond to collect donations for the construction of the college's first observatory. The culmination of the work was the installation of a great refracting telescope in 1844. With a length of 22½ feet and a lens 15 inches across it was then rivaled in size only by a twin in Russia.

It was this telescope that Whipple envisioned using. Bond apparently was not overly enthusiastic about the project, but gave his permission. Astronomical observation then consisted of painstakingly meticulous measurements of star positions through the use of equipment attached to the eyepiece end of the telescope, equipment that had to be removed to accommodate Whipple's camera.

The notebook of observations recorded at the Harvard observatory on December 18, 1849, reads:

> On the evening of the 18th just as we were commencing observations on Mars, Messrs Whipple and Jones came to take a Daguerreotype of the Moon. And very much against our inclinations we unscrewed the Micrometer (for the first time for more than a year past I should judge).[7]

The efforts of Whipple and his photographic assistant William B. Jones were again unsuccessful. The clockwork that kept the telescope fixed on a star moving across the heavens was too rudimentary for the smooth tracking needed to keep the stars' images from wandering across the daguerreotype plate. "The governor had a tendency to move the instrument a little too fast, then to fall slightly behind," [8] complained Whipple.

Whipple did not get permission to return to the Harvard observatory until half a year later, the night of July 16, 1850. This time he was more prepared for the clockwork's eccentricities:

> By closely noting [the tracking machinery's] motion, and by exposing my plates those few seconds that it exactly followed between the accelerated and retarded motion, I might obtain one or two perfect proofs in the trial of a dozen plates, all other things being right. [9]

Those "other things" were lack of clouds, city smoke, and other atmospheric impediments. Whipple did not succeed with the moon, but he did take the first picture of a distant star that night: the star Vega in the constellation Lyra. This made Bond take a little more notice of Whipple's efforts, and in time accounts had it that Bond first conceived of the astrophotography work, and under his direction the star photographs "were obtained at the Observatory of Harvard College by the assistance of Mr. J. A. Whipple, of Boston." [10]

On March 12, 13, and 14, 1851, Whipple again worked at daguerreotyping the moon. On the night of the fourteenth all the problems had been eliminated and a daguerreotype plate was mounted in place of the eyepiece of the telescope. The great telescope lens focused an image of the moon about three inches in diameter on the plate, the exposure was counted out at thirteen seconds, and thus Whipple made the first fully successful daguerreotype of the moon (page 36). "A better representation of the Lunar surface than any engraving of it that I have ever seen," [11] commented Bond. With this triumph, Whipple seems to have been given the run of the observatory.

On March 22 he returned, and the observatory log noted:

> Succeeded in Daguerreotyping Jupiter at about 11 PM — took six plates. . . . Could distinguish the two principal equatoreal belts — Time about as long as the Moon required or not much longer. [12]

On July 28 he daguerreotyped a partial eclipse of the sun, and for the next nine months he took pictures of the moon in various phases as well as images of the stars and star clusters. By April of 1852 he had exhausted the potential of the

still rudimentarily driven telescope and ceased his project. He had by that time amassed a collection of about seventy daguerreotypes of astronomical subjects, many of which remain at the observatory.

Though contributing little to the astronomical knowledge of the day, Whipple's work demonstrated the possibilities of a marriage between the camera and telescope, and marked the real start of astronomical photography. Whipple sent enlargements of his March 14 daguerreotype of the moon to England to be displayed at the 1851 Crystal Palace exhibition. This picture showed English and European astronomers for the first time what the camera and telescope combination was capable of doing. The exhibition jury awarded it a gold medal and hailed it as the commencement of a new era in astronomical representation. Today a modest peak on the moon's surface is officially known as Mount John Adams Whipple.

All of the works thus far discussed were made by the daguerreotype process (except for those noted in chapter 1, and the later Southworth and Hawes portraits). At the same time many experimenters were trying to find a satisfactory way of producing photographic images on paper. Time and again tinkerers and chemists of the 1840s and early 1850s worked in secret only to discover and rediscover each other's inventions. What often seemed like the right path usually led to a dead end.

The Waterbury (Connecticut) *Republican* reported on February 14, 1851:

NEW APPLICATION OF THE DAGUERREOTYPE! — Mr. Hiram Hayden, an ingenious artist of this village, has shown us three landscape views taken by the usual Daguerrian apparatus upon a white *paper surface,* all in *one* operation. This is the first successful attempt to produce a *positive* picture by this extraordinary medium. The pictures exhibit the effect of light and shade, similar to a fine engraving, bringing out the most delicate minutia, with the fidelity of the ordinary Daguerreotype. For many purposes this improvement will be of great importance, as it will enable the operator to produce views and portraits of any size that may be required and at a cheap rate. We understand that Mr. Hayden has made application to secure a patent upon the mode of preparing the paper previous to its use.

Hiram Washington Hayden (1820–1904) did not obtain a patent, for he soon found that his discovery had been around at least since 1841. "By preparing a black carbonaceous [charcoal] paper with iodine of silver, the vapor of mercury brings out a sort of positive picture which may deserve some attention," [13] wrote William F. Channing in 1842. This apparently was Hayden's discovery, for the

only remaining print by his process is a portrait of a woman, on a charcoal-like paper with chalky whites.

Samuel Bemis also tried a paper process around 1840, using silver-coated paper rather than the metal daguerreotype plate. Again, it was a stillborn effort. Although these paper-based processes required less costly materials than did the daguerreotype, their end products were greatly inferior to the beautiful, clear, and vibrant daguerreotype image. Still, the daguerreotype had its share of disadvantages. Its metal backing was expensive, its surface was easily marred by a careless fingerprint, it was hard to make duplicates of an image, and its shiny surface made the image sometimes hard to see. All these drawbacks called out for improvement, which came with the perfection of the two-step negative and print photographic process that is common today.

This process had its real American start in 1850 with the patenting of the crystallotype process by John Whipple. Like Hiram Hayden's "discovery," it too was a rediscovery of someone else's developments. To explain fully the pedigree of this invention would be to descend into a mire of conflicting claims by inventors whose processes sometimes differed only in the name given them.

The history of Whipple's crystallotype starts with the discoveries of William Talbot during the 1830s. While one might call the daguerreotype the metal-backed equivalent of today's Polaroid print (a no-negative print that is one of a kind), the paper talbotype was the rudimentary beginning of the conventional two-step negative and print procedure.

Talbot and other photographic experimenters of the mid-nineteenth century faced the problem of how to bind photographic chemicals to paper. Talbot soaked common writing paper in a saline solution, then dried it before reimmersing it in light-sensitive chemicals, which bonded to the impregnated salt crystals. To make a picture Talbot put one of these sheets in the camera and made his exposure. Once developed, it became his negative. It was placed over another prepared sheet and put in the sun to make the print. The problem was that as the light passed through the intermediary paper negative it produced on the printing paper below not only the image on the negative but the texture of the paper as well. Talbotypes were characterized by their soft, fuzzy images, making them, at the time, undesirable in comparison to the sharp, clear daguerreotypes. In addition, Talbot patented his process and was quick to prosecute anyone who used it without first paying exorbitant permission fees.

The challenge, then, was to do away with the paper negative and break Talbot's patent. The most obvious approach was to use glass rather than paper for the negative, but no one knew of a substance that would bind the photographic

chemicals to a smooth glass surface. In the mid-nineteenth century chemistry was in its infancy, and experiments were rudimentary. One might compare these experimenters with a youngster on Christmas morning with his first chemistry set, rummaging through his mother's kitchen cabinets for bleaches, alkali detergents, formaldehyde disinfectants, and other household chemicals.

The "kitchen chemistry" nature of scientific investigations of the day — the mixing together of whatever was at hand to see what would happen — was never so apparent as in the field of photographic experimentation. Whipple, a noted chemist who had given up the business of chemical manufacture in 1844 and turned to photography because of allergic reactions to the substances he handled, first tried dried milk as a binder to hold the light-sensitive chemicals to the glass for negatives but found it unsuitable. In 1848 he began trying out albumen, the white of an egg, as the binder. The merit of this idea can be attested to by anyone trying to remove dried egg from a leftover breakfast dish. In the spring of 1850 he found that the addition of two or three grams of honey per egg white increased the negative's sensitivity to light — honey taken directly from the comb being superior to commercially crystallized or bottled honey.

On the basis of these discoveries, Whipple and his assistant William B. Jones received, on June 25, 1850, a patent for their crystallotype process, named after the so-called crystal clear prints produced by the use of the glass, rather than paper, negative. While Whipple was the first to receive an American patent for a practical glass negative, in Europe this process had been perfected a few years before. Complicating matters further, the United States Patent Office issued a patent for an almost identical process five months after Whipple had received his.

Although the arguments as to who was first, and who gets what credit, have been going on for the last hundred years with no sign of settlement, it is definitely John Adams Whipple who deserves credit for popularizing and disseminating the idea of using the glass negative and paper print to replace the metal-plate daguerreotype. (Interestingly enough, Whipple did not completely abandon the daguerreotype process at this time. He continued making portraits for any customer who wanted to be daguerreotyped, and his was one of the last Boston studios to discontinue its use in the early 1860s.)

Whipple was quick to adopt any innovation others brought forth that improved the glass-negative process. In the first years of the 1850s what he called a crystallotype was actually any number of things. He began by using the glass negative coated with honey and egg white but made the prints on the "salted paper" devised by Talbot. A few years later he abandoned the albumen glass negative for one using a binder of guncotton dissolved in ether; this became known as the

"wet plate" negative, since the chemicals were sensitive to light only while the guncotton-ether binding was damp. Soon after this, he gave up using the salted paper and instead used albumen to hold the chemicals to the paper.

In 1853 Whipple's crystallotypes won national fame when they received the highest award for photography at the New York World's Fair. In the same year *The Photographic Art-Journal,* then America's leading photography magazine, began mounting one of his prints as a frontispiece to each issue. As the exposure time required by the glass-plate negatives was extremely long in comparison to the daguerreotype, Whipple at first found it easier to submit to the magazine crystallotypes of art objects or copies of daguerreotypes, such as one of his moon daguerreotypes, which graced the July 1853 issue. One of his crystallotypes also appeared in the first American book published with a photographic image. This was *Homes of American Statesmen,* printed in Boston during the fall and winter of 1853 but bearing an 1854 publication date. The book's frontispiece is a mounted photographic print of the now-razed John Hancock mansion, measuring 3¾ × 5 inches. Beneath each print is penciled, "Hancock House Boston, an original sun picture."

The fame that these pictures brought to Whipple soon had professional photographers flocking to his Boston studio eager to learn the intricacies of crystallotype making. For such instruction and permission to use his patented processes, Whipple charged as little as $50 — equivalent to the price of a few dozen pictures. For this fee, the student was given the run of Whipple's three-story establishment and was led through all the steps in the new process by James Wallace Black, then Whipple's newly made full partner. The studio and darkrooms were quite a large concern, employing forty people, mostly women. A steam engine did most of the hard, tedious work as well as supplying heat in the winter and turning fans in the summer. One student remarked that the chemical trays in the darkroom were more like vats.[14] Whipple also devised a means of projecting a picture onto a wall, to be traced and painted by artists should anyone want a life-size painting from a photograph.

One of those to take Whipple's course was Nelson Augustus Moore (1824–1902) of Kensington, Connecticut. Better known for his Hudson River School landscape paintings, Moore and his brother, Roswell A., ran a photographic studio in Hartford from 1854 to 1865. Moore went to Boston to study under Whipple and Black, returning to announce on February 2, 1855:

CRYSTALLOTYPES, OR LIKENESSES ON GLASS AND PAPER.
— This NEW ART which is so extensively practiced by Mr. Whipple of Boston, and [Jeremiah] Gurney of New York, has just been introduced

The Charter Oak, Taken on the Morning of Its Fall. *Nelson Augustus Moore. Hartford, August 21, 1856. Salt print from a wet-plate negative, 10 × 13½ inches. After the great oak, which once hid the Connecticut colonial charter from the grasp of* the British crown, fell in a storm one night, artist I. W. Stuart engaged Moore to record the scene photographically. Stuart then produced a lithograph from the image which enjoyed great popularity in its day. Connecticut Historical Society, Hartford.

into N. A. MOORE'S NEW GALLERY, and it is believed that this is the only place in the State where Photographs* can be obtained. . . . N. A. Moore has just returned from Mr. Whipple's gallery, where he has not only learned this art, but also all of his late improvements in Daguerreotyping.[15]

Moore apparently was an apt pupil at Whipple's studio; by the summer of 1855 he received a gold medal for photographs exhibited at the Connecticut State Fair, which in those days exhibited agricultural, mechanical, and artistic works. In April 1856, he advertised his purchase of "the largest camera to be found in the city."[16] That summer he used it, along with the training he had received from Whipple, to make his most important photograph.

The photograph was of Hartford's Charter Oak. This giant of a tree had been the hiding place in 1687 for the royal charter declaring the Connecticut colony a self-governing entity, when Sir Edmund Andros attempted to seize and destroy it in his effort to bring all of New England under his control. Over the centuries

* Although Whipple had coined the term *crystallotype,* the common designation of the paper print became *photograph,* to differentiate it from the daguerreotype.

the Charter Oak became a symbol of early resistance to British tyranny, and at one time was held in as high regard as the Liberty Bell.

Soon after midnight on August 21, 1856, the old tree finally fell in the midst of a storm. The next day the city went into mourning, crowds collected to see the fallen giant, bands assembled to play funeral dirges, and the tree was draped in bunting. Nelson Moore and his great camera were sent for by the man on whose property the oak stood. Moore arrived, prepared his equipment, and, as the crowd stood motionless, he exposed a number of negatives, each over 10 × 13½ inches in size. While the people in the photographs are not blurred, the arching sweeps of the windblown tree limbs give evidence that the exposures were quite long.

Although Moore's photos of the fallen Charter Oak had limited distribution, one became the basis for a lithograph sold throughout the country. His work that day was one of the earliest records of an historical event in America to be preserved by the paper photographic process.

As the paper photographic print came to the public's attention in the 1850s, many quickly adopted it for their own ends. One such group was the scientific community. Before this time, scientists depended on hand-drawn illustrations in their publications. But an illustration supposedly showing proof of a discovery was open to charges of artistic license or even wholesale fabrication. Photographs, on the other hand, didn't lie (at least in those days). With a photograph to back up a discovery, there could be no accusation of subjectivity.

The first photographic dissemination of scientific evidence in America was a thin volume entitled *Remarks on Some Fossil Impressions in the Sandstone Rocks of the Connecticut River* written by John Collins Warren, M.D., an eminent surgeon and scientist, and printed in Boston in 1854. The frontispiece to this work was a photograph of a trail of dinosaur tracks found along the banks of the Connecticut River in central Massachusetts. The nature of these tracks was the subject of a raging controversy at the time, and the photograph, taken by George M. Silsbee (1816–1866) of Boston, did much to disprove theories that they were simply natural formations.

The controversy began in 1835 when Dr. James Deane took an interest in the strange markings on sandstone rocks that had recently been laid as sidewalk in his hometown of Greenfield, Massachusetts. These "turkey tracks," as the townspeople dubbed them, intrigued him and he soon set to work digging up and classifying a great collection of the tracks. In his campaign for their scientific recognition he contacted Edward Hitchcock, Massachusetts state geologist, Amherst College professor (and later president), and eminent scientist. Hitchcock, after continued prodding by Deane, finally began a serious study of the rocks and

Fossil Footprints in a Sandstone Slab. *George M. Silsbee (of Boston). Greenfield, Mass., ca. 1854. Salt print from a wet-plate negative, 8⅛ × 8¹⁄₁₆ inches. Recognized as the first photograph to appear in a published scientific work anywhere (1854), and the second to appear in an American book.* "We are indebted to Photography for enabling us to represent the remarkable slab from Greenfield, and its numerous objects, in a small space, yet with perfect accuracy. This slab is four feet seven and one-half inches in one direction, and four feet one inch transversely to this." (*Warren,* Remarks on Some Fossil Impressions.) *Private collection.*

Fossilized Raindrops. *Photographer unknown. Greenfield, Mass., ca. 1858–1861. Albumen print, 6 × 8¼ inches. Taken for James Deane's comprehensive study of the fossil prints from the Connecticut River sandstone. Deane died in 1858 before completing his laboriously hand-drawn plates of the various specimens of tracks in his collection, and the remaining slabs were reproduced photographically. The Boston Athenaeum.*

soon was publishing claims of discovery that made little mention of "country doctor" Deane. By the 1850s, investigation and classification of the tracks, then believed to be of large birds, reptiles, and frogs, was well advanced. In 1854 Dr. Warren, in his capacity as head of the Boston Society of Natural History, published *Remarks on Some Fossil Impressions* to announce the knowledge gained. He included Silsbee's photographic print (only then just available) so that

> the surface [of the sandstone rock] represented in the plate may, by the aid of a magnifier, be studied without the presence of the stone itself; for the photographic art displays the most minute objects without alteration or omission.[17]

Deane himself worked on a photographic atlas of the various fossil impressions he had collected (*Ichnographs of the Sandstone of the Connecticut River* [Boston, 1861]) but he died before its publication. The third photographic work on the subject was published by Hitchcock: *Ichnology of New England: Supplement* (Boston, 1865). The disagreement over the exact nature of the creatures that made these tracks was not settled with any finality until 1893, when a fossilized dinosaur skeleton was unearthed in the area.

John Adams Whipple also made use of his glass negative and paper print process for the scientific community. In 1857 the Harvard College Observatory finally installed a new, more accurate, clock drive for its great telescope. Harvard astronomer George Phillips Bond, son of the observatory's first director, decided to try its accuracy on the photographic plate, and in January 1857 the observatory log notes: "Messrs Whipple and Black came this evening to see what equipment will be necessary for recommencing Lunar Photography."[18]

By April 3 Whipple and his partner James Wallace Black had devised the proper equipment and were at work at the telescope. The target this time was not the moon, for Bond wanted to see how precisely they could photograph a star. On every clear night, from April 27 through May 8, they trained the telescope on Mizar in the Big Dipper: a system of two stars formed simultaneously and traveling so close together that they revolve around each other. To obtain a photograph of this double star Whipple exposed the negative for eighty seconds, and the results caused Bond to exclaim over their "singular and unexpected precision."[19] Taking measurements of angle and position of the star pair from the photographic plate, Bond found the calculations to be as exact as those laboriously done at the telescope eyepiece. Suddenly the full scope of astrophotography's future opened up to Bond:

> Groups of ten, or fifty even, [stars] . . . will be taken as quickly as one alone would be — perhaps in a few seconds only — and each mapped out with unimpeachable accuracy. . . . The intensity and size of the images, taken in connection with the length of time during which the plate has been exposed, measures the relative magnitudes of the stars.[20]

From 1857 to 1860 Whipple made over two hundred photographs of stars at the Harvard observatory. In one image taken on June 2, 1857, he and Black photographed the moon as it passed close by in front of a star, finding that the star's bright point of light needed less exposure to record it than did the light of the moon. In 1860 Whipple made two different photographs of the full moon, on the nights of February 7 and April 6. When the pair were combined on a stereo

card (see chapter 4), the slight difference between the two images gave an extraordinary three-dimensional effect, "and the sphere rounds itself out so perfectly to the eye that it seems as if we can grasp it like an orange," [21] exclaimed Oliver Wendell Holmes on looking at it through a stereoscope.

Yet all of Bond's hopes for astrophotography were not immediately realized. Though the telescope and its machinery were now up to the task, the photographic process was not. To take a picture at that time using the guncotton-and-ether-coated negative, one had to prepare the negative just before exposure and then take the picture before the coating dried. Once dried, it lost its sensitivity to light. This meant that the exposure itself was limited to the length of time it took for the coating to dry out: about fifteen to twenty minutes when being exposed in the camera. As a result, Bond and Whipple could photograph only stars that showed up during this length of exposure, and they soon exhausted the possibilities within this time limit. In August 1860 Whipple packed his gear and left the observatory for the last time. Although he did accompany the Harvard astronomers to Shelbyville, Kentucky, in 1869 to photograph an eclipse of the sun, no more photographic work was done at the Harvard observatory until the 1880s.

During the 1857–1860 period that Whipple worked with astronomer Bond in addition to running his own gallery, James Wallace Black left Whipple's studio to start one of his own. In 1860 Black produced a series of images that rivaled the moon pictures taken by his old partner — the first aerial views taken in America (and today the earliest extant in the world).

This first successful attempt at aerial photography in America had its beginnings earlier that year during a Fourth of July celebration on Boston Common. William H. Helme, a Providence dentist, had come up for the celebration, and especially for the balloon ascensions promised by "aeronauts" E. S. Allen and Samuel Archer King. Since there were three balloons and two aeronauts, Helme persuaded the pair to allow him to go up in the third balloon. Helme had a delightful ride and soon began thinking of what an airborne camera could do on such a flight. "The idea that it was possible to get photographic pictures of the appearance of the earth from a balloon grew into a conviction," [22] he recalled. He campaigned in Providence to raise funds for such a venture and after consultation decided that James Wallace Black was the man for the job.

After making plans with Black and renting King's *The Queen of the Air,* everything was made ready for an ascension from a park in downtown Providence in mid-August 1860. Bad weather delayed the attempt for two days. The morning of the sixteenth dawned clear and dry, and preparations were quickly begun to inflate the balloon. Unfortunately, a broken valve impeded progress and the

balloon was not ready until just after noon. By this time, however, clouds began to fill in overhead, endangering the chance of successful photography. The slow wet-plate process required full sunlight illumination if the exposure was to be "instantaneous." Deciding it was too late to retreat, Helme and Black ascended in the balloon to a height of 1,200 feet, tethered by a cable from below. Two exposures were made by Black. Related Helme:

> One was a view westward, and enclosed a portion of Federal Hill, with At-well's avenue in the foreground and the Atlantic Delaine Mill in the distance. . . . The cracking of the collodion film when drying, spoiled this plate, and the print from it looks as if an earthquake was plunging the whole region about into chaos, but enough of it was preserved to show what the picture might have been.
>
> The second picture was to the southward and along the western shore of the bay. It embraces a portion of the western part of the city and South Providence–Field's Point and the whole shore to Conimicut Point in the distance, and hints at Prudence Island twelve or fifteen miles away. This picture was blurred by motion, from an attempt to give it a longer exposure.[23]

Black was dissatisfied with the results, and the pair signaled to be hauled down and the experiment terminated.

By the end of September, Black had made two sets of plans for further ascensions with his camera: one over Boston and a second one over Providence. Black wanted to take more equipment with him and asked Helme if he would make a trial flight with three people in the basket to see if the balloon could rise with this amount of cargo. In early October, Helme and two friends went up in the balloon planned for the second Providence attempt, the *Jupiter*. Unfortunately, the winds that day carried the trio into southeastern New Hampshire, with the balloon breaking free after landing and finally being caught and torn by a tree in Kittery, Maine. This disaster cancelled the second Providence flight.[24]

Black's next ascension was over Boston on October 13, 1860. It was made that Saturday noon with Samuel King in his balloon *The Queen of the Air*. Due to the amount of equipment carried, Helme did not ascend with the pair. Black had converted most of the balloon's basket into what could only be called a "dark closet." The camera itself, a Voigtlander with a lens of about 8-inch focal length, was fastened to the side of the basket. To make the exposure, Black had cut slits through the sides of the lens barrel to hold a rectangular strip of pasteboard. This pasteboard strip itself had a rectangle cut out of its center. It was then inserted through the lens barrel until one end of it blocked the light coming through the

Providence, R.I., Looking West. *James Wallace Black, August 16, 1860. Albumen print from a wet-plate negative, 8 × 10 inches. The first aerial photograph taken in America. Defects in the image, caused by the flaking of the material binding the light-sensitive chemicals to the glass negative, occurred when Black developed the negative while still aloft in the basket of the balloon. The view includes Atwells Avenue, lower center (note traffic); Potter (now Harris) Avenue, center; the village of Olneyville with the Atlantic Delaine Mill (long light-roofed building), left center. Collection, The Museum of Modern Art, New York.*

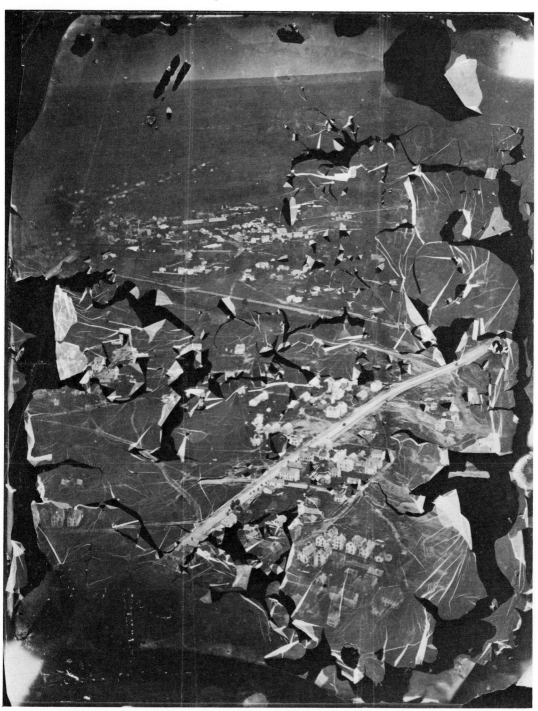

Providence, R.I., Looking South. *James Wallace Black, August 16, 1860. Albumen print from a wet-plate negative, 8 × 10 inches. The second aerial photograph taken in America. Dissatisfied with the strength of the image on the negative in his first picture, Black exposed the second negative for a longer time, which caused its image to be* blurred from motion. *The view includes Narragansett Bay, upper left; Warwick Neck, top right; Fields Point, left middle; Eddy St., from left center edge to upper center; Plane St., from lower center to middle center. Collection, The Museum of Modern Art, New York.*

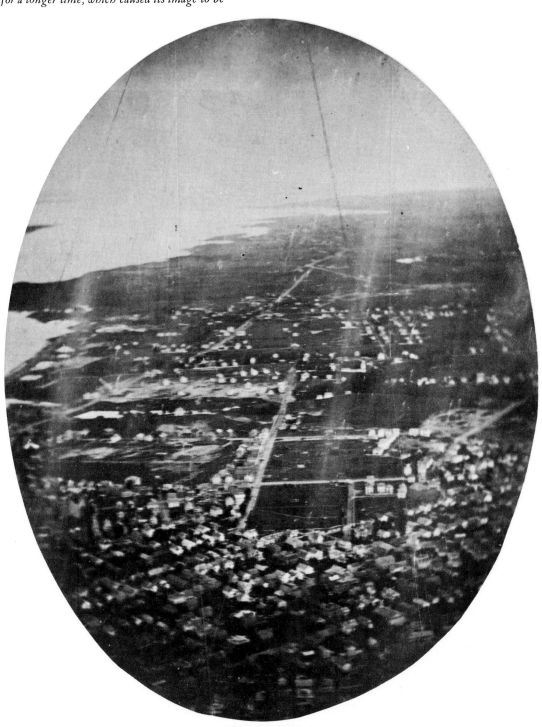

lens. At the trip of a trigger, a piece of rubber band pulled the cardboard slide across the lens face, allowing light to pass through the lens for the exposure, then cut it off again as the other end of the cardboard strip came to rest in front of the lens.

With a light wind blowing off the ocean, and the sky exceptionally clear, *The Queen of the Air* and its cargo lifted off from the Common. Like the Providence ascension, a windlass on the ground played out a stout cable attached to the balloon. At 1,200 feet of rope the windlass stopped, and Black set to work. In all, he exposed six negatives while tethered above the city. Of these, three were of note in their time: two views of the downtown and waterfront (prints extant), and a view of Charlestown (no copy is known to have survived). The rest were reportedly blurred because of the incessant swaying, twisting, and rolling of the balloon in the wind — gyrations that even the anchoring rope and Black's contrived shutter could not surmount.

After about an hour's time, Black and King were hauled back down to the ground and made ready for a free flight. The rope was then cut and, with crowds cheering, Black in the basket, and King in the rope rigging above the basket, they rose above the clouds to float southeast away from Boston. Black, according to King's account of the voyage, "proved himself to be peculiarly fitted for the object we had undertaken. Entirely absorbed in his manipulation, he worked with a celerity that was truly astonishing . . . never allowing the novelty of the scene to divert his attention for a moment when there was an opportunity for securing a picture." [25]

Black had additional problems on the free flight. The gas from the balloon poured down on the men as their increasing altitude expanded the air within the bag. This gas reacted with the photographic chemicals and turned the negatives dark brown. But by mid-flight they had solved this problem and, reported King,

> we moved along, sometimes taking views immediately beneath us, and at others bringing into focus objects that were miles away. None of these views were equal to those taken while hovering over the city, for the clouds had now gathered thick in every direction, and an intervening mistiness in the atmosphere prevented the impressions from being clearly defined. [26]

By mid-afternoon the balloonists saw their path approaching the waters of Massachusetts Bay, and they concluded their flight of two and a quarter hours and thirty miles' distance.

Of the six pictures taken while tethered over Boston, and the dozen taken on their free flight, at least five have survived. [27] Two are of Boston as seen from the

Boston from a Balloon. *James Wallace Black. Boston, October 13, 1860. Albumen print from a wet-plate negative, 8¼ × 6½ inches. The best of a series of Boston and surroundings taken that day by Black. Wrote Oliver Wendell Holmes: "Boston, as the eagle and wild goose see it, is a very different object from the same place as the solid citizen looks up at its eaves and chimneys. The Old South [left center] and Trinity Church [lower right] are two landmarks not to be mistaken. Washington Street slants across the picture as a narrow cleft [bottom]. Milk Street [left center] winds as if the* old cowpath which gave it a name had been *followed by the builders of its commercial palaces. Windows, chimneys and skylights attract the eye in the central part of the view, exquisitely defined, bewildering in numbers. Towards the circumference, it grows darker, becoming clouded and confused, and at one end a black expanse of waveless water is whitened by the nebulous outline of flitting sails."* ("Doings of the Sunbeam," The Atlantic Monthly, July 1863.) *Massachusetts Institute of Technology Historical Collections, Cambridge, Mass.*

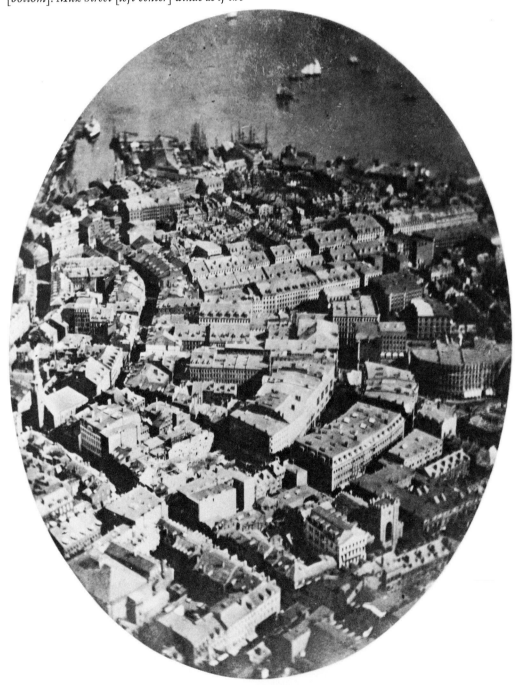

Boston from the Balloon in Free Flight. *James Wallace Black, October 13, 1860. Albumen print from a wet-plate negative, 8 × 10 inches. After photographing Boston from a balloon tethered above the Common, Black and Samuel King made a free flight. This picture was taken as the balloon rose above the city. The escaping gas from the balloon reacted with the negative to darken it as it was being exposed in the camera, hence the lack of contrast. North is to the top. The small dark rectangle at center left, above the State House, is the old city reservoir. At lower left, facing the State House, is the Common. The Metropolitan Museum of Art, The Robert D. Dougan Collection, Promised Gift of Warner Communications, Inc.*

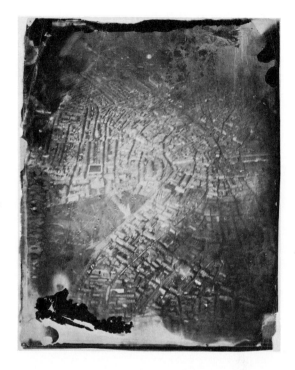

balloon tethered above the Common. Another shows the city from a much higher altitude, and was taken during the free flight. Two others show the shoreline and the towns of North Weymouth and Hingham. These were probably the last pictures taken that day, as King reported that Black gave up attempting any more pictures just after passing over East Weymouth.

Despite the historical importance of Black's Providence and Boston area views, all but one have faced over a hundred years of obscurity. One image of downtown Boston, taken while over the Common, was described by Oliver Wendell Holmes in *The Atlantic Monthly* (page 58). Though this image was soon reproduced as a woodcut in a contemporary periodical, the photograph itself did not appear in print until 1903, when King's own copy was used to illustrate a photo magazine's article on aerial photography.[28] Since that time it has been continuously reproduced and incorrectly identified as the earliest American aerial photograph ever taken.

The medical field also found good use for the photographic image. The application of photography to medicine was appreciated quite early, and within a few years of the daguerreotype's introduction in the United States in 1839 doctors were sending their most interesting cases to daguerreotypists' studios to have their conditions recorded for posterity and used as records for the doctors themselves.

North Weymouth, Massachusetts, from the South. *James Wallace Black, October 13, 1860. Albumen print from a wet-plate negative, 7¾ × 10 inches. Black and King's free flight took them southeast along the edge of Boston Bay, and Black photographed a number of the villages beneath them. This view was one of the last to be taken before he packed up his equipment in preparation for their descent. It includes: Hough's Neck (the dark land mass across the upper portion of the image); Gull Point and Rock Island Cove (just below Hough's Neck at upper left); North Street (entering the village from lower left); Bridge Street (paralleling the coastline through the village); Sea Street (beginning in the village at North Street, then left diagonally across Bridge Street, curving gradually before ending at the shoreline). The Metropolitan Museum of Art, The Robert D. Dougan Collection, Promised Gift of Warner Communications, Inc.*

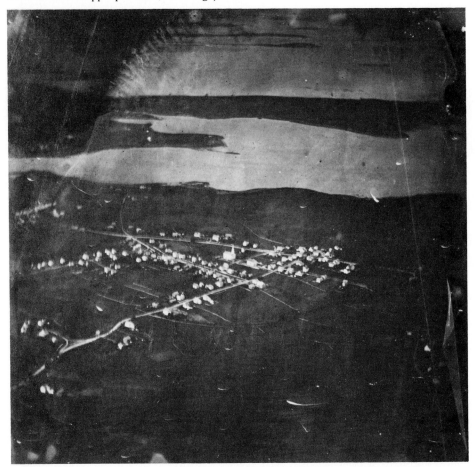

At first these daguerreotypes of the 1840s and 1850s had no real medical value. Knowledge of the day was simply too rudimentary to contend with the many gross diseases that are today all but eradicated. A mid-nineteenth-century doctor would simply have a mortally diseased patient photographed in the hope that the image might contain some information that later could be deciphered, making the photograph worth the effort. Boston's position of having many excellent photographers, as well as being, along with Philadelphia, a leading center of medical activity in America, made the city especially rich in such medical daguerreotypes and photographs. A great many grave or strange cases, beyond the help of the average doctor, were referred to the Boston medical community by their rural colleagues. In 1847 Dr. John Collins Warren donated his collection of medical specimens to Harvard University. They formed the basis of the Warren Ana-

Third Operation Using Anesthesia at the Massachusetts General Hospital. *Josiah Johnson Hawes. Boston, mid-October 1846. Daguerreotype. W. T. G. Morton began his use of anesthesia on October 16, 1846, at Massachusetts General Hospital. Hawes was engaged to daguerreotype this historic medical first. He arrived and set up his equipment, but the sight of blood unnerved him and he ran out without taking the picture. He apparently conquered his queasiness, returning later for this third opera-* tion. *It should be noted that the doctors have the patient anesthetized, but appear to be waiting for the picture to be taken (and for Hawes to leave the operating theater?) before beginning the operation. Oliver Wendell Holmes stands at the lower right. Later, the first operation was reenacted for the camera of another, unidentified, daguerreotypist. News office, Massachusetts General Hospital, Boston.*

tomical Museum which by 1870 had a collection of over 3,600 specimens of medical curiosity. It soon became the repository of many early daguerreotypes and photographs of patients with annotations concerning their cure or ultimate fate.

It was not until the 1860s that New England doctors began including actual photographs in medical publications, a practice that had been started in England and Europe in the 1850s. One of the first publications to make full use of the medical possibilities of photography was Boston doctor John Dean's *Microphotographs of Spinal Cord Sections,* published by the American Academy of Arts and Sciences in 1863 and republished in 1864 as *The Gray Substance of the Medulla Oblongata and Trapezium,* a Smithsonian (Institution) Contribution to Knowledge, Washington, D.C. Dean's photographs were 2× to 5× enlargements of thin cross sections of the human spinal cord. Oliver Wendell Holmes wrote in 1863:

Photograph of Patient from Buckminster Brown's *Cases in Orthopedic Surgery* (Boston, 1868). *Josiah Johnson Hawes. Albumen print from wet-plate negative. The pair together, 3½ × 5½ inches. An early medical photograph of a young boy with* *lateral curvature of the spine. The boy is shown before and some months after the onset of Dr. Brown's orthopedic treatment. Countway Library of Medicine, Boston.*

Figures drawn from images seen in the field of the microscope have too often been known to borrow a good deal from the imagination of the beholder. Some objects are so complex that they defy the most cunning hand to render them with all their features. When the enlarged image is suffered to delineate itself, as in Dr. Dean's views of the *medulla oblongata,* there is no room to question the exactness of the portraiture, and the distant student is able to form his own opinion as well as the original observer.[29]

Another early medical publication using photographs was Dr. Buckminster Brown's *Cases in Orthopedic Surgery,* published in 1865 in Boston by the Massachusetts Medical Society. The work contains eight pages of photographs made by Josiah Johnson Hawes. For the most part they depict a number of plaster casts of feet before and after their deformities were cured by Dr. Brown's orthopedic techniques. Also included are studies of patients before and after the treatments, which are set forth in the text.

Some doctors, less eminent than Dr. Brown, did not wait for their efforts to be chronicled in medical journals. During the 1860s and 1870s, in a practice that would make the American Medical Association shudder today, doctors often had before-and-after photographs of their more successful cases pasted on a card with a flattering description of their medical powers printed on the back. These they distributed to their medical brothers as well as to the local public in the hopes of increased trade.

While most early medical photography recorded either anatomical parts or patients' appearances, one extremely innovative use was made by Dr. Oliver Wen-

Boy with Lymphoma. *Photographer unknown. Boston, 1864. Ambrotype, 2¾ × 3¼ inches. Item no. 1862 in the Warren Anatomical Museum, Boston. The child was admitted to Massachusetts General Hospital with a growth just below the left ear; operated on by Dr. J. H. Bigelow and discharged Oct. 26, 1864, fully recovered. Warren Anatomical Museum, Boston.*

dell Holmes. In an 1863 article for *The Atlantic Monthly* he described recent advancements in the design of artificial limbs, improvements necessitated by the many soldiers returning from the battlefields of the Civil War minus arms or legs. Holmes's own son was wounded three times on the battlefield, the last time in the heel of the foot. Yet Holmes had another reason for writing the article. He had

> for a long time been lying in wait for a chance to say something about the mechanism of walking, because we thought we could add something to what is known about it from a new source, accessible only within the last few years, and never, so far as we know, employed for its elucidation, namely *the instantaneous* photograph.[30]

Holmes was an avid stereo card collector, and in a number of short-exposure views of city streets had found pedestrians frozen in positions of movement that seemingly defied the accepted norms of how a person looked while walking. "No artist would have dared to draw a walking figure in attitudes like some of these," [31] he wrote. Holmes used sketches from these stereo views to show how people actually do walk, detailing all the intricate motions of the legs and feet. "We find out how complex it is when we attempt to analyze it, and we see that we never understood it thoroughly until the time of the instantaneous photograph." [32]

Once again photography was combined with another field of study to open up new realms of possibilities and discoveries. Yet, as in the case of astrophotography, the photographic investigation of motion could progress only so far. The state of the photographic art needed another twenty years of improvement before hundredth-of-a-second exposures became feasible, and photographers like Eadweard Muybridge could carry out their extensive studies of human and animal locomotion.

4 "Such a frightful amount of detail"

Kent Corners, Calais, Vt., Looking South over Mill Pond. *Photographer unknown, ca. 1860. Albumen print, approximately 4 × 7 inches. Courtesy Vermont Historical Society, Montpelier.*

OUTDOOR SCENIC AND STEREOSCOPIC PHOTOGRAPHY

ca. 1860–1900

*I*n the 1840s and 1850s, scenic photography — the photographing of landscapes and natural vistas — was yet to be exploited as a commercial endeavor, and thus did not attract the best of America's photographers. The one-of-a-kind daguerreotype did not lend itself to landscapes and was used outdoors primarily for commissioned pictures of buildings. The early paper prints of the 1850s, while more suited to outside work, were not sharp enough to capture the details of foliage and rock to realistically portray the natural world.

One early attempt at scenic photography was made by James Wallace Black in 1853, within a few years of partner John Whipple's perfection of the crystallotype process (see chapter 3). Black returned that year to his native New Hampshire and took a series of at least fourteen views of the White Mountains, using glass negatives and printing on salted paper (see chapter 11). His efforts were followed by few other photographers, however. Such work required the overland transportation of large cameras, various chemicals, and a portable darkroom; and unless in the hands of a master, the final print was poorly detailed and lacked any sense of depth — utterly unconvincing as an evocation of nature.

It was not until around 1860, when improvements in the mechanical apparatus associated with stereoscopic photography made possible widespread dissemination of vivid photographs of outdoor scenes, that public attention turned toward scenic photography. Soon dual-image stereo cards, along with their viewers, were to grace the living room of seemingly every American home in the latter part of the nineteenth century.

Public enthusiasm for stereo views resulted in the establishment of factories solely for the manufacture of stereo cards and viewers, and produced an army of photographers combing the countryside for new and different views to add to the millions of scenes already "stereoed." These views were sold at photographers' studios, at retail outlets, and ultimately door to door.

Stereoscopic photography got its start in 1832, when English inventor Sir Charles Wheatstone realized he could artificially reproduce the sense of depth we experi-

ence naturally with binocular vision. He constructed a viewing instrument into which he put two drawings, both identical, but one made from a viewpoint slightly to one side of the other. When a person looked into Wheatstone's instrument, each eye saw only one of the drawings, and the brain rounded out the slight differences in perspective, forming an impression that the eyes were viewing a single three-dimensional scene. Wheatstone dubbed his device a *stereoscope* (from the Greek — *stereos,* solid; and *skopein,* to see). Wheatstone at first saw little use for his device. The photograph had not yet arrived to mechanically replace the artist's painstaking work of drawing the two images with the necessary precision. He laid the device aside and did not bother to make the invention public until 1838.

The stereoscope first caught on in 1849 in England and on the Continent when another Briton, physicist Sir David Brewster, simplified Wheatstone's original viewer and adapted it for use with two small daguerreotype images. Soon America too heard words of this amazing device: "The magic result of the resolution of two plain pictures into one, possessing to the eye the most positive solidity, is so striking when witnessed for the first time, that it appears to be a deception of the senses." Enthusiasm ran so high that some predicted the demise of the single-image photograph: "The day must soon come when nearly all important photographic pictures of landscape, monuments, portraits, etc., will be produced double." [1] Still, the stereo's hour in America had not yet arrived. Brewster's viewer, though simpler than Wheatstone's, was physically cumbersome and straining to the eyes. In addition, the mirror-like surface of the daguerreotypes made it difficult to view both images in the best position and still avoid glare in one or the other of them.

The earliest American stereos were most often daguerreotype portraits. The usual procedure was to set up a pair of cameras side by side, take the pictures, then mount them in a case with a foldout flap containing the viewing lenses. In 1853 studio photographer Mary A. Parker of Hartford advertised: "DAGUERREOTYPES, STEREOSCOPIC PICTURES. A new and beautiful style of Daguerreotype Miniatures, in which the simple shadow appears to the delighted vision in a splendid reality." [2]

While the average daguerreotype stereo was only a few inches on a side, the Boston firm of Southworth and Hawes made, in 1853, a "Grand Parlor Stereoscope" which took a dozen pairs of $6\frac{1}{2} \times 8\frac{1}{2}$ inch daguerreotypes that could be successively cranked into view. The size of a piano, it was a device few could afford but, exhibited in the waiting room of Southworth and Hawes's establishment, it became an excellent attraction to draw customers.

The next attempt at improving the stereo view came with the use of pictures printed on glass. Similar to black-and-white versions of today's color slides, they were quite sharply detailed but, according to Oliver Wendell Holmes, "twenty-five

Woodcut from an 1856 advertisement showing Southworth and Hawes's Grand Parlor Stereoscope. The viewer peered into the circular window at center to see the 6½ × 8½ inch stereo daguerreotype plates. The pictures were set on vertical drums on either side within the instrument and seen through the viewing window by two mirrors set at 45° angles. The instrument held twelve different views, and the viewer changed the picture by rotating the drums with a small crank at the right side of the indented base. The machine, with its cast-iron stand, twelve views within, and twelve pairs of additional views, cost $1,160 in 1853. The one on display in the Southworth and Hawes studio may have been the only model ever built. At the top right of the picture is a stereo daguerreotype portrait in its viewer-case. The strangely shaped devices at either side are for an unknown purpose. However, they conceivably may have been stereo viewers utilizing wedge-shaped glass prisms for making the double images coincide. From A Directory of the City of Newburyport . . . for 1856–1857.

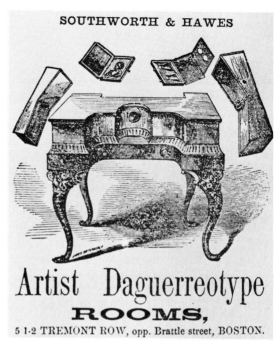

glass slides, well inspected in a strong light, are good for one headache."[3] Glass stereo views were popular until the early 1860s, when they gave way to paper prints.

In the 1850s three photographic firms were largely responsible for the production of glass stereo views of New England: the Langenheim Brothers of Philadelphia, who first introduced the glass stereo to America; the Bierstadt Brothers of New Bedford, Massachusetts; and Franklin White of Lancaster, New Hampshire.

Franklin White, a landscape painter who turned daguerreotypist in the mid-1850s, took up photographing the sights of the nearby White Mountains around 1858. In that year he published one of the region's earliest photographic albums, *Photographic Scrap Book, Containing Views of Mountain Scenery. . . .* This was quickly followed by three more albums: *Photographic Scrap Book (2nd Series)*, *Photographic Views from Mount Washington and Vicinity and the Franconia Range,* and *White's Photographic Views, for 1860, 2nd Series,* all published in 1859 and 1860.

While the first three albums contained full-page photographs, the 1860 album consisted simply of halves of paper stereo pairs. The reason for this was the sudden enthusiasm for stereos across America around 1859. White, like many other photographers, had geared up to cater to this demand, and in 1859 he advertised for sale an assortment of sixty-six different stereo views, most of them on glass.

White was one of the best of the early White Mountain photographers. He operated his own studio until 1867, when he sold a half interest in his firm to Franklin G. Weller, who was to gain fame for his posed stereos of Victorian sentimental scenes. Soon after forming this partnership White gave up photography and returned to landscape painting.

The work of Franklin White, along with that of Franklin B. Gage, of St. Johnsbury, Vermont, was the forerunner of the great stereo card industry that grew up

17. Whale Ship Hove Down for Repairs, N. Bedford, Mass. *Bierstadt Brothers, 1862. Half stereo card. One of a series of views made by the Bierstadts of this ship being recaulked and repaired. The Whaling Museum, New Bedford, Mass.*

Interior of Chamber in the Summit House, Mt. Washington, N.H. Feb. 11th, 1862. *Franklin White (of Lancaster, N.H.). Glass half stereo. About eight o'clock on the evening of Feb. 10, 1862, White and two other men from Lancaster made the first nighttime winter ascent of Mount Washington. Under bright moonlight they snowshoed to the edge of the summit ice field. At dawn, they cut steps to make their way to the Summit House, entering through an attic window. The weather quickly clouded over and the three men spent two days in the snow-covered living quarters, protected from the elements by a few mattresses and the heat of a small stove. Connecticut Historical Society, Hartford.*

around the White Mountains of New Hampshire — which in the mid-nineteenth century were second only to Niagara Falls in popularity as a scenic tourist attraction. The business began with the sale of views of the mountains to tourists coming up the newly opened railroad lines for a stay at one of the "mountain houses." Within a few years, the photographers began shipping their stereos to "stereo view stores," which catered to those interested in seeing America's scenic beauties but unable to travel. The possibilities for profit soon attracted other photographers to the region.

One firm was the Bierstadt Brothers of New Bedford, Massachusetts, who gave up their woodturning and lathworking shop for photography. In all, there were three brothers — Charles, Edward, and Albert. Albert Bierstadt (1830–1902) had only a partial association with the firm, as his primary work was his great romantic landscape paintings. He did, however, contribute greatly to the business in its first years. In 1857 he photographed and sketched in the White Mountains, and the following year found him with an expedition in the American West, painting and taking stereo views. During the summer of 1860 the three brothers worked in the White Mountains taking large photographs as well as stereos. In 1860 they published a catalogue of their works for sale listing about 175 stereo views ($4 a dozen on paper, $15 a dozen on glass), of which a quarter were New Bedford locales, another quarter were Western views, and the rest White Mountain scenes.

The Bierstadts sent copies of their White Mountain photographs to *The Crayon*, then America's leading art magazine. *The Crayon*'s editors found them quite beautiful and "remarkably effective," stating that "the artistic tastes of Mr. Albert Bierstadt, who selected the points of view, is apparent in them. No better photographs have been published in this country." [4]

Albert soon left to devote full time to painting. His brothers, too, had something of the artistic taste and continued to produce strong photographs. In the early 1860s they photographed the ships and wharves of New Bedford's declining whaling industry. In 1862 they pasted forty-eight stereo pairs onto book pages, one pair to a page, and bound them up as albums titled *Stereoscopic Views among the Hills of New Hampshire*. A flap on the cover folded out to show two small lenses set into it, creating the album's own stereo viewer.

Other striking works made by the brothers included their 1866 glass-plate stereos of moonlight shining through clouds and reflecting off water. These nighttime views were some of the last they produced together, as in 1866–1867 the pair broke up and sold their New Bedford studio to S. F. Adams. Edward set himself up in New York City and Charles established residence at Niagara Falls. Charles later became a world renowned stereo photographer and in his day was as well known as his painter brother Albert, which was no small feat.

The original Holmes Stereoscope. *Assembled by Oliver Wendell Holmes around 1859 in the basement workshop of his Boston home; now a part of the Holmes collection at the library of Phillips Academy. Within a few years of its creation, this design became the standard for the industry. The hood is blackened pasteboard, the handle is an awl stuck up through the hardwood body into the roofing shingle that serves to mask each eye from seeing the stereo half intended for the other eye. Its overall length is 8½ inches, height with handle is 5½ inches, and width of hood is 5 inches. Photograph by permission of the Oliver Wendell Holmes Library, Phillips Academy, Andover, Mass.*

As the nucleus of a stereo industry formed around the White Mountains and studio photographers began making stereos of local sights, it was in Boston that the next steps were taken to make the stereo an American household word. The man to do all this was one who has appeared several times in these pages — Oliver Wendell Holmes, author, doctor, Boston Brahmin, and photo enthusiast (see page 18). A garrulous genius, Holmes's love for the sound of his own voice was exceeded only by his love for the audience that enjoyed it with him.

In a series of articles for *The Atlantic Monthly* between 1859 and 1863 Holmes held forth on the subject of photography, and especially the stereo business. These fascinating essays did much to familiarize the public with the actual workings of the photographic process and its achievements, and created a public taste for the art beyond the typical family portraits.

Holmes coined the word *stereograph* to describe the stereo card and went on to write of how "the sights which men risk their lives and spend their money and endure seasickness to behold . . . are offered you for a trifle, to carry home with you, that you may look at them at your leisure." [5] He believed that the stereo card was a perfect replacement for the real-life scene. If a person stood upon the spot where a stereo card was taken and looked at the card in a viewer through one eye, and at the original scene with the other eye, the two views (real and photographic) would superimpose exactly. (For Holmes, color was only an incidental attribute.)

Holmes's other contribution to the popularization of the stereo was an improved viewer. Around 1859 (his writings never mention the exact date) he received a couple of dozen views and a box-like viewer from a friend. A standard viewer of the day, it had two eyepiece lenses set in one side and a removable top for the light to illuminate the stereo card within. No provisions were made to adjust for varying widths between people's eyes or to focus the stereo image. Dissatisfied with this clumsy device, Holmes began "the carrying out of a plan to reduce the

instrument to its simplest terms." [6] According to a later reminiscence, "He went to his work room, took a shingle, stuck an awl into the flat side to hold it, fitted the two lenses to one end by wires and the picture at the opposite end in the same way." [7] Holmes spent the next few days with knife, wood, lenses, and pasteboard, assembling the finished model with hooded viewer and handle so familiar to us today, a device simpler, cheaper, and more efficient than other viewers of his time.

Holmes soon found it harder to promote his viewer than it had been to invent it. "All I asked was, to *give* it to somebody who would manufacture it for sale to the public." [8] He combed the stereo shops of New York, Boston, and Philadelphia with little success. "They looked at the homely mechanism as a bachelor looks on the basket left at his doorstep, with an unendorsed infant crying in it." [9] Finally, six months after initially rejecting Holmes's viewer, Joseph L. Bates, a Boston stereo view shop proprietor, took a longer look at the contraption, added a few changes of his own, and the Holmes-Bates stereoscope was born. It soon caught the public's attention, and many other shops began making their own copies of the design, causing Bates to warn his customers to beware the cheap imitations, as they are "regular eyetwisters, making it quite impossible to see straight for some time after using them." [10]

The invention of an inexpensive, easy-to-use viewer greatly increased the stereo view's popularity among the general public. For the modest cost of a stereo card, one could obtain an image that reproduced the natural world with incredible life and precision. Though the twin photographic prints on the stereo card measured only about 3×3 inches each, seeing them together through the viewer brought out detail only faintly suggested on the individual images. "There is such a frightful amount of detail, that we have the same sense of infinite complexity which nature gives us," [11] observed Holmes.

Photographers delighted in the capability of a small twin image to equal in sharpness a single photographic print 16×20 inches or larger. Now, instead of carrying a giant camera that took a 16×20 inch negative — the enlarger had not come into common use, so the photographer was required to use a negative the size of the planned final print — he could buy one of the little twin-lens stereo cameras then coming on the market, which recorded a double image on a $3\frac{1}{2} \times 7$ inch negative.

A photographer could now escape the portrait studio to wander the countryside, giving free expression to his artistic sensibilities. No longer need he sit in his studio waiting for the rush of sitters who came on fair days, then frantically work in the darkroom to make the prints ready, only to hear the sitter decide they were not to his liking. With stereo views as his main business, a photographer could plan ahead for a steady work schedule, roam about in search of the picturesque, return

Slate Quarry. Littleton, N.H. *Kilburn Brothers,*
about 1865. Half stereo card, no. 2. The second card
published by the firm. The Boston Athenaeum.

to his darkroom to print up the photographs, and then market them himself or
turn them over to a distributor. If a picture caught the public's fancy, he might
sell thousands of prints from a single negative.

Around 1860, as Holmes was writing his essays on photography and creating
his stereoscope, one could find only about a dozen competent stereo photographers
working in New England. Among them were Franklin White; the Bierstadt
Brothers; Delos Barnum, John Heywood, John P. Soule, and William Notman,
all of Boston; Franklin Gage of St. Johnsbury; and J. A. Williams of Rhode Island
(Providence, later Newport and Portsmouth). While their output was small com-
pared to the high tide of the industry during the decades to follow, some of the
best stereo work was done by these pioneers. Having no tradition to follow, they
worked out their photographic compositions through instinctive artistic response,

producing strikingly beautiful images which did not rely on accepted conventions of subject or point of view, as did many stereo cards of the latter part of the nineteenth century.

While the output of New England, and American, stereo photographers was still modest at this time, England and Europe were in the middle of a stereo boom. Holmes, in his essays, wrote of viewing well over 100,000 cards, most of them originating from across the Atlantic. Yet even this number was nothing compared to the wholesale production of stereo cards that began just after the Civil War. By the end of the century over 700 stereo photographers had photographed New England, and advertised different views numbering in the hundreds of thousands.[12]

One stereo photographer to appear at the start of this peak of activity was Benjamin West Kilburn (1827–1909), "a much respected citizen and noted rifle shot" [13] of Littleton, New Hampshire. From youth, Ben Kilburn had roamed the nearby White Mountains, hunting, fishing, and climbing. In the mid-1860s he added photographing to this list.

> Mr. Kilburn with his camera and outfit strapped on his back soon became one of the most familiar figures in the mountain region. He went everywhere; the show places, hotels, coaches, all the scenes known to the traveler received his attention; while the many charming bits of scenery by craggy cliff, purling brook, or lake . . . seen from well-nigh inaccessible places . . . were caught on the sensitive plates of his camera,[14]

wrote a contemporary. In the spring of 1866 Kilburn printed up a series of 175 views, mostly White Mountain locales plus a few of Maine and Vermont. His first customers were the tourists who had come up the railroad to Littleton since the town became the line's terminus in 1853. Kilburn also submitted a set of these pictures to Edward Wilson, editor of the prestigious magazine, *Philadelphia Photographer*. Wilson marveled at the variety and quality of the views, and Kilburn's fame was made.

He launched upon a long and famous career in photography. To his neighbors and the photographers who visited him, he was an educated mountain man — boon companion, lover of nature and art, raconteur, and a man who, when all others feared for their lives, would set out in a blizzard to carry someone trapped on a mountaintop down to safety on his shoulder. To the public at large, he was the man who made electrifying pictures. A Kilburn view was not simply an informational presentation of how a place looked; it was a delicious shudder, as the armchair viewer found himself looking from a crazily tilting angle down a mountainside, or up at a great looming boulder ready to topple and crush all in its path. Other views evoked natural grandeur. A favorite composition for Kilburn was a glassy lake sur-

Mt. Washington Railway, Looking Down. *Kilburn Brothers, ca. 1869–1870. Stereo card, no. 519. One of the Kilburns' classic cliff hangers. Private collection.*

519. Mt. Washington Railway, looking down.

face balanced by distantly retreating mountain masses — a simple composition, but one made successful by the three-dimensional balance of the three or four masses that made up the picture. In much of his landscape work, Kilburn used height to great advantage.

> The ability to climb is one to be cultivated by the would be successful mountain photographer. A great many pictures I have seen made in mountain regions are imperfect and unsatisfying, because the camera was placed at too low a standpoint. . . . To correct these evils you must climb — climb to a point where you can overlook the immediate foreground, and secure a good expanse between you and your principal point of interest, the mountains.[15]

In more level areas, Kilburn relied on wagons, high tripods, or church towers from which to transform a jumble of structures into a harmony of square buildings and curving roads receding to the horizon.

The quality of a Kilburn stereo did not depend solely on the artistic eye of Benjamin West Kilburn. His brother Edward (1830–1884) also deserved great credit. A retiring, slight figure, Edward had a meticulous nature that balanced his brother Ben's boisterous enthusiasm. When the pair officially went into business together in 1865, Edward took charge of the darkroom end, leaving Ben to roam the countryside. Because of Edward's perfectionism the Kilburn Brothers label on the back of a stereo card became an assurance that the view had been produced to the highest

View from Newbury, Vt. *Kilburn Brothers, ca.
1869–1870. Half stereo card, no. 559. Private
collection.*

standards of quality and would not fade or mottle from inadequate processing. A
stereo card made under the supervision of Edward Kilburn is as bright and clean
today as it was the day it left the shop over a hundred years ago, a compliment that
can be paid to few of the Kilburns' competitors.

By 1868 the brothers listed 426 views for sale and produced about a thousand in-
dividual cards daily. Ben by now had covered most of northeastern America with
his camera. In 1873, having outgrown their old studios, they built what was then
the largest stereo card factory in the world: a three-story, 60 × 36 foot building.
The Kilburn list now numbered over 1,000 titles, including Ben's views of Cali-
fornia, Mexico, Bermuda, the Holy Land, and Europe. In 1886 they added sixty
feet and another floor to the "view shop."

The Kilburn catalogue did not consist solely of scenic views. Ben's other typical
subjects were the Mount Washington Railway and its ever changing rolling stock
(Kilburn at one point had a high platform built above the treetops to take pictures
of the railway's base station below), mountain frost and ice formations, and hunting
scenes, these last usually including a number of Ben's favorite backwoods characters.

The Kilburn Brothers' work, which reached its height in quality in the early
1870s, suffered greatly from Edward's retirement from the firm in 1875. Soon after-
ward Ben began buying the negatives of other photographers and printing them
under his own name. His personal work had by then lost its old vigor. Nevertheless,
the business prospered and in 1879 it began employing clean-cut college students to
travel door to door selling Kilburn views. Soon the students covered the whole na-

The Kilburns' Stereoscopic View Company building at the turn of the century. Halftone from James R. Jackson's History of Littleton, N.H., *1905.*

tion each summer, peddling that season's new stock of views along with old favorites. Like most stereo photographers, Ben Kilburn did his best to take pictures that could not be dated, so that they would have as long a commercial popularity as possible.

Though the quality of Kilburn's work had tapered off long before the turn of the century, he was by then "The Grand Old Man of Landscape Photography." He crusaded vigorously for the acceptance of photography as a legitimate art form, lauding (or criticizing) paintings and photographs in the same breath. Recognizing the limits of each discipline, he had no qualms about commissioning a painter friend to capture on canvas a scene he wanted for his walls that defied the photographic medium.

When Ben Kilburn died in 1908, his Littleton View Shop produced over 5 million cards annually from a list of over 100,000 views. Soon afterward the company closed its doors, the negatives were sold to another stereo card company (The Keystone View Co., of Meadville, Pa.), and the view shop ultimately became the apartment building it is today.

While the Kilburn Brothers' work included some of the best White Mountain stereos ever taken, many other photographers competed with them. Some were locally based and others came from afar to try their hand in the region.

William B. Sweet, a White Mountain guide, told of being hired around 1870 by

a seedy looking man, whose baggage was two heavy chests, and who, as we soon discovered, was a photographer sent up by a firm in New York to take views. . . . He had come to the Mountains at the wrong time [November], July and August being the best months for photographing. He remained over a week without seeing a single fair day, and was almost in despair.[16]

Notwithstanding the overcast weather, photographer and guide set out for the Basin, a deep pool worn into solid rock by the swirling water of a mountain stream. The guide relates how the photographer, in setting up his camera at the water's edge,

hit one leg of the stand with his foot and sent the whole thing into the Basin. In trying to save it, he slipped, and fell in himself. I was standing near him, and, knowing that he could not swim, I made such haste to catch him that I, too, went headlong into the water. The water was icy cold, it being November.[17]

Sweet rescued the photographer and soon the pair stood at the pool's edge looking down at the camera equipment submerged under fifteen feet of icy water. Wrote the guide of the photographer, "The poor fool actually wept, believing he had lost it forever; but I told him I would get it again, even if I had to dive for it." [18] Sweet cut a long pole and, after a few failed attempts and renewed dunkings, fished out the equipment. "Oh how we capered and laughed, forgetting that we were thoroughly wet, two miles from any house, and without the means to make fire." [19]

The pair survived and continued their pursuit of scenes to photograph. They had little success. With each carrying nearly a hundred pounds of photographic equipment, they tried climbing one of the mountains for a view of other distant peaks, but as soon as they neared the summit, a sudden blizzard forced them to retreat. After another week of these failures, related the guide, "my photographer friend gave up the job, packed his things, bade farewell to the Mountains, and returned to New York." [20] As an act of kindness, Sweet omitted the photographer's name from his memoirs.

By the 1870s literally all of New England had been explored and recorded by the stereo camera. Every conceivable subject that might turn a profit as a stereo card had been photographed — fires, prisons, Shakers, scenic locales, cities, rural life, railway lines, tunnels, bridges, disasters, maritime industries, to list a few. Most stereo photographers, while they might produce views of a variety of subjects, usually devoted their efforts to one geographical location.

A. F. Styles of Burlington, Vermont, did some of the best work in that state. His catalogue was small, listing only about five hundred Vermont scenes. His views are not mere representations of flat landscapes, but (like Kilburn's) intriguing three-dimensional compositions, involving people, buildings, and scenic background. At one time William Henry Jackson worked in Styles's studio before making a name as a photographer of Western scenery.

Along the seacoast, E. G. Rollins of Gloucester, J. Freeman of Nantucket, G. H. Nickerson of Cape Cod, R. E. Moseley of Newburyport, and John Heywood of Boston all captured the life, scenery, and industry of New England's shoreline.

Other photographers staked out vacation areas: B. Bradley of Mount Desert, Maine, whose specialty was strange rock formations; J. Hall of Great Barrington, whose views of the Berkshire region are sure to contain a person or two, stiffly and

Two Men Dressed as Arabs, Fighting. *T. E. M. White (of New Bedford, Mass.). Lakeville, Mass., late 1870s. Half stereo card. After a tour of Egypt, New Bedford artist Robert Swain Gifford (left) organized a group of Egyptology enthusiasts who assembled in Arab garb along the shores of nearby Great Quittacas Pond. The "Quittacas Club" engaged photographer T. E. M. White to accompany them and record their antics. The Whaling Museum, New Bedford, Mass.*

peculiarly posed; J. A. French, who migrated from town to town in southern New Hampshire, exploring each locale, then setting up his camera to photograph the sights before packing up and moving on (see frontispiece); S. F. Adams of New Bedford, who set up his camera each summer atop Mount Washington to photograph the tourists as they alighted from the cog railway to the summit.

Other stereo photographers traveled the countryside like gypsies in specially constructed wagons set up for photography; the less affluent pushed their equipment in wheelbarrows. Some worked out of a studio where they returned to print up their views; others sent their negatives to stereo view factories like that run by Charles Pollock at Foxborough, Massachusetts, where free-lancers' work was printed, mounted, labeled, and captioned at the rate of 4,000 stereo cards a day.

Probably the most comprehensive survey of New England through the stereo camera was made by John P. Soule (1827–1904) of Boston. His work covers the gamut of subjects: cities, mountains, trades, unusual events, artful still lifes, and the sea. He began making stereo views in the late 1850s and gained mention by Oliver Wendell Holmes for a view looking over Boston's Charles River from the window of Holmes's Back Bay house. By 1867 Soule offered for sale about 900 views under his name, and the Soule Photographic Company of Boston lasted well into the twentieth century, selling photographs of people, scenes, and works of art.

The stereo craze peaked around 1880. Soon afterward improved methods of producing larger photographic prints by enlargement and the introduction of gravure and halftone printing techniques began to compete with the stereo view (see chap-

Boston Harbor and East Boston, from State St. Block. *John P. Soule, 1863. Half stereo card, no. 578. The Boston Athenaeum.*

From Pic Nic Grounds Salisbury Lakes. *J. Hall (of Great Barrington, Mass.). Salisbury, Conn., ca. 1870. Stereo card. Private collection.*

ter 6). The appearance of the motion picture in the early twentieth century also did much to destroy the stereos' monopoly of bringing distant places to armchair travelers. Though stereo card production lasted into the 1930s, it was by then only a skeleton of its former self. Most cards were produced by a few large companies that had bought up negatives from closing stereo firms. The stereo viewer and its companion basket of views had been banished to the attic, and their place of importance in the American living room usurped by the radio.

5 "What better 'vehicle of expression'... than a carte visite?"

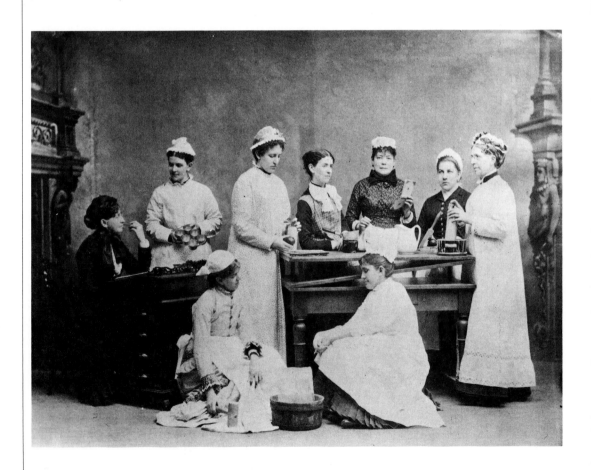

The Boston Cooking School. *Allen and Rowell, ca. 1880s. Paper print, 7 × 9¼ inches. Boston in the 1880s was internationally known for a number of cooking schools founded there. Shown here is the one made famous by Fannie Farmer. The Boston Athenaeum.*

*I*n the early 1860s, at about the time stereo views were catching on, portrait photographers too began discarding their daguerreotype equipment and turned to making paper prints mounted on 2½ × 4 inch cards. The idea originally came from France, where a nobleman had instructed his photographer to print up small pictures which he might leave as visiting cards. The idea spread quickly, and around 1859 the first American photographers were producing cartes de visite. Unlike daguerreotypes, they were cheap and could be had in any quantity desired. "Twenty-five handsome photographs at one sitting for one dollar," [1] advertised the Moore Brothers of Springfield, Massachusetts, in 1859.

The cheapness, portability (in contrast to the glass-covered, cased daguerreotype), and novelty of cartes de visite intrigued the public, and soon "card portraiture" became a booming business. "What better 'vehicle of expression' is there than a *carte [de] visite?*" [2] quipped one photographer's advertisement in 1862.

The carte de visite had only one drawback: its image was utterly primitive in appearance. Even in the hands of portrait masters like Southworth and Hawes the early card photographs are quite drab. At first, fashion called for a head and shoulders view of the customer. The diffusion of the image caused by the fibers of the paper surface, the granularity of the early negatives, and the faded quality of the early prints themselves robbed all character from the sitter. Shadows under the eyes no longer made a sitter look dynamic; rather, it seemed that he needed a good night's sleep. The light areas of the face showed no detail; instead, the face merged with the blank background giving the person a pasty-faced appearance. One wonders whether the apparent hopelessness of achieving artistry in the carte de visite was a factor in Southworth's decision in 1861 to dissolve his partnership with Hawes and turn to other pursuits.

To compensate for this lackluster quality of facial features, portrait photographers moved their sitters farther away from the camera, added chairs, drapery, columns, and backdrops, and took full-length photographs. The face in the photo-

Carroll Couch, Photographer, Concord, N.H.
Carte de visite, date unknown, probably 1860s.
Taken at Couch's studio. New Hampshire
Historical Society, Concord.

Unidentified man. *John Adams Whipple.*
Boston, date unknown. Carte de visite. Pri-
vate collection.

Chase Family Member. *T. M. V. Doughty. Winsted, Conn., ca. 1860s. Carte de visite.* Sometimes, despite all efforts by the photographer, the customer simply didn't want to be photographed. Note the black outline of the head clamp around the youth's head, and its base at his feet. Connecticut Historical Society, Hartford.

graph now became so small that the lack of detail went unnoticed among all the apparel and props.

Still, there were those who deplored "the common taste which prefers the card portrait." [3] Oliver Wendell Holmes marveled how people fell into rapture over hideous portraits of their loved ones, "in contemplation of the shadowy masks of uglyness which hang in the frames of the photographers, as the skins of beasts . . . stretched upon the tanner's fences." Holmes preferred the edification of a good stereo view over a portrait of a friend; however, for the rest of mankind, he concluded, their affections "are better developed than their taste." [4]

Another reason for card photography's popularity was the introduction of the photographic album in 1861:

> PHOTOGRAPH ALBUMS are all the rage; go where you will, on everybody's center-table, lies a more or less ornate book, with a clasp, generally rather flashy in style, silver or gilded, with Morocco or Russian leather bindings. You open, and behold papa, and mama, and the baby; Gen. McClellan, a few cousins, some handsome friends of the family, one or two fearfully-homely things, and a considerable blank space for future acquisitions. Such is the photographic album. [5]

The first albums were somber little volumes, similar in appearance to small bibles. As their popularity grew, many New England paper manufacturers began turning

out ornate volumes "resplendent as a tropical butterfly," [6] according to Holmes. Soon one might buy the "Graphotrope," with revolving pages set on a turntable, the "Photographicon," in which individual pages were cranked into view, or a pocket album made by Samuel Bowles & Co. (photographic album manufacturers of Springfield, ca. 1860s): "It can be filled with Pictures (16) and sent by mail to soldiers in the army, or friends anywhere in Uncle Sam's dominions, at the very trifling sum of Thirty Cents postage." [7]

In the early 1860s, Uncle Sam's dominion had shrunk considerably. The Civil War (1861–1865) drew many a young man from the family circle, creating a need for mementos of the family's loved ones off in uniform.

> The Moore Bro's. photographers, always first in the field, are building a large wooden house on the grounds of the 16th Regiment for the purpose of taking the soldiers' pictures. Now the girls will have a chance to have their lovers taken before they go to war. [8]

During the war, the Moore Brothers did not confine their portraiture to combatants of the current battles. In 1864 they photographed the

> LAST MEN OF THE REVOLUTION. — Messers. N.A. & R.A. Moore, photographers of this city [Hartford], visited several months ago the homes of all the surviving soldiers of the revolution, and obtained their photographs from life. This collection has been embodied in a book of sixty-four pages, containing historical sketches of the lives of the venerable men, with views of their homes printed in colors. The biographies are written by Rev. E. B. Hilliard. It is an interesting work and should have a large sale. The publishers advertise that they are now ready to supply copies. [9]

In early 1864, Congress had introduced a bill to increase the pensions of the dozen remaining soldiers who had fought in the revolutionary war. The Moore Brothers took an immediate interest:

> Having determined for a long time, if possible to obtain the photographs of the last twelve veterans of seventy-six. . . . We found the utmost difficulty in ascertaining their address, it not being known in many cases to the Pension Agent of the district where they received their pensions. They however, furnished us with the information in their possession with the exception of the one in the Albany district who is one of the most disobliging men we ever met. [10]

Two of Moore's "Last Men of the Revolution." Left, William Hutchings, aged 101 years. Right, Adam Link, aged about 104 years. N. A. and R. A. Moore (of Hartford), 1864. Albumen prints, ca. 3⅜ × 2¼ inches. In August of 1864 the Moore brothers advertised: "THE LAST MEN OF THE REVOLUTION. We have visited their homes and secured likenesses of these few remaining patriots. None of them are less than 100 YEARS OLD. Their 'CARTES DE VISITES' are for sale at our Rooms, and among them will be the last survivor of the American Revolution." (Hartford Courant, Aug. 11, 1864.) The last survivor of those photographed by the Moores was Samuel Downing, who died in 1867. However, many historians believe Daniel Bakeman of Freedom, N.Y., unknown to the Moores, was the last revolutionary war veteran when he died in 1869. Connecticut Historical Society, Hartford.

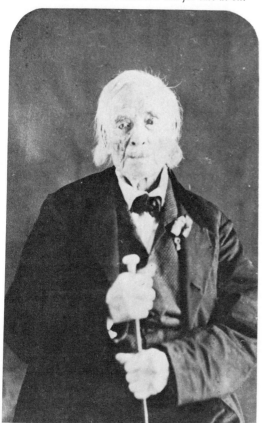
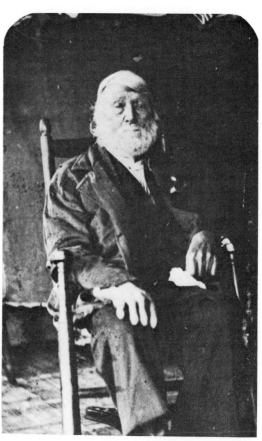

After much correspondence, the Moores found the veterans "scattered from Maine to Missouri, and that four resided in the New England States whose faces we went to secure first. Of these we found only one living" [11] — William Hutchins of Penobscot, Maine, age 101 years. In all, as the Moores journeyed to photograph the soldiers and their homes, they found only eight of the twelve still living.

In July 1864 the Moores sent Rev. Elias Brewster Hilliard to interview the pensioners they had located and photographed. In his travels, Hilliard found that two more had died. Another two died before the book went to press in September 1864.

The Last Men of the Revolution received public acclaim when it appeared in early 1865. Published toward the end of the Civil War, it harked back to a more chivalrous conflict, to patriotic and ennobled aims, reaffirming the American credo in a period of national anguish. "Our own are the last eyes that will look on men who looked on Washington," [12] wrote Hilliard.

Dentist. *Burnham (of South Paris and Bethel, Maine), date unknown. Carte de visite. Private collection.*

The portraits of the men themselves are strikingly simple. They sit in their Sunday best, before an old woolen blanket backdrop, all but one staring directly at the camera. Strong sidelighting brings out all the marks of age on their faces, giving them the simple dignity of common men who lived out great destinies. "As we look upon their faces, as we learn the story of their lives, it will live again before us, and we shall stand as witnesses of its great actions."[13]

At the end of the Civil War, the public embraced yet another style of photograph, the cabinet card. In effect, it was simply a carte de visite enlarged to 4½ × 6½ inches. While the smaller carte de visite still found use throughout the rest of the nineteenth century, the cabinet card's larger size and, consequently, greater detail made it the mainstay of portrait photography.

Popular enthusiasm for the cabinet card, along with many similar mounted photos in different sizes — the Promenade, Imperial, Victoria, and Boudoir — called for a change not only in photographic equipment (larger cameras) but in artistic technique as well. Defects that passed unnoticed in the carte-de-visite format were all too glaringly apparent in the larger cabinet card.

In the 1860s and 1870s a number of New York photographers (especially Napoleon Sarony, William Kurtz, and José Maria Mora) developed techniques to compensate, as much as possible, for the drawbacks of the cabinet card. These methods were quickly adopted by photographers throughout America. As a result,

save for the work of a few photographers whose creativity made such tricks unnecessary, most of the portrait photographs made from 1870 to 1910 were virtually interchangeable. They included a variety of costumes for the sitters, painted backdrops and appropriate props (such as woods in the background and a fake stump for the sitter to lean against), and a chiaroscuro means of lighting the face called the Rembrandt effect. In the Rembrandt effect the strongest light came from above and behind the sitter, with reflectors below and in front to bounce back enough light to softly illuminate the face. Done well it gave the subject an ennobling countenance. It was not often done well.

Stock poses also became the order of the day. The "turned head" pose, so well liked, in which the sitter's shoulders were square to the camera and the head turned in profile, caused the head to automatically lean toward the camera. If the photographer did not have the sitter consciously tip his head slightly back the effect was that of a person with a broken neck. "You have only to add a rope to make the thing complete," [14] put in one photographer.

For the most part, portrait work of the late nineteenth century consisted not of interpreting character, as with the great daguerreotypes, but in pleasing the public's demand for sameness. "Everybody must be cut to the same size and shape, and form, and brought to that state of imbecile appearance to which photography is popularly supposed to reduce its victims." [15]

Nevertheless, there did exist a number of accomplished portrait photographers in New England. J. E. Purdy, Allen and Rowell, George K. Warren, James Wallace Black, Josiah Johnson Hawes, John Adams Whipple, Russell A. Miller, and William Notman, all of Boston; Charles T. Stuart, and Richard S. Delamater, of Hartford; E. P. Dunshee, Gustine L. Hurd, and the Manchester Brothers (Henry N. and Edward H.), of Providence; the Kimball family of Concord, New Hampshire; and Frank Lawrence of Worcester; all produced excellent work. The best of the group were Hawes, who had by now regained some of his old power, Black, Warren, and Allen and Rowell.

While Hawes haunted his old studio on Tremont Street, still filled with daguerreotype equipment, the others all had prosperous and large concerns. In the 1860s Black employed over sixty people to work not only in the darkroom and studio, but also as cameramen on various assignments, from Arctic expeditions to college yearbooks.

In their time, Edward L. Allen and Frank Rowell were the most popular portrait photographers in the Boston area (see page 80). Like Southworth and Hawes a generation before, the partnership attracted the famous in search of a likeness. Customers were disarmed by Frank Rowell's geniality and personal attention. This al-

lowed him to "control the *expression, for over the subject he seems to throw a feel-ing of ease and carelessness, in consequence of which the expressions are wonderfully natural and pleasing."* [16]

At the other end of the business ladder from the grand Boston portrait studios were the tintype galleries, which typically set themselves up in beach and resort towns. The tintype was virtually the same as a daguerreotype, but on iron rather than on silvered copper. Unlike the daguerreotype it did not mar easily and was cheap and quick to make. Though it produced a milky image, it attracted those unable to pay for a real studio sitting. H. J. Rodgers, a Hartford photographer, took a tour of tintype galleries in 1871 and found most of them producing hideous pic-tures. He noted that many stayed in business by employing a barroom bouncer as the complaint department. The low social standing of the tintype was admitted to even by its proponents: tintype instruction books themselves delicately suggested that the photographer, in deference to lady sitters, keep spittoons away from the posing chair, and invest in a chair that would not collapse under the weight of a portly customer.

In the middle ground between the Boston masters and the tintype galleries were most of the studio portrait photographers. For them, the greatest challenge was not so much obtaining an artistic portrait as it was contending with the various charac-ters who came through the door to "have their picture took." One who managed to take vengeance on his customers was H. J. Rodgers. In 1872 he published *Twenty-Three Years under a Sky-Light, or Life and Experiences of a Photographer.* Much of the book consists of his lampooning of sitters who claimed to be cheated in pay-ing full price for a picture that showed them only from the waist up, or of young bucks who, leaving the door open in winter,

> step carefully over the door rug, and after having approached the middle of the room, wipe their feet on the Brussels carpet . . . they spit tobacco juice all over a newly polished stove, when the spittoon is standing near, puffing on a dilapidated penny cigar, with the force of a hydraulic machine.
>
> They approach the show case, unintelligibly expressing a desire to have their *mugs* taken. When told that they must wait five or ten minutes, and after roughly handling specimens of art, especially selections framed in gold-leaf, they "sit down" elevating their muddy *under-standings* . . . into the best and most expensive upholstered chair. [17]

Rodgers's other peeves included customers determined to assume a melodramatic pose despite the photographer's entreaties, those who tried to beat the price down after the picture had been taken, those who decided the picture did not do them justice and walked out without paying, and those who cost the photographer half

Advertising card. *Partridge (of Boston Highlands, Mass.), ca. 1890s. Cabinet card. For the turn-of-the-century portrait photographer, the best season was just before Christmas. This card, with its assortment of stock poses, has a poem on the back, reading in part: "The season's kindly greeting, | O patron old and new! | Hie to our workshop early, | Get ye a likeness true; | Fond memories shall waken | In near and distant friend, | If Christmas hopes and wishes | The souvenir attend. | Father, we'll paint thy portrait | To deck the parlor wall; | Or loving mother's features | Her wanderer to recall. | A panel for your easel, | A card for album place | Or, for the jewelled locket, | The lover's image trace." Connecticut Historical Society, Hartford.*

A Photographic Van and Customers. *Specially equipped wagons such as these wandered the American rural regions, where population was insufficient to support a local studio. Here the photographer points his camera at a family group in their carriage, but he was also ready to usher customers inside his rolling studio to sit for portraits. (From an illustration by Edwin Austin Abbey for Harper's Weekly, ca. 1875.)*

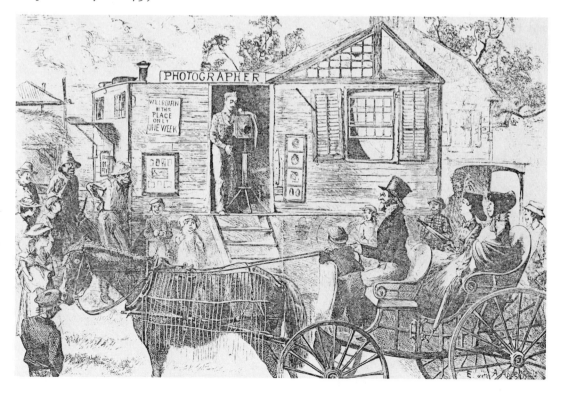

a day's time by arriving with screaming children to be photographed. Such was the lot of the nineteenth-century portrait photographer.

Of all the work produced by these portrait studios, the most intriguing are the "curiosity" cards: mass-produced images of anyone from Abraham Lincoln to Jo Jo, the Russian Dog Faced Boy. Albert Sands Southworth observed in 1870:

> So necessary to human intelligence have become its historic recordings, that in almost all cities and towns and villages may be found the displays and sample show-cases, ... [containing portraits ranging ...] from theatrical mimics, clowns, and stagedancers, in their various costumes and poses (or without costumes), to the presidents and sovereigns of the republics and kingdoms and empires of the world.[18]

Most of these cards came from the larger city galleries, where they were printed up and then distributed to smaller studios throughout the country. In Boston the Soule Art Company (established by John P. Soule in 1859) listed in its catalogue of around 1900: cards of 234 authors, 22 composers, 58 contemporary artists, 322 members of royalty, and 190 of various famous personages — presidents, generals, New England statesmen, scientists (including Daguerre himself), and philosophers. The Soule Company had purchased the negatives for these cards from galleries both in America and abroad. This dignified stock photographic house listed no freaks or theatrical figures, and its one concession to the stage consisted of an image of singer Jenny Lind. The price was 20 cents apiece or $2.00 for an assorted dozen.

The more modest studios also did their best to produce card photographs that would catch the public's attention. Some simply pirated the more popular images, recopying and selling them under their own label. More industrious studios sought out local photographers to produce pictures of regional interest. These they sold at their own studio, distributed to other galleries, or sometimes hawked on the streets.

On March 27, 1862, Connecticut State Prison convict Gerald Toole, previously whipped for not completing his required quota of making a dozen boots per day, and faced with another whipping for the same offense, stabbed the prison warden to death. After a well publicized trial, he was condemned and hanged. The *Hartford Daily Courant* for September 20, 1862, noted "Messrs. Moore Bros., Photographers, took an excellent likeness of Toole the day before he was executed. The news boys have it for sale." Pictures such as these found their way into family albums to enliven the usual gallery of relatives. Some studios produced larger-size portraits suitable for framing. Hawes of Boston realized a good portion of his revenue in the 1870s through 1890s by the sale of copy prints of the great statesmen he and South-

The Old Leather Man. *H. J. Rodgers (of Hartford), 1885. Cabinet card. From the 1860s until his death in 1889, this leather-clad recluse tramped a fixed, 300-odd-mile circuit about every thirty-four days through southern New England and lower New York State. Living on the handouts of those to whom he was a familiar sight, he slept in caves, huts, and barns. He stimulated a great deal of romantic speculation concerning his origins and secrets. By the time of his death he was well known throughout the northeastern United States. He was wary of photographers and posed for pictures only. about three or four times. Those few who caught him on the road and convinced him to sit before their cameras found a ready market for his portrait. Connecticut Historical Society, Hartford.*

worth had daguerreotyped in the 1840s and 1850s, to be hung in law offices, homes, and public buildings.

One final sideline — for the more shady studio — was the production of "spirit" photographs, in which a little darkroom work added the image of a deceased relative (or reasonable facsimile thereof) to the photograph taken of a gullible customer. The practice reputedly began in the 1850s in Boston when a photographer inadvertently gave a daguerreotype plate an insufficient rubbing to remove an old image before reusing it. By the 1860s it had become a thriving racket, preying on the hopes and emotions of those who had recently lost loved ones. For the general public, however, it was a supreme joke, and most concluded, as did Oliver Wendell Holmes, that "an appropriate background for these pictures is a view of the asylum for feeble-minded persons." [19]

6 Scenic Gems and Eminent Citizens

Rockville Opera House. *Arthur R. Newell, 1895. Heliotype from Newell's* Souvenir of Rockville, Connecticut. *Connecticut Historical Society, Hartford.*

From the earliest days of photography, many photographers, printers, inventors, and others sought to solve the problem of transferring the photographic image to the printed page. With the delicate-surfaced daguerreotype, their only course was to use its image as the basis for an engraving done by an artist specializing in this practice (see chapter 2). But in the early 1850s, John Adams Whipple's new glass-negative and paper-print process opened another avenue of getting pictures to the public: the paper print mounted in a book or periodical. This procedure had actually been in use since the early 1840s in England and on the Continent, where the paper-negative, paper-print talbotype was more acceptable than it was in daguerreotype-oriented America.

In 1854 the first books appeared in America with tipped-in photographs: *Homes of American Statesmen,* with a photo by Whipple of John Hancock's Boston mansion; and *Remarks on Some Fossil Impressions in the Sandstone of the Connecticut River,* with a print of "prehistoric bird tracks." In April 1853 the *Photographic Art-Journal* began including a photographic frontispiece, usually by Whipple.

While mounting photographs provided excellent images for the printed page, it was an expensive and laborious process. Each of the prints had to be made in the darkroom by hand. They were then pasted onto blank pages in the already printed books, again a time-consuming operation. The cost of all this work usually reserved the tipped-in photograph for the impressive frontispiece, and it was an expensive volume that had a number of photographs distributed throughout the text. Despite these drawbacks, photographically illustrated books appeared in the 1850s through 1880s in editions sometimes numbering in the tens of thousands, though the number of individual titles was only a few hundred.

In New England, only a handful of books appeared with tipped-in photographs. Among the most interesting were three books illustrating fossil tracks (see chapter 3); the Moore Brothers' *The Last Men of the Revolution* (see chapter 5); *The Landing of the French Atlantic Cable at Duxbury, Mass., July, 1869,* commemo-

rating America's first telegraphic link with the Continent; and the Bierstadt Broth-
ers' *Stereoscopic Views among the Hills of New Hampshire* (see chapter 4).

In addition to these works there appeared numerous volumes consisting of photo-
graphs of local "eminent citizens" or members of state legislatures. Also common
were memorial volumes to the recently deceased, often printed at the family's ex-
pense, containing funeral sermon, biography, and tipped-in frontispiece photo.

Yet these sporadic efforts were exceptions to the general practice of using steel or
wood engravings to illustrate books up to the last two decades of the nineteenth
century, when the halftone process became dominant. To solve the problem of
reproducing photographs effectively in cheap, mass-produced works, many people
experimented with a variety of techniques.

In the mid-1850s experimenters devised a number of printing processes based on
the properties of gelatin mixed with bichromate of potassium, a light-sensive chemi-
cal which hardens when exposed to light. In one process a gelatin-bichromate mix-
ture is applied to a flat surface and covered with a photographic negative. With
exposure to light, the gelatin is hardened by the bichromate in proportion to the
amount of light passed through the different areas of the negative. Water washing
over the plate will remove the softer gelatin completely, the partially hardened areas
to some degree, and the completely hardened areas not at all. The final result is a
gelatin plate with the original picture in relief.

Eminent Citizens of Gilsum, N.H. *Photographer unknown, 1881. Heliotype from Silvanus Hayward's* History of the Town of Gilsum, N.H. *Private collection.*

This basic gelatin relief technique was modified into different forms. Some used the original relief plate as the printing surface, others used it as a mold for lead, plaster, or other materials. In each technique, however, the printing of the picture depended upon getting ink to pool in various depths upon the plate, in proportion to the relief, and then transferring that ink to paper.

The best images produced in this manner had the smooth tonal gradations of the photograph, though often lacking in strong blacks. The usual press run of these plates ranged from 500 to 1,500 copies before they wore out. Their one disadvantage in the eyes of the printers was that they required special paper, special inks, and special presses, different from those used in printing the book's text pages. As a result, illustration pages had to be printed separately and then gathered with the text pages during binding.

Besides the gelatin relief processes, lithography, used in the nineteenth century to reproduce prints and drawings such as those by Currier and Ives, was also adapted to photography. In this process, the negative was laid over a specially prepared surface, as in the gelatin process. After a number of steps, the end result was a flat surface in which the white areas of the picture were greasy and would not hold ink, while the dark areas were clean and would retain ink when an inked roller was

passed over them. James Ambrose Cutting (1814–1867) and Lodowick H. Bradford (1820–1885) of Boston experimented with this process in the late 1850s, and issues of *Humphrey's Journal of the Daguerreotype and Photographic Arts* of 1859 contain images produced by the pair.[1] Unfortunately, the photo-lithographic process had its limitations, as it tended to produce high-contrast images with few middle tones.

Another process, the collotype, combined aspects of gelatin relief and lithography. In the modern collotype, a gelatin-bichromate–covered plate is baked to harden the gelatin and produce a wrinkled texture on its surface. The gelatin plate is then covered with a negative, exposed to light, and washed, as in the relief process. Since the gelatin has already been hardened, however, the water removes the unhardened bichromate, but does not work at the gelatin itself. The plate is then soaked in a glycerine solution, and where the bichromate has been washed out, the glycerine is absorbed. This creates a plate in which the glycerine has been laid down in direct proportion to the light passed through the negative. When greasy lithographic ink is rolled over the plate, it takes to the fine gelatin wrinkling in inverse proportion to the amount of glycerine absorbed beneath. In this manner, an ink image with a full range of tones is formed on the plate, and is simply printed on paper.

By about 1870 American photographers and printers were acquiring licenses to make prints by means of these various procedures, patented under a variety of names, such as Albertype, Artotype, Autotype, Collotype, Heliotype, Lithotype, and Woodburytype.

In 1869 Edward Bierstadt began to produce albertype prints, by a process developed in Germany by Josef Albert. The prints were made at a New York City factory licensed by a fee paid to Albert. In New England, the same patent rights were sold in 1872 to the newly formed Albertype Printing Company of Boston, which advertised "distinctness and durability of steel engravings and the accuracy and truthfulness of the photograph."[2] An English process, the heliotype, was licensed by the well-known Boston publishing house of Ticknor and Fields, later carried on by James R. Osgood. Concurrently, in the town of Gardner, Massachusetts, there appeared a number of printing houses specializing in printing photographic images by various processes, such as the Art Publishing Co. and the Lithotype Co.

The photogravure process, invented in 1879 by Karl Klíč of Austria, made use of a relief printing plate to reproduce the image, as in the gelatin relief processes. Here, however, the relief surface was produced by an acid etch. By the turn of the century, this process, which produced a soft-edged image, was to find great popularity among artistic photographers such as the Photo-Secessionists.

In New England, the first books to make use of the new photomechanical il-

Pine Street, Waltham, Massachusetts. *Bradford and Williams, 1886. Heliotype from* Waltham Illustrated. *The Boston Athenaeum.*

lustrations were popular regional books. Wilson Flagg, a well-known nature writer (*Studies in Forest and Field, A Year Among the Trees, The Birds and Seasons of New England*), illustrated his 1872 *Woods and By-Ways of New England* with seventeen heliotypes of various trees. The next year saw the publication of Samuel Adams Drake's *Historic Fields and Mansions of Middlesex,* with twenty heliotypes of famous buildings and homes of Massachusetts's Middlesex County. Neither of these works identifies the photographers.

While such books by successful authors served to test public reception of photomechanical illustrations, they were quickly surpassed in popularity by "view books." These volumes consisted almost entirely of scenic views taken of one locale, such as the Maine coast, the White Mountains, or the Yale or Harvard campus. Soon, however, local subjects became most popular as publishers in Boston and Gardner produced works entitled *Worcester Illustrated, Sunlight Pictures of Hartford, Picturesque Providence, Souvenir of Rockville, Connecticut* (see pages 92–93) , and *Fifty Illustrations, Comprising Views of the Principal Business Blocks, Manufactories, Residences, Streets and Points of Interest of Keene, New Hampshire.* Sometimes us-

ing the work of local town photographers, sometimes commissioning big-city studios, these books had the effect of turning photographers from photographing individual buildings for owners to aiming their cameras down city streets to portray a town in its entirety. From an examination of a great number of these city view books, they appear, with notable exceptions, repetitious in content and photographic style, showing the business district, churches, factories, and opulent homes, usually when the trees are bare of leaves and the streets devoid of people.

Another local orientation of the photomechanically illustrated book was the town history, often published in conjunction with the centenary or other anniversary of the town's founding. Though often photographically primitive, the naïveté of these books sometimes make them charming: schoolchildren dressed in period costumes for a reenactment of some early event in the town's history, or the "eminent citizens" posed with smug satisfaction that their faces are obviously needed to add dignity to such a volume.

Only a handful of the New England view books printed in the 1870s through 1890s had an avowed intention of producing an aesthetic response to the images, and even fewer succeeded. The works are reflected in such evocative titles as *Our New England, Poetic Localities of Cambridge,* or *By the Sea.*

Few of these view books could compete with the work of any competent stereo photographer of the day. Despite this, the picture publishing houses cut deeply into the stereo view market. In 1879 Charles Bierstadt wrote to the magazine *The Philadelphia Photographer,*

> In my opinion, printing-ink will sooner or later drive silver photographs [standard photographs in which the image is produced by silver nitrate] out of use. I told you that the price of stereoscopic views was at present so low . . . that . . . if I could begin business anew I would certainly adopt the artotype process.[3]

In some cases stereo views themselves were produced by photomechanical processes, such as Edward Bierstadt's *Gems of American Scenery* (1878). It contains twenty-four stereo pairs, one set to a page, with a viewer flap — similar to the Bierstadt Brothers' 1862 book of mounted stereo views.

The era of the "gravure" books, as they came to be called when the photogravure process superseded all the rest, lasted until the 1890s (see pages 218–219 for a selected list). At this time another photomechanical process came into its own — the now standard halftone. In a sense it was the reverse of the gravure process. A gravure plate is eaten by acid, forming recesses where ink is trapped and transferred to the printed page, whereas the halftone's depressions are not inked —

only its raised surfaces are. To produce a halftone, the original picture is first re-photographed through a fine screen, breaking the image down into dots of various density. This negative of the original is then placed over a light-sensitive plate and exposed to light. (The surface of the plate hardens when exposed to bright light.) The black area of the negative (the whites of the original) and the screen itself let no light on the surface, while the light areas of the negative (darks of the original) let the light through. After the soft portions of the image are washed away, acid is poured over the plate. This eats away the metal backing along the screen lines and eats at the dots in proportion to the hardness of the sensitized material. The end result is a printing plate that has the same relief printing surface as regular letter type. To print the picture, the halftone plate is simply locked into position with the type, inked by rollers, and impressed on paper.

The first publications to make extensive use of this process were the illustrated magazines, such as *Harper's* and *Leslie's,* which began using halftones along with engravings in the early 1890s. Within the next decade, many publishers abandoned their old "-type" processes in favor of the more economical halftone — less expensive because it did not require special presses or printing paper, and did not wear out after relatively few impressions.

In New England, as elsewhere, the advent of the halftone spelled doom for the finely detailed view books, their place taken by coarse halftone images. Today this era survives in the work of only a few high-quality specialized printers, such as the fine collotype printing done by the Meriden Gravure Company of Meriden, Connecticut.

7 "Keeping pace with the very motion of life"

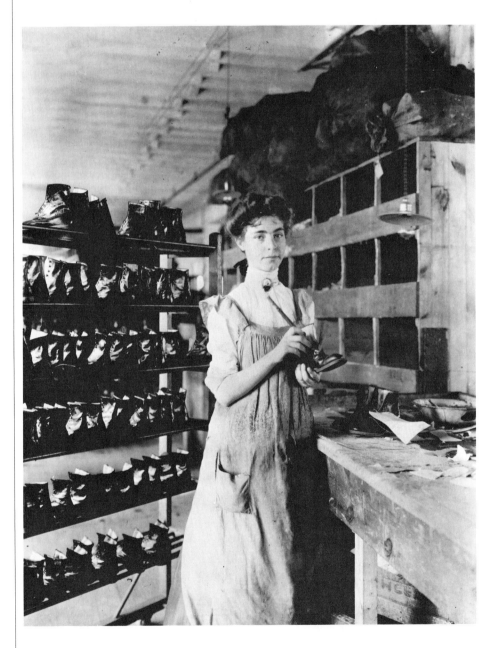

Mill Girl. *Frances Benjamin Johnston. Shoe factory, Lynn, Mass., 1895. Modern print from original negative. Taken during a photographic survey of working conditions for women in Lynn. Library of Congress.*

*I*n the 1870s, photographers were still finding new uses for photography. Some dreamed up ideas in the safety of a laboratory or study, while others risked their lives in the pursuit of novelty.

One such adventure was the first winter occupation of the summit of New Hampshire's Mount Washington, known to have the worst weather in the world outside of a few isolated Antarctic peaks. This expedition took place during the winter of 1870–1871 and included two photographers: Howard A. Kimball, a studio photographer from Concord, New Hampshire, and A. F. Clough, a White Mountain–bred stereo photographer in the style of mountain man Ben Kilburn.

The idea for the expedition apparently originated with Clough and J. H. Huntington of the New Hampshire State Geological Survey. In late 1864 Clough had climbed snow-clad Mount Moosilauke, another White Mountain peak, and became entranced with the delicate frost formations on the barren mountaintop. For a number of winters thereafter, he climbed the mountain with photographic gear, but was prevented by the weather from photographing. In 1869 he teamed up with Huntington to spend the winter atop the mountain.

On December 31 the pair set off. "I was determined," Clough related, "to try until my chemicals or myself froze up; so with my traps lashed to a hand sled, we toiled up the mountain of 5,000 feet, walking on snow shoes." [1] The pair reached the top and spent two months there photographing and making observations before almost losing their lives in a descent during a raging storm on the last day of February 1870. From his negatives, Clough published a series of thirty-six stereo views of the peak and far vistas "amongst clouds, storms, and frost." [2] While on the summit neither Clough nor Huntington could keep their eyes from Mount Washington towering in the distance. They soon were determined to find themselves atop that mountain come next winter.

Huntington spoke with Charles Hitchcock, Dartmouth professor and New Hampshire state geologist, and the two scientists began planning the expedition and soliciting funds. The actual winter party was to consist of Hitchcock, Huntington,

Depot-Observatory — 60 Feet Long, 25 High, and 22 Wide. *Clough and Kimball. Half stereo card from "Views Taken on the Summit of Mount Washington . . . Winter of 1870–71," no. 31. Anchor chains were passed over the roof and bolted to the rocks to keep the building from blowing away in a storm. Private collection.*

S. A. Nelson as observer, Theodore Smith from the U.S. Signal Service as observer and telegrapher, and Clough as photographer. Preparation for the ascent and occupation of the summit attracted great interest, especially from photographer Howard A. Kimball. Not knowing of Clough's position as expedition photographer, Kimball formally applied to join the party; he was referred to Clough, the pair met, and they decided to work as a team. The two photographers donated some of their own money for expedition costs, and Kimball worked the Concord area canvassing for additional funds.

On November 12, 1870, the main party, without Clough and Kimball, ascended the mountain to set up their occupation of the Summit Observatory, a shed set on the mountaintop with anchor chains strung over its roof and bolted to the bedrock in hopes that this would be sufficient to keep the hurricane-force winds from blowing it away.

On November 30, Clough and Kimball, accompanied by local photographers C. F. Bracey and C. B. Cheney, began their ascent. The four set out from the railway terminus at the mountain's base at 2:30 in the afternoon under a clear sky. By the halfway point, according to Clough,

> the complexion of things changed; dark threatening clouds stretched along the crest of the Green Mountains, and were moving down upon us in a solid mass. We made haste to reach the top. Kimball, not being used to such tramps, was getting fatigued.[3]

The four men each carried from 75 to 100 pounds of photographic equipment on their backs. Their plight soon worsened. "We were soon in a dense cloud. Mr. Bracey got separated from the rest of us here, and Mr. Kimball declared himself 'played out.'"[4] With mists thickening, daylight waning, and the winds rising to

hurricane force, Kimball lay down to die, telling his comrades to push on and save themselves. Clough would not allow this.

> What was to be done? Leave him to perish and save ourselves, or make an effort to get him up? I thought I had strength to do it, I *certainly had the will*. Mr. Cheney declared himself ready to try, so we went around the ridge a little, out of the wind, and rested. At the same time we rubbed and slapped our exhausted friend with the flat of our hands, which does a great deal towards restoring a person in that condition.
>
> After a short rest, and having dropped all traps that would load us down, he [Kimball] took a small cord in his hand, whilst I drew the other end over my shoulder, Cheney locked arms with him, and then we pushed up into the clouds and darkness. We had a full mile to go, and he was growing worse fast. We had to resort to rubbing and slapping, letting him drop behind anything that would break the force of the wind. He begged us to leave him and take care of ourselves.[5]

The trio finally attained the open slopes of the summit with the observatory in sight, but the wind was so fierce they could not stand in their weakened condition. Finally, prostrate and within a few yards of the shelter, their cries were heard and the rest of the team inside rushed to their rescue. There they were reunited with Bracey, the fourth photographer, who had followed the railway tracks to the summit and arrived a half hour earlier.

By the next day, all involved, including Kimball, had recovered from their exhaustion, and only some soreness and stiffness lingered from their adventure. They found the day quite clear and calm and immediately set to photographing. It was their intent to do a series of stereo views of the expedition's work and the interesting sights on the summit. Cheney and Bracey soon left to descend the mountain, leaving only the original expedition.

Unfortunately, Clough and Kimball found few days settled enough for photographic work. From Kimball's summit diary:

> *Thursday, December 29, 1870*. This morning I went out to see if we could make some negatives during the day. I had barely got out when the wind swept me . . . away from our entrance . . . and I only saved myself . . . by catching the chain which passes over the building.[6]

Luckily, he landed in a snowdrift rather than on the bare rock outcroppings. During the short lulls in the intense wind, he made his way on hands and knees back into the observatory, "determined to stay there as long as the wind blew so furiously;

and we have decided without much question, that it will be impossible to photograph today." [7]

> The next day, Friday, December 30th, dawned clear and calm: It is what
> we have waited a month for. We commenced work on our chemicals at
> daylight, warming and filtering our baths, suitably tempering developer,
> etc., and heating all our instruments to drive the moisture from them;
> putting our darkroom in order [a small corner of the observatory room
> they had sectioned off], and melting ice for water to use in washing the
> negatives. We commenced making negatives at sunrise. Experienced great
> difficulty, in exposing the sensitized plate, to avoid the destruction of the
> film from freezing. We carried the plate in a warm woolen blanket, but
> this could only serve in carrying. As soon as the plate was put in the
> camera from the warm branket, it would raise a cloud of vapor from the
> moisture inside, which would congeal on the plate and inside the camera,
> and give the inside of the lenses of the tubes [the twin barrels of the stereo
> camera] the appearance of ground glass. . . . Our only resort was to keep
> the plate and holder only a few degrees warmer than the camera. Then
> putting our plate into the camera, exposing, taking it from the camera,
> and carrying it under protection of the heat of the body and the coat,
> developing as soon as possible, success crowned our efforts. We were two
> to five seconds in taking the plate-holder from its shelter under our coats,
> fixing it in the camera, lifting the slide, exposing and returning the plate
> to shelter. If we delayed in the least, the negative would be frozen and
> thus spoiled. [8]

For the most part, as they awaited breaks in the weather, Clough and Kimball spent their time rendering whatever assistance they could to the rest of the expedition party. Kimball apparently turned out to be a fine cook. Although the expedition officially lasted until May 13, 1871, by that time they had given up hopes of many good days of photography and descended the mountain, returning for a few days at a stretch if the weather looked promising.

The expedition itself drew great public attention. Scientific journals of the day hailed it as a pioneering experiment in cold weather research. Newspapers eagerly awaited dispatches teletyped from the summit. While providing no astounding discoveries, it proved the feasibility of sustaining a station atop Mount Washington in winter and provided a fascinating insight into the extreme weather conditions there. Clough and Kimball's contribution to this work consisted of a series of forty-six stereo cards, "Views Taken on the Summit of Mount Washington, during the Winter of 1870–71, by Clough & Kimball, Concord, N.H." The views depict the icebound summit, the observatory both outside and in, the distant mountains, and

Measuring the Wind at 83 Miles an Hour, Mts. Adams and Madison Beyond. *Clough and Kimball. Half stereo card from "Views Taken on the Summit of Mount Washington . . . Winter of 1870–71," no. 12. The supine figure holds an anemometer. A safety rope can be seen attached to his waist. The boardwalk in the foreground was later completely blown away in a storm. Private collection.*

Interior of the Observatory — Messrs. Clough [right], Smith, and Nelson. *Clough and Kimball. Half stereo card from "Views Taken on the Summit of Mount Washington . . . Winter of 1870–71," no. 32. Private collection.*

the expedition members at work — sometimes in winds approaching 100 miles an hour.

While Clough and Kimball had to work with the cumbersome wet-plate process, in which the glass plate of the negative was coated with the required chemicals just before use and then exposed and developed before it dried, the introduction of the "dry plate" in the early 1880s revolutionized photography.

The dry-plate negative had all the basic characteristics of film used today. Supplied by the manufacturer in final form and used as is, it could be stored for long

periods without drying out or losing sensitivity, and it came in a variety of sensitivities to light. (For further discussion of the introduction of the dry plate, see chapter 9.)

An early New England experimenter with the scientific possibilities of this new type of negative was William H. Pickering (1858–1938), instructor at Massachusetts Institute of Technology (later assistant professor of astronomy at Harvard College Observatory). Pickering applied the camera to a number of fields, of which microphotography, astrophotography, and high-speed photography were his most successful ventures.

Since the early days of John A. Whipple's astronomical daguerreotypes, astronomers had been stymied first by the delicacy of the image on the daguerreotype plate, and then by the wet-plate negative's drying out during long exposures at the telescope. Pickering made some preliminary experiments in the feasibility of astrophotography with the dry plate, and in 1882 advised his brother, Harvard astronomer Edward C. Pickering (1846–1919), concerning the successful results. Edward (who was to become one of the first great astrophysicists) shared his brother's enthusiasm for adapting this new type of negative to astronomical work, and in December 1882 they began experimenting at the Harvard College Observatory to determine the equipment best suited for astrophotography. Finding that high-quality, commercially produced portrait lenses worked best, they constructed a small telescope around a 7-inch diameter, 37-inch focal length portrait lens. A pleasant surprise came when the pair discovered that simple, small cameras attached to the telescope's clock drive produced excellent results. In 1883 they began to make a systematic "map of the heavens" by photographing the night sky section by section in 30-second exposures. By 1885 they had sufficiently perfected the system to raise money for an eminent telescope lensmaker to grind them a lens 8 inches in diameter with a 45-inch focal length. Put into use in 1885, this astro-camera, using 8 × 10 inch negatives, became their basic instrument for mapping the heavens and determining the brightness of individual stars. Along with the efforts of the Pickering brothers, it established Harvard as the leading center for astronomical photography. The instrument itself was used continuously until it was finally retired around 1950, by which time it had taken over 75,200 photographs of the stars.

The Pickerings continued to develop and expand the field of astronomical photography. Their prediction that one well-equipped observatory, with the aid of the photographic plate, would replace the need for hundreds of observers at separate telescopes proved true. The funds for myriad smaller telescopes, at which individual observers spent long hours tediously making observations, could now be funneled into the construction of one large telescope. Here an astronomer made his photo-

Harvard Observatory, Photographic Telescope. *Photographer unknown. Cambridge, Mass., 1888. Heliotype, 8⅛ × 6¾ inches. Harvard's 8-inch Bache telescope, installed by the Pickerings in 1885 and used continuously to map the skies until around 1950. From* Memoirs of the American Academy of Arts and Sciences, *1888.*

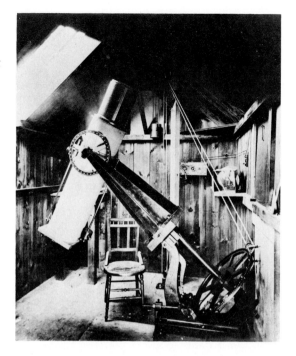

graph and then retired to his office to study the developed plates, allowing many others their turn at the great instrument.

During the time that William Pickering worked making long exposures at the telescope, he also experimented with short-exposure, "high speed" photography. Before the introduction of the dry plate, the fastest exposure feasible was about 1/20 second. Edward Anthony's stereo cards of busy New York City streets, which Oliver Wendell Holmes used in studying human locomotion, were "the state of the art" (see chapter 3). With the increased sensitivity of the dry plate, many photographers — both amateur and professional — were able to experiment with ways of "keeping pace with the very motion of Life." The most famous result was Eadweard Muybridge's stop-action series of the human figure and the horse in motion done first on wet plates in 1877 in California and on dry plates in 1884 in Philadelphia.

William Pickering devised a number of lens shutters that allowed him to make exposures of from 1/50 to 1/200 second. He published his results in 1885 and exhibited a number of his high-speed photos — a horse in motion, a speeding train, a falling glass of water, a stone falling into a tub of water, and a glass chimney lamp being hit by a bullet. Today one sees these images as precursors to the millionth-of-a-second pictures taken by another M.I.T. experimenter, Dr. Harold E. Edgerton, in the twentieth century.

For Pickering, his contemporaries, and those who came in the decades after him, high-speed photography depended on constructing faster lens shutters and manufacturing more sensitive negatives. Over the years photographers had attempted to increase the amount of light on the subject in order to shorten exposure time, but

Instantaneous Photographs. *William H. Pickering. Cambridge, Mass., ca. 1885. Composite print, totaling 5½ × 3⅝ inches. Top: 1/50 second exposure. A splash caused by dropping a six-inch stone mortar into a bucket of water from a height of six or seven feet. Three distinct waves of water can be counted. Lower left: 1/150 second exposure. Water falling from an upset tumbler. Taken indoors. Lower right: 1/150 second exposure. Lamp chimney at the instant of being shattered by a bullet. The horizontal streak is explosive gases following the bullet. "The difficulty in making the exposure at the right time was not so great as might first be supposed. I stood quite near the chimney, and held the gun, while my assistant's finger was on the trigger of the shutter. I counted, and at the word 'three' we both pulled." By this method Pickering was successful with about one out of every three trials. Photograph and quotation from Pickering*, Methods of Determining the Speed of Photographic Exposures.

for the most part this resulted in bringing the time down from a good portion of an hour to a few minutes. Since the early 1850s, many photographers had experimented with carbon arc lights for interior or nighttime exposures. In most cases, however, these were one-time trials using borrowed equipment. On May 23, 1856, Robert O. Doremus, a New York scientist (later professor of chemistry and physics at the College of the City of New York and vice president of the American Photographic Society), visited Hartford to demonstrate his "galvanic battery." Nelson Augustus Moore took the opportunity to use Doremus's apparatus to make a number of daguerreotypes of a bust of Benjamin Franklin at the lecture hall where Doremus spoke. On the night of August 6, 1863, John A. Whipple illuminated Boston Common with an electric arc and obtained excellent results using a 90-second exposure. In April 1879, Isaac White, of the Hartford studio of Prescott and White, photographed the interior of the Willimantic Linen Company's mill. With two carbon arcs, the exposure time was 12 seconds.

Few studios, however, made use of the expensive and cumbersome electric arc. The latter half of the nineteenth century, and a good portion of the early twen-

A Football Being Punted. *Harold Edgerton, Kenneth J. Germeshausen, and Herbert Grier. Cambridge, Mass., ca. 1934. Modern print, 8 × 10 inches. Exposure time: approximately 1/100,000 second. The white spots above the football are dust particles that were on the ball before it was kicked. Courtesy Harold E. Edgerton.*

Setting Up to Take a High-Speed Photograph. *Photographer unknown. Cambridge, Mass., ca. 1939. Modern print, 8 × 10 inches. Dr. Harold Edgerton prepares to swing the golf club while his associate, Kenneth J. Germeshausen, readies the equipment. Two fine wires connect when the club hits the ball to trigger the flash of 1/80,000 second duration. Massachusetts Institute of Technology Historical Collections, Cambridge, Mass.*

tieth century, saw photographers relying on burning magnesium, either in wire form (ca. 1865), or as the more familiar "flash powder" (ca. 1886). It was not until the late 1920s that flashbulbs appeared, making magnesium powder obsolete. While electrically fired, the flashbulb was still only combustible metal in a contained glass bulb. Even by this time, electrical illumination was little used for outside or remote work. One usually found it in use only in the studio itself and by photographers affluent enough to afford (and have room for) the bulky and expensive apparatus.

In 1931, Harold Edgerton (b. 1903), working at Massachusetts Institute of Technology, changed all this. Assisted by Kenneth J. Germeshausen, he devised an electronic circuit in which a large electrical charge was built up to be discharged through a tube containing rare gases. The effect produced a brilliant light — many times brighter than sunlight — which lasted only an infinitesimal portion of a second, approximately 1/100,000 second in the first experiments. Later Edgerton brought this down to a millionth of a second. Using this flash lamp, they were able to photograph a ball in motion, flying birds, water droplets hitting a fluid surface, and bullets in flight, all with ordinary film and a simple studio camera. Edgerton also found that successive flashes over a period of a few seconds produced striking stroboscopic images of people and objects; for example, a golfer swinging a club and an object exploding. Today the electronic flash, based on Edgerton's principles, has become a standard photographic accessory.

Given the relative compactness of dry-plate equipment, it seemed inevitable that some brave soul would attempt to adapt it to aerial photography. That individual was John G. Doughty, who in 1885, along with Alfred E. Moore, self-proclaimed "aeronaut," floated in a balloon from Winsted, Connectictut, high in the Litchfield Hills, to Windsor, on the Connecticut River almost thirty miles to the east.

Information on John Doughty is sketchy. The son of a Winsted studio photographer of some merit, T. M. V. Doughty, and a descendant of Hudson River School landscape painter Thomas Doughty, he left few clues to his life besides his aerial photographs. In 1886 he appears to have been in charge of the dynamo at Winsted's first electrical plant, and in 1901 he partnered in organizing the Flexible Rubber Company, an apparently unsuccessful attempt at manufacturing and marketing rubber track shoes with suction-cupped soles for traction.

The idea of aerial photography took hold in the mind of Alfred Moore during the summer of 1885. Moore had made his first balloon flight on the Fourth of July that year and, as soon as he was sure that he had survived the experience, became a ballooning enthusiast. He quickly had a balloon of his own built and approached his photographer friend John Doughty about the possibility of photographing from it. Doughty happily offered assistance and advice until he realized that Moore

expected him to come along on the flight. Although at first horrified at the prospect, Doughty finally convinced himself to go. "After this decision, which I felt to be final, I went about with the emotions of a criminal whose sentence is deferred: for the day of the ascension had not been fixed." [9]

The pair's first photographic flight took place on September 2, 1885. All was made ready, the bag filled with gas, and Moore and Doughty needed only to climb in the basket to begin the flight.

> Moore took his place, and I was told to get my apparatus and get in; camera and plate boxes were brought from their place of storage, and I made my way back through the crowd gathered around the balloon, conscious of being very white, and moving very carefully to avoid trembling. [10]

Until the last moment before lift-off Doughty was one step from diving out of the basket and making his escape through the crowd.

Once aloft, Doughty's fear vanished as he marveled over the many familiar landmarks as seen from above. Unfortunately, the trip was a failure photographically. Threatening weather had delayed the ascension until five in the afternoon, leaving the land below in twilight shadow — too dark to produce anything but murky negatives.

A second flight on October 16 proved an immense success. Doughty prepared his equipment from knowledge gained on the first balloon trip. He chose a camera using 5 × 8 inch negatives,

> as it allows a considerable extent of the country to be included in the view, while the apparatus need not be bulky or heavy. The camera was quite light, as all the apparatus used in a balloon must be, but not so fragile as to sacrifice rigidity in keeping the distance at which the plate is set from the lens. [11]

He attached a smaller camera to the large one and used the image projected on its ground glass as a viewfinder.

The trip itself was quite pleasant for Doughty and Moore. They rose up through scattered light clouds to an altitude of about two miles and floated southeast. Doughty took pictures by holding the camera under his left arm and the shutter release in his right hand. When a suitable subject appeared, he waited for the slow rotation of the balloon to bring it in view and then tripped the shutter. Moore meanwhile recorded the subject, plate number, and altitude. The journey ended late that afternoon in the branches of a large chestnut tree in the town of Windsor.

Photography from a Balloon. Interior View of Balloon Looking toward the Neck. *John G. Doughty (of Winsted, Conn.), 1885. Paper print, 5 × 8 inches. Doughty is second from left, Moore is second from right.* "600 yards of material were required in the manufacture of this machine upon which was put one and one-half barrels of special varnish. Height of balloon complete 80 feet, cir-cumference 120 feet. Weight 650 pounds. When filled with hydrogen gas its lifting capacity is 2,640 pounds; when filled with coal or illuminating gas its lifting power is 1,320 pounds. When this picture was taken the balloon was filled with air." *(Description, reverse of card mount.) Connecticut Historical Society, Hartford.*

The pair later published a series of fourteen 5 × 8 inch prints selected from the negatives taken during the flight, inaccurately billing them as "the *first* and *only* successful views ever taken from a balloon" [12] (see chapter 3). The views included the interior of the gas bag as it lay half inflated with Doughty, Moore, and assistants sitting within; the balloon on the ground; towns and rural areas from the air; and the landing scene with the curious local residents lined up in front of the balloon.

Doughty and Moore apparently made two more attempts at aerial photography. In 1886 *The Photographic Times and American Photographer* of New York noted a planned flight over that city by the pair on a date "when the wind is blowing inland. Mr. Doughty goes to photograph the ocean." [13] The event never occurred, but they did attract the attention of the *New York World,* which financed a journey to St. Louis, where they made an ascension on June 17, 1887.

Another photographer, William Blake Luce of Hingham, Massachusetts, perfected around 1898 a kite camera with which he was able to take aerial photos from altitudes of 300 to 1,000 feet. A large triangular box kite served as the platform. Once the kite was in the air he used a second line passing through a pulley attached to the kite to bring the camera up. The camera (taking 3¼ × 4¼ inch

Photography from a Balloon. View of a Portion of Winsted, Conn. *John G. Doughty (of Winsted, Conn.), 1885. Paper print, 5 × 8 inches.* "Taken *from the balloon 3050 feet from the earth. . . . Although we are at this time less than three-quarters of a mile high, and can hear a distant car whistle and the discharge of a gun immediately* under us, it is impracticable with the naked eye to distinguish any animal life in the view below unless it is motion." (Description, reverse of card mount.) The view is looking west; at left center is the Gilbert Clock Co. complex on the Mad River. Connecticut Historical Society, Hartford.

No. 3

negatives) had a plunger sticking out that attached to the shutter. To make the exposure Luce released a small square sail hooked to the kite string that blew up the line to hit the plunger, tripping the shutter.[14]

The turn of the century also saw the increased use of photography for medical and sociological ends. Some applications, like the X-ray photograph or documentation of the plight of the poor, made definite contributions to society, while others appeared and then vanished as curious but unproductive fields of endeavor.

One such curiosity was the composite photograph popularized in 1887 by John T. Stoddard (1852–1919), professor of mathematics, chemistry, and physics at Smith College, Northampton, Massachusetts. In a pair of articles in *The Century*[15] he explained how he superimposed all the portraits of the members of a college class into one picture to produce a "pictorial statistic" of the class: the "ideal" student. Stoddard found that if all the portraits were uniformly taken — all of the same size, and with the same lighting and exposure time — rephotographing them all by giving each a partial exposure on a "master negative" always gave the same result: a soft-edged, ethereal image in which one could make out a face with quite definite features.

To some, Stoddard's work was simply amusing. One student, on seeing a com-

Forty-Nine Members of the Class of '86 of Smith College. *John T. Stoddard. Northampton, Mass., December 1885. Halftone of a composite photograph. From* The Century, *March 1887.*

posite made of herself and her classmates, remarked, "It is charming to enjoy the society of somebody who is all one's intimate friends at once."[16] The more learned took a greater interest in Stoddard's quasi-scientific work. Henry Pickering Bowditch, an eminent Boston physician, spent some effort in researching the possibilities of producing the image of a racial or social type through the composite photograph. Among his collection Bowditch procured an "ideal" Harvard professor, a Saxon soldier, a Boston intellectual, a horsecar driver, and a streetcar conductor.

While composites were a fad for a few years, they ultimately proved to be of no scientific value and faded into obscurity. A more influential type of photography coming into its own in the 1890s was social documentation: recording the working places, homes, and habits of the nation's laboring class. It first became prominent in the New York area, where photographers like Jacob Riis worked among immigrants at Ellis Island and in their city slum neighborhoods. Soon, it spread into neighboring New England.

In 1895 Frances Benjamin Johnston (1864–1952) traveled to Lynn, Massachusetts, to photograph women laborers in the shoe factories there. More a society and artistic photographer than a social documentarian, she saw little hardship in the women's work and concentrated instead on the slightly regimented, "protected" life they led in the mills and factory-built dormitories. By standards of the day the workers were well treated, and Johnston's series of thirty photographs reflect this (see page 100).

One of the more home-grown "sociological studies" made at this time in New England was the documentary work on tramps and hoboes done by Dr. John

Horse Car Drivers. *Photographer unknown, ca. 1885–1890. Composite photograph, 5 × 6¼ inches. From a collection of composites assembled by Dr. Henry P. Bowditch, Boston. Countway Library of Medicine, Boston.*

James McCook (1843–1927) of Hartford. Dr. McCook was a jack-of-all-trades — physician, Episcopal rector, professor of languages and fundraiser at Trinity College, Hartford ("Beggar General," as McCook characterized himself), and lastly, "investigator of so-called sociological phenomena and writer concerning them." [17]

In 1890 McCook, ever a dynamic man, was involved in a dispute over the misuse of funds supposedly to be distributed to the city's poor. (His work fully exposed the graft and waste in Hartford's "Outdoor Alms" budget.) As his interests turned toward the plight of the poor, he received an invitation to speak in New York about tramps and vagrants. McCook apologetically declined the offer on the grounds that he was not sufficiently versed on the subject. He then immediately began a study of it, which lasted until 1924 and soon made him one of the nation's experts on hoboes.

McCook sent questionnaires to sheriffs throughout the country. He visited the haunts of tramps in Hartford, Boston, and New York — bars, jails, mission houses, charity wards, flophouses, barns, railside camps, and even morgues, where their remains awaited unmarked graves in potter's fields. He also interviewed many tramps and carried on long correspondence with a few. From 1893 to 1895 McCook's son Philip accompanied his father on these forays and photographed the hoboes in their environment. The elder McCook used these pictures to illustrate his many articles.

Another aspect of McCook's study was his practice of sending the more interesting looking tramps to local studio photographers to have their portraits taken. Sometimes the photographers found themselves visited by utter sots, drunk to the gills, leaning against each other to keep from toppling. Other tramps showed strong dignity, character, and intelligence.

McCook's efforts on behalf of hoboes never touched the public as did the work of other social reformers, simply because the tramp was very much contented with his lot.

> Give the tramp a chance! I know him very well. I have found him a pleasant, approachable fellow, and I should rather take my chances of reforming him, with purely civil and secular measures, than the ordinary felon. [18]

Though often victimized and derelict, the tramp did not cry out for aid as did the children of the poor and the immigrants in ghettoes. All he wanted was a clean bed and a few coins in his pocket.

The man who made photographs that spoke to the hearts of the American people was Lewis W. Hine (1874–1940). Unlike Johnston, who concerned herself as much with artful composition as with revealing the humanity of her subjects,

A Quintet of Lodgers. *Charles T. Stuart (of Hartford), April 27, 1893. Paper print, approximately 6½ × 4½ inches. Taken by Stuart, a professional studio photographer, for John James McCook's* *study of tramps and hoboes. Butler-McCook Homestead Collection, courtesy Antiquarian and Landmarks Society, Inc., of Connecticut, Hartford.*

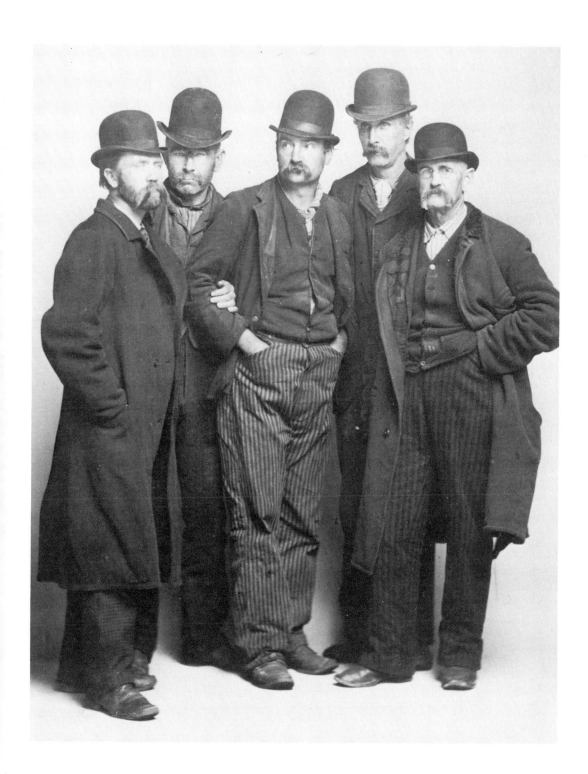

Hine purposely sought a sympathetic response from the viewer of his pictures. He had one cause: to show the true condition of the bewildered immigrant in the tenement and of the exploited child at the mine, factory, and mill. The latter subject Hine illustrated so well that he was instrumental in the passage of many child labor laws.

Hine began his photographic work in 1905 to illustrate sociological studies. Soon the texts seemed superfluous, since a series of Hine's pictures presented sufficient documentation. His method was to make photographic surveys in various areas and then combine the best pictures with articles which usually appeared in *Survey,* a periodical of the early 1900s committed to eradicating social and economic injustices.

A number of these trips took Hine into New England. In March 1909 he photographed the street trades of Hartford, Bridgeport, and Boston. July 1909 found him covering the New England textile mills. In 1911 he continued his mill survey as well as the Maine and Massachusetts cranberry fields. In 1915 he again covered the cranberry harvest as well as the region's tobacco workers.

For the most part Hine dwelt on the problem of child labor, producing poignant images of young children doing back-breaking work, or of teenagers: streetwise, cigar smoking, prematurely jaded by their harsh environment. Hine gives us few bittersweet images. Perhaps his scene of children scavenging in the Charlestown, Massachusetts, dump affirms that childhood will find its joys no matter the odds. The rest of Hine's work shows us children thrust into worlds with very little patience for laughter, play, or tears.

Hine was not alone in his work, as a number of now unidentified photographers or long-defunct local organizations documented the urban blight in their areas. Among the best of this work surviving today are the anonymous photographs (now in the Rhode Island Historical Society) taken in 1903 of Irish and Italian immigrants scavenging at the Providence dump, and the pictures by Boston commercial photographer Charles H. Currier of that city's street beggars, charity houses, hospitals, and soup kitchens.

Charlestown. *Lewis W. Hine, ca. 1910. Modern print, 4½ × 6 inches. Children scavenging in a dump near Boston. A man at left supervises the youths. Courtesy of the Boston Public Library, Print Department.*

8 "Wanderers with a camera"

67 Milk Street, The Boston Button Company — Opposite the New
Post Office. *James Wallace Black, November 1872. Albumen print
from wet-plate negative, 7 × 9 inches. Among the many photog-
raphers who made and sold prints of the ruins of a fire that razed
much of old Boston, Black produced some of the best images. From
his album,* Ruins of the Great Fire in Boston. November 1872. *The
Boston Athenaeum.*

As photography became less and less a novelty to the public in the latter half of the nineteenth century, professional photographers found more people willing to commission them to photograph a variety of new subjects. Soon the "commercial photographer" could be found photographing buildings, group convocations, animals, ships, trains, disasters, special events — virtually anything that might turn a dollar.

The earliest commercial work on paper prints appeared in the mid-1850s in commissioned views of public buildings and business establishments. One of the earliest in New England to produce quality work of this nature was Josiah Johnson Hawes of daguerreotype fame. From around 1855, when he learned the art of the glass negative/paper print from Whipple and Black, he covered Boston and environs taking photos of businesses, private residences, churches, clubs, and, occasionally, an unusual picture someone might purchase for hanging on the parlor wall. He usually did this work by commission.

By 1865, Hawes advertised, "Particular attention given to Views of Scenery, Villas, Public Buildings, or Private Residences."[1] His architectural photographs are often in a circular format. The early photographic lenses took in a very narrow field of view, creating a problem in tight quarters such as inside a room or on a narrow city street, where the photographer could not move his camera as far back as needed to get the whole subject into the picture. To counter this (as much as it was possible), Hawes simply used an oversize negative that recorded the whole circular cone of the image projected by the lens. It is a credit to his artistic eye that he could compose a rectangular subject such as a building and make it seem natural in a circular picture. Today 450 of Hawes's architectural negatives still survive, and prints from this collection are found in many Boston libraries and museums.

Unlike Hawes, some of the larger photographic firms worked on speculation. In 1867 the Peck Brothers of New Haven advertised,

The largest Photograph Establishment in the State.... We have made, and have for Sale, the largest collection of VIEWS OF PUBLIC BUILD-INGS, And Places of Interest in this City, Both STEREOSCOPIC, CARD, and LARGE SIZE for framing.[2]

Architectural photography of the 1850s through 1870s was usually done in cities, except by those photographers with large portable darkrooms capable of handling 8 × 10 inch or larger negatives. City photographers, when ready to photograph a building, could simply send an assistant off to the studio to bring back a newly coated negative, then, after the exposure, have him rush to the studio darkroom to develop it before the wet plate dried.

Union Club, Park Street, Boston. *James Wallace Black, June 17, 1875. Carbon print, 6 × 8 inches. Taken during the celebration of the one hundredth anniversary of the Battle of Bunker Hill. Courtesy of the Boston Public Library, Print Department.*

These early photographs can be recognized by the way people are represented in the scene. If the picture was taken during the day, pedestrians or vehicles passing during the necessarily long exposure of the wet-plate negative often appear as horizontal streaks in the print. If the photographer worked at dawn before any people were about, the scene often has a desolate look. Views also were taken with people posing:

> A splendid photograph of the Allyn House [Hartford] has been taken by Prescott and White and a number of them will be printed and framed to hang in other first class hotels. The photograph is very large sized, beautifully finished and perfectly natural. The proprietor, and Mr. Lord, his gentlemanly and accomplished clerk, are "took" on the balcony, also a number of the guests of the hotel. . . . These pictures are handsome enough to adorn anybody's office.[3]

John A. Whipple deserves recognition for producing the largest architectural view

Panorama of Boston. *Photographer unknown, ca. 1858. Albumen prints from wet-plate negatives. Total of five prints taken from the dome of the Boston State House, each approximately 9¾ × 14 inches. Left to right: downtown, Common and Public Garden, Back Bay (now filled in), Beacon Street, Charles River. The Boston Athenaeum.*

in New England: a print made from a five-foot-wide, three-foot-high negative of Jeffries' Building, on Beacon Street in Boston, in 1865.

In an extension of architectural work, many photographers tried their hand at city panoramas. Typically, these consisted of a number of individual photographs made from the same point in different directions. The prints, usually from two to four in number, were then mounted side by side to give a continuous panorama. One of the earliest in New England was taken in the late 1850s from the dome of the State House in Boston. The unknown photographer took a series of five negatives of the city to produce a continuous 270-degree sweep of the skyline, from due west to due north. In all, the final image measures about 10 inches high by 70 inches wide.

By the 1880s, the idea of "aerial panoramas" had become so popular that a number of photographers specialized in such work. The best of them was the Alden Photo and View Co., 63 Court Street, Boston, who advertised their proficiency in "high views," and climbed many a church steeple and factory chimney all over New England.

One specific type of architectural study was the depiction of colonial homes and churches, a subject that has always had a particular place in New England. From earliest days, cameras were focused on the region's old homesteads. The first book published in America with a tipped-in photograph, *Homes of American Statesmen* (1854), illustrated the John Hancock mansion on Boston's Beacon Hill (see chapter 3). One of New England's earliest books with mechanically reproduced photographs, Samuel Adams Drake's *Historic Fields and Mansions of Middlesex* (1873), contained twenty heliotypes of historic Massachusetts homes (see chapter 6). Throughout the nineteenth and twentieth centuries, photographers have faithfully recorded the region's old houses, churches, and meeting halls.

The number of photographers of colonial architecture increased in the 1880s with the availability of the dry-plate negative and with the impetus of the centennial

Below: South-West from the Top of the Chimney of the Lincoln Wharf Power Station. Nov. 26, 1900. *Photographer unknown. Boston. Paper print,* 10 × 13½ *inches. The camera looks down on* Boston's North End (right) and the intersection of Commercial Street and Atlantic Avenue. Courtesy of the Boston Public Library, Print Department.

celebration of the United States. Wilfred A. French of Boston, an active member of the Boston Camera Club, was one of the leading practitioners at that time. Wrote one admirer,

> The value of this kind of work which Mr. French has done in these photographs is practically without price for the future historian. No pen picture, however eloquently drawn, can ever equal a photograph for accuracy and detail of statement. Its general adoption throughout the country would revolutionize historical methods and lead the way to a better preservation of historical data for the future.[4]

French was one of the founding members of the National Historic Picture Guild, which by 1905 had five hundred members. The guild was a loosely knit group of amateurs and professionals who became members by simply forwarding their names along with identified photographs of architectural landmarks in their area to the guild officers. The photographs in turn were sent on to the Smithsonian Institution for deposit there.

By the turn of the century, many accomplished architectural photographers were recording New England's pre-Revolutionary legacy for various publications. Frank Cousins (1851–1925) published books depicting the houses and doorways of Salem,

Massachusetts, around 1910. Albert G. Robinson toured New England ten years later, also to document doorways and homes. This dual subject study was to characterize the region's colonial heritage genre.

In 1915 there began a serial publication which was to become the most extensive documentation of such architecture. Eventually titled "The Monograph Series Recording the Architecture of the American Colonies and the Early Republic," its first and more familiar name was "The White Pine Series of Architectural Monographs." Published bimonthly from 1915 to 1940, first in St. Paul and later in New York, the work aimed to "present classified illustrations of wood construction, critically described by representative American architects, of the most beautiful and suggestive examples of architecture, old and new, which this country has produced." Though encompassing the whole country, many of its studies were devoted to towns and regions of New England. Much of the New England photography was done by Kenneth Clark.

Unlike photography of New England's architectural landmarks, which still enjoys a great following, another type of photography had only a short-lived prominence: rural home portraiture. With the arrival of the portable, storable, dry-plate negative in the early 1880s, photographers struck out into the New England countryside to capitalize on this now profitable field. Like salesmen can-

E. Birge Home, Fox District, Westfield, Mass. *John L. Baume, for the Homestead View Co., ca. 1885–1890. Paper print, 6⅝ × 8½ inches. A typical rural "home portrait": the husband, wife, farmhand, and prized animal, all photographed in front of the farmhouse. This style of photography enjoyed only a short lifetime, made possible by the invention of storable negatives and outmoded by the common roll-film camera. Notations on the back of this print indicate that Baume made three attempts to deliver it and collect his money before abandoning the effort. Clark Collection, Connecticut State Library Pictorial Archives, Hartford.*

vassing their territory, photographers for such firms as the Northern Survey Co. (Albany), Homestead View Co. (Springfield), or Manhattan View Co. (which operated out of various hotels), traveled an assigned route with camera, film, and contracts and knocked on every front door, offering to make a fully framed portrait of one's own "home sweet home" to hang in the parlor. In the farming regions, these pictures show the whole family assembled before the homestead with prized possessions: oxen, a matched pair of horses, a snappy buggy. The figures sit in parlor chairs brought outside for the occasion, the men often with Sunday coats thrown hurriedly over their farm overalls. One almost always sees the front of the house, and the images' angle of elevation suggests they were taken from atop the photographer's wagon drawn up before the house.

In the villages and mill towns the pictures usually do not include men or school-age children. One sees only the wife seated on the front steps, smiling and perhaps telling her toddler to hold still while the nice man takes the picture. One wonders

how many domestic quarrels arose over the wife's announcement of her purchase to the husband returning from a day's work.

Though these rural house pictures are all virtually identical except for the individual subject, they do provide a rich cross section of the appearance of the New England countryside before the turn of the century. This type of traveling photography business soon died out with the arrival of the Kodak and other inexpensive easy-to-use cameras in the early twentieth century.

In addition to the rural home photographers, the 1880s and 1890s saw a number of quite gifted regional photographers who took pictures of people at work, interesting characters, and whatever sights might be salable as photographic prints. Among the best of these were the Howes Brothers, Alvah and George, of Ashfield, Massachusetts, who documented western Massachusetts and parts of Connecticut, especially street tradesmen and agricultural work; and Henry S. Wyer, who, from 1895 to 1914, published a number of books illustrating the sights and characters of his native Nantucket. Writer-photographer Clifton Johnson (1865–1940) of Springfield did the same for central New England.

Other accomplished "wanderers with a camera" were Porter Thayer of Vermont and Baldwin Coolidge (1845–1928) of Boston. Coolidge learned photography as an assistant to another Boston photographer before he set up his own studio in the 1890s. By the early 1900s he gained a great portion of his income from selling photographic reproductions of the works of art in Boston's Museum of Fine Arts. In

Waterspout. Vineyard Sound. *"Lon. 70° 25′ Lat. 41° 31′. From 12:45 to 1:25 P.M. Wednesday, Aug. 19, 1896."* Baldwin Coolidge (of Boston). Paper print, 7½ × 9½ inches. Coolidge, a pro- *fessional photographer, was probably on a busman's holiday when he photographed this waterspout off the island of Martha's Vineyard. Courtesy of the Boston Public Library, Print Department.*

addition to this trade, he produced souvenir portfolios of Boston historical landmarks, the White Mountains, and a singular collection of six images of a waterspout seen off Martha's Vineyard in 1896.

Photographers always rushed to the scene of interesting events, for one could always find purchasers for photographic prints of them. In 1865 John A. Whipple photographed the National Congregational Church Council meeting at Plymouth. He massed the group around Plymouth Rock and took a negative about 15 × 19 inches in size and so sharp that one can distinguish the faces of the more than one thousand people in the print. Other profitable subjects were Fourth of July celebrations, balloon ascensions, and firemen's musters. One such picture, advertised in an 1879 sportsmen's magazine, depicted the Barnes Hose Company, an eighteen-man firefighting team from Burlington, Vermont, decked out in the awards given in 1878 for winning the national running team prize in Chicago. The advertisement for the photograph, made by L. G. Burnham of Burlington, claimed it "will make one of the finest pictures for a Hose, Engine, Hook and Ladder Co.'s room, a Bar or Saloon or Clubroom." [5]

A real money-maker for the photographer was disaster work. By the late nine-

teenth century, uneven technological progress had created great cities with virtually no way to combat fires, bridges that periodically collapsed from poor design, railroad trains that could attain impressive speeds but could not be relied on to stay on the tracks, mill towns that harnessed their waterpower by building dams that often gave way. All this was possible profit for the enterprising photographer, as, before the days of pictorial newspapers and halftone reproductions, only a photograph could best satisfy public curiosity.

In New England large city fires — 1870 and 1882 in Haverhill, Massachusetts, 1872 in Boston, 1886 in Portland, and 1887 in Concord, New Hampshire — were the most lucrative prospects; that is, if the photographer's studio was not consumed in the blaze. The Boston and Portland fires resulted in the most dramatic photographs. John P. Soule of Boston made quite interesting stereo views of both. His Boston studio missed going up in the Great Boston Fire of November 9 and 10, 1872, by half a block. His photographs of the still smoldering ruins, which were once Boston's downtown, are fascinating in their combination of the jagged rubble of buildings and soft mistiness of the smoke. Of all the Boston fire photographs, however, those of James Wallace Black are the most impressive (page 120). He treated the "burnt region" as one would the ruins of some ancient castle and went in search of the artistic and picturesque, as opposed to the many who simply documented the fire's destruction. Black not only recorded the burnt-out area as a whole, but also the peculiarities created by the buildings' collapse: an enclosed stairwell, all that remained of one building, its upper-story door still intact; or a street-level facade whose arched window frames now resembled the ruins of a Roman aqueduct. In all, Black produced a series of forty-four views of the "Ruins of the Great Fire in Boston. November 1872."

Other well-documented disasters included the Wallingford, Connecticut, tornado of August 9, 1878; the Mill Creek flood in central Massachusetts, May 16, 1874; and the Blizzard of 1888 (photographed by virtually every city studio photographer in the northeast).

With the introduction of the halftone, disaster photography became the realm of the professional newspaper cameraman, yet even then local photographers who dared to be on the scene could be assured of selling prints for newspaper publication.

Photographing prized possessions continued to provide monetary remuneration for the photographer willing to travel. The wealthy had their estates photographed, railway companies commissioned pictures of their new locomotives, and gentlemen farmers wanted pictures of their blue-ribbon animals. This latter subject was harder to photograph than it sounds. The owner often wanted a picture of his horse or bull with its head raised, a position not usually assumed by an animal at ease. One photographer made his fortune by setting up his camera in the field, then having

an assistant stand in front of the animal just outside camera range. At the photographer's signal the assistant opened a large umbrella, the startled animal raised its head, and the photographer tripped the shutter before the animal either lost interest and returned to grazing, or, panicked, bolted or charged the assistant.

At a more genteel end of the spectrum lay the photography of yachting, the turn-of-the-century sport of New England's rich. Before the introduction of the dry plate, few action photographs of ships moving under sail were taken because of the bulky equipment needed aboard the photographer's boat and the long exposure required for the wet-plate negative. The dry plate made it possible for the photographer to hold the camera in his hand, aim, and catch the yacht as it sailed past. This was what the yacht owners wanted; not bland pictures of their expensive playthings tied up at dock, but under full sail — clean lined, white sails billowing, evoking a feeling of feminine beauty and greyhound speed.

The best photographers in the yachting trade were Frank H. Child of Newport; Willard B. Jackson of Marblehead; Edwin Hale Lincoln, Nathaniel L. Stebbins, and Henry G. Peabody, all of Boston. Stebbins photographed much of the Boston waterfront, as well as the incredible variety of ships passing through its harbor. His daughter wrote of seeing her father in action, "his rather small, spry figure balancing by the rail in the heaving bow of the boat, while he lifted the great camera to get his shot. Of course we held our breaths, for he couldn't swim a stroke." [6] Stebbins published a number of books containing his ship photographs as well as an innovative photographic guide to all the landmarks — lighthouses, buoys, headlands, rocks — listed in the coastal pilot books of the Atlantic and Gulf Coast.

The best yachting photographer was Henry G. Peabody (1855–1951). His ship pictures have more of a feeling of dynamism, motion, and sensuousness than those of his competitors. Not solely a yachting photographer, Peabody (Dartmouth, class of 1876) also did landscape and architectural work while a professional photographer in Boston from 1886 to 1900. He was also the official photographer for the Boston and Maine Railroad during part of that time. He later joined William H. Jackson of Western renown to become a roving photographer for the Detroit Publishing Company, printers of postcards and halftone picture books. Peabody achieved his greatest fame for his outdoor nature work in the early years of the twentieth century. Interestingly enough, Edwin Hale Lincoln also turned nature photographer, moving to the Berkshires to produce some quite beautiful wildflower studies (see chapter 11).

While most commercial photographers in urban areas had, by the turn of the century, begun to specialize in depicting subjects such as home interiors, building exteriors, yachts, "high views," and so forth, their rural counterparts still kept up

the old tradition of taking on any profitable commission. The account book of an unidentified photographer working in the Contoocook, New Hampshire, area, lists among the various subjects photographed during 1909 the following:

Howard Taylor's Colt . . . Albert Corliss' Little Boy . . . A.G. Symond's Hen Coop . . . J.A. Jones' Dog "Will" . . . Actors in "Comrades" . . . Bert Blanchard's Baby . . . G.A.R. Parade . . . Chas. Hunt on Horseback . . . A. Burgess in Costume . . . Gardner Green's Team . . . Glanville House

Execution Chamber, Wethersfield, Connecticut, State Prison. *Photographer unknown. From an album of professional photographs of the prison, ca. 1900. Paper print, 7¾ × 9¾ inches. Connecticut Historical Society.*

The Bicycle Messengers. Charles H. Currier. Probably Boston area, ca. 1889–1909. Modern print from original 8 × 10 glass negative. Library of Congress.

. . . Golf Club Souvenir . . . Local Circus . . . Mrs. J.S. Kimball's Parlor . . . Flowers at R.R. Station . . . Silk Mill Building . . . New Ell at Perkins Place.[7]

The charge for such photographic work and a few prints averaged about $1.50 per commission.

Of all New England's commercial photographers, the most gifted was Charles H. Currier (1851–1938) of Boston. His pictures cover the whole range of commercial photography: homes, businesses, people at work, as well as somewhat tongue-in-cheek posed scenes taken apparently for his own enjoyment. Currier began to photograph as a hobby while running a jewelry store, before turning professional in 1889. He brought a jeweler's precision to his new craft, and his photographs sparkle with luminous highlights and detailed shadows. Yet it is not the technical side of his pictures that catches the eye; rather, it is the unassuming immediacy of his straightforward record. It strikes the eye as do the bare interiors and stark architectural views of a later photographer, Walker Evans. Currier's photographs transcend mere representation and stand as entities independent of

their three-dimensional originals, yet they were all made within the contemporary conventions of commercial photography.

In addition to his architectural and business photographs, Currier made photographs while on vacation in Maine. These reflect a technique similar to his commercial work but have the added spice of a little wry humor. Currier had a knack of posing his sitters in such conventional, stiffened attitudes that they became parodies of the photography of the day.

Little biographical information is known about Currier besides his life span, his marriage in 1875, his one child born in 1882, and his retirement in 1909. In his day, he was not a figure to be written about, as was his brother, famed landscape painter Joseph Frank Currier (1843–1909). He was simply one of a multitude of professional photographers who worked in their chosen field producing images which are only today recognized as artistic achievements.

Hunters and Their "Patented Portable Hunters Cabin." *Charles H. Currier. Probably Maine coast, ca. 1900. Modern print from original 8 × 10 glass negative. Prefabricated cottages and cabins, which could be freighted to any site and assembled with screwdriver and wrench, were quite the rage around the turn of the century. Currier summered with* his family at Little Deer Island, Maine, and this *is probably the locale of this picture. Currier may have taken it at the request of the gentlemen shown here or with an eye toward selling a print to the cabin's manufacturer for advertising purposes. Library of Congress.*

9 "A picture that will live"

Blacksmith Shop. *Chansonetta Stanley Emmons, Kingfield, Maine, 1902. Paper print, 5 × 7 inches. Collection of and copyright © 1977 Marius B. Péladeau and Samuel Pennington.*

*I*n addition to the commercial photographers of the nineteenth and early twentieth centuries was the ever-growing band of amateur and professional photographers who began using the camera for their own artistic pleasure. At first they were few in number. Before the advent of ready-to-use dry-plate negatives in the early 1880s (see chapter 7), unless one was a professional with all the cameras and darkroom equipment, the pastime required a sizable financial outlay. Also needed were a strong back to carry the equipment outdoors, the patience and dexterity to coat the wet-plate negatives before each exposure, and a thick skin to wifely complaints about the appearance of photographic chemical stains throughout the house.

Despite these considerable requirements, Oliver Wendell Holmes in 1863 commented on the growing number of amateurs in the Boston area. "Some of the friends in our immediate neighborhood have sent photographs of their own making which for clearness and purity of tone compare favorably with the best professional work." [1]

One amateur of the old wet-plate days was Hartford merchant Thomas Sedgwick Steele (1845–1903). A precursor of the modern-day shutterbug, Steele would drag out his camera at the drop of a hat, or, more likely, already had it set up and hidden to catch the hat falling. His dedication to the craft in the face of all social conventions apparently left his friends no choice but to suffer his good-humored photographic exploits.

Steele took a number of canoeing expeditions into the great north woods of Maine in the 1870s and 1880s, carrying with him camera, tripod, fifty plates of 5 × 8 inch glass for negatives, portable darkroom, and a complex array of bottled chemicals for coating and developing the negatives in the wild. By the early 1880s, his photographic paraphernalia for his canoe trips consisted of seventy-five glass dry plates and a Tourograph camera, which the upstate Mainers mistook for a newfangled patent coffee grinder. The Tourograph camera, manufactured by the Blair Camera Company (originally of Chicago, then ca. 1883 in Boston, then

finally Rochester, New York) was one of the first cameras designed for amateur dry-plate work. Weighing less than ten pounds and costing $27.50, it was designed so that nine negatives could be carried within it and successively exposed before the need for reloading.

Another early amateur-oriented camera kit was the Scovill "$10. Outfit": a dry-plate bellows camera, lens, and tripod. Introduced in 1881, it did not really become popular until 1883, when photo manufacturing companies began producing a trustworthy dry-plate negative.

The Scovill Company of Waterbury had been supplying photo materials since the early 1840s, when it began making daguerreotype plates (see chapter 1). Over the years it expanded, making brass fittings and metal lens barrels for wooden cameras, then subcontracting for the cameras and lenses themselves. It also bought up many daguerreotype case factories, and by the early 1880s was one of the world's largest photographic supply houses, gaining great esteem for the quality of its Waterbury View Camera and Waterbury Lens (based on the best lens design of the day).

With the introduction of its $10 Outfit, Scovill invested money and effort in selling the idea of amateur photography to the public. The firm advertised heavily in popular magazines, especially those directed toward teenagers and college-age

Detective Shot of the Great Snow Storm, Main St., Springfield, Mass., March 12 and 13, 1888. *A. V. Brown. Paper print, 3 × 4 inches. Brown, a professional studio photographer, made good use of the new, amateur, "detective" hand-held camera to wander through the drifts of the Great Blizzard of '88, taking photographs unobtainable with the tripoded professional cameras. Courtesy Springfield City Library.*

readers. It initiated *The Photographic Times* magazine and issued a series of seventy-odd publications for the amateur photographer, some with mounted photographs taken by well-known photographers, like Ben Kilburn, with the $10 Outfit. While deserving much credit for making the camera a familiar item in the American home, Scovill's photo division underwent so many mergers and name changes (from Anthony and Scovill to Ansco, then Agfa Ansco, and finally the now-defunct GAF Photo Division) that there exists no corporation to protest Kodak's claim that the Brownie camera of 1888, and not the $10 Outfit and Scovill's advertising blitz of the early 1880s, began amateur photography.

Unfortunately, the amateur photographers who made any sort of contribution to photography in the 1880s and 1890s were few and far between. Though unrestrained by the professional photographer's commercial demands, the first amateurs delved little into artistic or experimental work. For the most part they simply reflected the Victorian sentimentality of the day, taking leisurely Sunday jaunts that combined photography of the countryside with reading tombstones in old graveyards. The tone of early amateur photography was summed up by Washington Irving Lincoln Adams, photo magazine editor for Scovill, in speaking

Near Williamstown. *Photographer unknown. From an amateur's album of platinum prints, ca. 1890, 4½ × 6½ inches. For the last decades of the nineteenth century, the amateur camera and the bicycle had an almost symbiotic relationship, each flourishing through the existence of the other. Bicyclists found the camera an enjoyable appendage to their travels, and photographers found the bicycle an excellent mode of travel for seeking out new subjects. Historical Room, Stockbridge Library, Stockbridge, Mass.*

of vacation photography at his Littleton, New Hampshire, farm at the turn of the century:

> Pictures abound at the very door of a New England farm. Indeed, even the familiar domestic scenes around the farmhouse itself, and the barn-yard too, are most successful in photographs. Here are groups of merry children to be taken, frolicking with their patient donkey or playing about the barn as little farmers; the sunny barn-yard with favorite cattle or horses prominent in the foreground unconsciously assuming the picturesque groups which they always so naturally seem to form; and simple fence corners, overgrown with a tangled mass of hop-vine, woodbine and clematis in the generous provision of nature.[2]

In time, there appeared cameras of all shapes and sizes to meet the whims of amateurs. Bowler hats, canes, pistols, cravats, watches — all were made to conceal cameras. The most popular model was the hand-held, shoebox-size "detective camera," so called from its comparative unobtrusiveness in relation to a view camera with tripod.

The amateur photographer also made use of another invention of the late nineteenth century, the bicycle. It was just the thing for touring the countryside in search of old houses and rural characters to photograph.

> The camera fiend, as he is called even today, has peculiar responsibilities awheel. He must never forget that in the eyes of nearly every picturesque subject he meets on the road, he is doubly damned, — first for riding "one of them things," and second for carrying "one of them things," [3]

wrote one adviser in 1898 — suggesting that to cavalierly photograph a rural character unawares and then make a laughing escape on wheels might set the scene for a violent encounter involving the next photographer who pedaled by.

Many of these amateurs formed local clubs, and by 1890 every modest-sized New England city had a photo society that met in private homes or at a rented clubroom. While most were local organizations, a few of the larger clubs, most notably the Boston organization, won national prominence. Created out of a number of Boston clubs that formed in 1881 and later combined to become the Boston Camera Club, it was one of the nation's earliest photography clubs and still exists today as the oldest surviving organization of its type. By the 1890s it was holding exhibitions with the New York and Philadelphia clubs and had established rooms on the top floor of 50 Bromfield Street. The clubrooms included a 20 × 35 foot exhibition/meeting room, a 25 × 25 foot studio with skylights, and three large darkrooms, one containing ten individually equipped darkroom stalls. The club was a quite dignified organization, and the hanging in its 1885 exhibition of male nude photographs elicited the complaint that they were "better fitted for a private view by members than for a public exhibition." [4]

The Boston club numbered among its members some accomplished amateurs, the best of whom was probably Horace A. Latimer (d. 1931). Upon his death, Latimer willed his property to be split between the Boston and Portland clubs. The Portland club apparently spent its $15,000 bequest quickly and later disbanded for lack of funds. The Boston club invested the bequest and is still in existence today thanks to the annual interest from Latimer's money. Other early Boston club members included F. Holland Day (see chapter 10); William S. Briggs, Boston merchant and amateur of the 1890s, whose forte was White Mountain landscapes and Boston streets and people; and Wilfred A. French, one of the club's founders and best known for his photography of colonial homesteads (see chapter 8).

In their earliest days, most photographic clubs were all-male enclaves; not one "Mrs." appeared on club rosters until the late 1880s, and the first "Miss" came ten years after that. It was not only masculine clubbiness that caused this; it was

also the messiness of the early photographic process. The classic artistic instruction book for ladies of the latter half of the nineteenth century, Madame L. L. Urbino's *Art Recreations* (first published Boston, 1859), in early editions included only instructions on tinting daguerreotypes and photographic prints. By 1884 the editor saw things differently.

> Recent improvements in photography have made possible the production of the highest-class pictures, through the medium of an equipment, which any one should be able to manipulate, and yet so light in weight as not to be burdensome. The apparatus is graceful in appearance, and many of the fair sex have become expert in its use.[5]

One of these recent improvements was Scovill Company's introduction of a camera taking 4 × 5 inch negatives, with attached tripod, the whole weighing 3¾ pounds, easily carried in "a hand satchel or velvet bag. The latter especially might be made very handsome, and at the same time so as to be used for a focusing cloth." [6] Scovill realized the enormous market potential of women amateurs, predicting, "Here, as well as abroad, amateur photography is destined to be taken up by ladies of refinement and quick artistic perception." [7]

New England's most gifted woman photographer of the era was Chansonetta Stanley Emmons (1858–1937). Born Chansonetta Stanley in the remote town of Kingfield, Maine, she grew up in the rural New England setting she was later to re-create photographically. She was the one girl in a family of six children, which included the inventive twins later famous for their Stanley Steamer automobile.

By the time of her marriage to James Emmons from the Boston area in 1887 Chansonetta had become an accomplished self-taught painter of miniatures and, through her twin brothers' entry into the manufacture of dry-plate negatives, had picked up a bit of photographic ability as well. In 1898 James Emmons died, leaving Chansonetta and her daughter Dorothy in a somewhat precarious financial state, but knowing that her twin brothers, now millionaires, would not let her starve.

It was about this time that she began to demonstrate photographic ability. She studied under painter William Preston Phelps in New Hampshire and began returning for the summers to her hometown in Maine, a hamlet of 800-odd souls. Her work very much followed the mainstream of amateur photography of the day. Her photographs contain the most hackneyed of rural genre scenes: children in the barnyard, the local miller at work, the blacksmith (pages 138–139), the aged patriarch, grandmother at the spinning wheel. Her lighting techniques include the overused Rembrandt effect of the uninspired studio photographer: bright light streaming over the shoulder, leaving the face relatively dark. Yet where others produced only banal repetition of trite images, Chansonetta Emmons used the medium to achieve striking immediacy. Her subjects are so stylized, so rigidly posed for the effects desired, that in the photographic print they seem just the opposite. They become seemingly fleeting images of a now vanished way of life, a romantic, golden age that progress at the turn of the century was slowly destroying.

Until her death in 1937, Chansonetta Emmons spent summers in Kingfield or, when financially possible, in other locales, painting and photographing with daughter Dorothy, her constant companion. Her work was her passion, and she made little profit from the sale of prints at salons and exhibitions. Throughout the twentieth century, her work remained, for the most part, quite standardized: arresting, carefully composed photographs of rural life, contact printed from negatives taken with a 5×7 inch view camera.

It was this obvious sentimentality that temporarily kept Emmons's work in obscurity. Photographic theories and artistic manifestos of the twentieth century vigorously deplored the ideals of the early amateurs and their rural genre. The

Farmer's Boy. *Chansonetta Stanley Emmons. Dublin, N.H., ca. 1900. Her data reads: "August, morning, Century 5″ × 7″ [camera], lens wide open; 1/5 sec.; plate, Eastman M.Q.; special Velvet Velox [printing paper]." Reproduced in the February 1920 issue of* Photo-Era *magazine, it was probably the only Emmons image to appear in print during her lifetime. Collection of and copyright © 1977 Marius B. Péladeau and Samuel Pennington.*

photographic merit of her work was discredited because of her sentimental subject matter, despite the vibrancy and immediacy of her scenes.

Other notable New England amateurs active during the 1890s and early 1900s include: C. W. Dearborn, J. R. Peterson, F. H. Thompson, and O. P. T. Wish, all of the Portland Camera Club; Sarah J. Eddy, Providence; Charles W. Hearn, Boston, president of the Photographers' Association of New England, ca. 1901; George A. Nelson, Lowell, acclaimed in *New England Magazine* as the best New England amateur of the 1890s;[8] Eva Newell, Southington, Connecticut (see Checklist of Photographers); and George E. Tingley, Mystic, a studio photographer best known for his landscapes (see below and bibliography). Almost all of them had their work reproduced in the national photographic magazines of the day. A number of these magazines originated in New England:

American Annual of Photography, begun in 1887 and published by Scovill in New York and Boston. It contained technical reference material as well as instructive and aesthetics-oriented articles.

American Amateur Photographer, Brunswick, Maine, edited by W. H. Burbank. Begun in 1889, it was published until 1907, when it was combined with Photo-Beacon of Chicago to form

American Photography, 1907–1953 (when it became Popular Photography). From 1907 to 1945, American Photography was published in Boston by the American Photographic Publishing Company, under the editorship of Frank Roy Fraprie. During most of this period, the publisher's offices were downstairs from the Boston Camera Club's rooms, then

Summer Days. *William B. Post. Fryeburg, Maine, 1895. Gravure from* The Photographic Times, *July 1895, 4⅝ × 6⅞ inches. Post, a well-known amateur of his day, shows not only the typical subject matter of the amateur, but also the beginnings of the influence of English photographers and writers,* who championed the idea of photography as pure art. This picture is a conscious imitation of Englishman Peter Henry Emerson's Gathering Water Lilies, 1886 (illustrated in Newhall, History of Photography, p. 96). Post went on to join the Photo-Secessionist movement (see chapter 10).

SUMMER DAYS

on Newbury Street. As a result, the club and publishing house had close ties; Fraprie served as club president for a long time, and the two organizations shared a common board of directors. The American Photographic Publishing Company also published a series of photo instruction books, eleven volumes in all, from 1915 to 1939 (with later editions and reprints), under the series title Practical Photography.

Photo-Era, begun in Boston in 1898 and covering both amateur photography as well as the artistic work of the Photo-Secessionists and Pictorialists. In 1932 it was absorbed into *American Photography.*

The Photographic Monthly, Providence, 1901–1902. A short-lived periodical, seven issues in all, published by Hall & Lyon, devoted primarily to Pictorialist work.

These periodicals, as well as others published in America and England, promoted the next step taken by the "amateur genre" photographers — the refinement of the photographers' point of view to enable them to produce images of the countryside and people with more artistic delicacy and restrained sentiment. By the late 1880s, they were publishing articles and reproducing photographs by pioneers

such as Peter Henry Emerson and Alfred Stieglitz — photographers whose images depicted the local people and rustic landscapes of the amateur, but somehow transcended these seemingly hackneyed subjects. This so-called naturalistic photography had developed in England in the 1880s and was identified with such figures as Emerson, Thomas Annan, and George Christopher Davies. In America, William James Stillman (1828–1901), printer, art critic, diplomat, journalist, and amateur photographer, had published in 1876 a small volume of poetic excerpts and gravure photographs titled *Poetic Localities of Cambridge* (page 99). This work anticipated the style of these later photographers in that Stillman had visited sites around Cambridge immortalized in prose and verse by Longfellow, Whittier, Holmes, and others, and tried to capture the sentiments expressed in the writers' words by means of the photographic image.

One New England photographer whose work received great critical acclaim was George Edward Tingley (1864–1958), a studio portrait photographer from Mystic. By the last years of the nineteenth century, his photography had achieved international attention, and one image, *The Light Beyond,* was singled out by Peter Henry Emerson as one of the best pictures to be made in 1899. The British annual of photography, *Photograms,* reproduced it that year with a commentary which sums up the aspirations of this school of photography:

> The sentiment of the scene, absolutely appropriate to the title, . . . appealing to the humblest intelligence, yet with no rough touch to jar the most delicate sensibility, carries conviction at once. It has the charm of the best "moaning eventide" work, plus a note of optimism or faith; and may fairly be described as one of the pictures of which very few are produced in any one year — a picture that will live.[9]

Tingley continued photographing in this style well into the early decades of the twentieth century. He also made a great number of dramatically lit portrait studies of local personalities and rustic tradesmen, as well as less dramatic but more revealing portraits taken before standard studio backdrops in stock contemporary poses.

Another photographer in this style was Arthur Scott, who photographed the fields and lanes of the Berkshires.[10] Before long, however, naturalistic photography was superseded by soft-focus Pictorialism (see chapter 10) and by sharply focused "straight" photography (see chapter 14). While photographers like Tingley and Emmons carried on the genre and naturalistic traditions of the nineteenth century, other twentieth-century photographers followed these changes in photographic aesthetics toward more "artistic" photography, of which genre photography was only the way station.

The Light Beyond. *George Edward Tingley.*
Mystic, Conn., 1899. Paper print, 4⅜ × 6¼
inches. Courtesy Elsie S. Barstow, Mystic, Conn.

"A shimmering Xanadu"

Japanese Landscape. *Fred Holland Day. Five Islands, Maine, ca.*
1910. Gravure from a platinum print, 3⅞ × 4½ inches. From
A. J. Anderson's The Artistic Side of Photography, *1911.*

PHOTO-SECESSIONISTS AND PICTORIALISTS

1890s–1930s

*I*n 1898, the year Chansonetta Emmons mourned her husband's death and took up serious camera work, photography of a much different sort was taking place not more than a dozen miles from the Emmonses' Newton home. On a hilltop in fashionable Norwood, Massachusetts, Fred Holland Day (1864–1933) photographically reenacted the crucifixion of Christ. Women in flowing gowns and men in Roman helmets and loincloths stood posed in positions directed by Day, himself "nailed" to the cross. Day ultimately produced about 120 prints of various stages of the crucifixion, from scenes of costumed friends and hired actors below the cross, to head portraits of himself depicting "the seven last words" — in all, a collection fascinating not only for its religious piety, but also for strange sensuality. Here was a different sort of photography from the amateur's Sunday jaunts into the woods and fields. Day produced the epitome of what was called artistic or pictorial photography, a deliberate attempt to make the photographic print meet the fine art tastes of the day.

At this time, the late 1890s, the "camera club annual show" was becoming known as an "exhibition of the photographic salon." Amateurs with artistic intent objected to having their prints hung in exhibitions on an equal footing with more mundane classifications such as machinery, interiors, instantaneous, scientific, or stereoscopic. These Pictorialists believed that artistic photography degraded itself by appearing side by side with such literal uses of the camera.

They saw the development of photography up to that time as solely a pursuit to improve the technical aspects of the craft, with "optician's sharpness" and "chemists' purity of print quality" taking precedence over artistic considerations.[1] In reaction, they embraced the work of early paper talbotype/calotype photographers like David Octavius Hill (1802–1870) and Robert Adamson (1821–1848). These Scotsmen used the paper-negative process, producing soft-edged, diffuse images with blotchy bright areas and deep, warm, dark areas. This effect, rejected in the 1840s for the sharp, precise daguerreotype, was imitated by artistic photographers at the turn of the century through the use of a number of intricate photo-

graphic and photomechanical processes such as the gum bichromate print (see below) and photogravure.

Stylistically, these photographers took their inspiration from Japanese woodblock prints and from the graceful curves and impressionistic lack of detail in the works of such painters as James A. McNeill Whistler. They trained their lenses not on wide, deep panoramas but on confined areas. They would arrange a pleasing composition using perhaps only the ground, a posed figure, and a portion of an interestingly shaped tree or rock, with the myriad details of the natural world deliberately subdued by extensive retouching, blurred focusing, or other manipulation in the developing and printing. In some cases, as in the work of Day, this impressionistic effect was often achieved not with the aid of darkroom tricks but through methods of focusing, lighting, and composition.

Day's best photographic work, which greatly influenced his contemporaries, was done from about 1896 until 1901. Afterward, although he continued photographing, his enthusiasm gradually turned toward other interests. The pampered only child of an extremely wealthy leather merchant, Day possessed a single-minded dedication to the arts, but it did not keep him from being very much the dilettante. He grew up to become part of a group of primarily affluent "Boston bohemians," who modeled themselves after such "decadents" as Oscar Wilde, Stéphane Mallarmé, Aubrey Beardsley, and Whistler. They shocked proper Boston society with their Pre-Raphaelite attire, incense, medieval pageants, and with the belief that life at its fullest should be an imitation of art. It was to this end that Day devoted much of his time, efforts, and substantial fortune. In doing so he soon became the center of this circle, which included such notables as poets Amy Lowell and Louise Imogen Guiney, art critic Bernard Berenson, and other literary lights.

Day's first passion was the poet John Keats. In 1885 he began actively searching out Keats material, eventually assembling one of the era's greatest collections of Keats artifacts and writings. But, true to form, he suddenly lost interest in Keats and turned to the establishment of a fine-press book publishing house in partnership with editor Herbert Copeland. The firm of Copeland and Day lasted from 1893 to 1899, when Day turned his full attention to photography.

Day first began using a camera around 1890 to photograph locales associated with Keats and to take portraits of friends. By 1895 he had gained an international reputation and in that year received the high honor of being elected to the prestigious London photographic group, The Linked Ring (Alfred Stieglitz and Rudolf Eickemeyer, Jr., were then the only other American members).

In the years following 1895, Day's photographic images quickly developed a distinctive style. They usually showed subjects posed in an outdoor setting —

women in diaphanous gowns, men naked save for romantic accessories such as panpipes, spears, or headdresses. One wonders what the thoughts of Day's middle-aged black chauffeur-butler were as he sat enthroned before Day's camera as "Menelek, the African Chieftain," naked except for spears, jeweled headband, and small pectoral draped over the navel. In addition to this work, Day also made portraits of friends in which he attempted to capture their faces in intense expressions, or enraptured in secret self-abandonment.

While nude boys in stylized Grecian poses must have startled the proper Bostonians, Day's next project, the crucifixion work, was even more outrageous. Day very likely received his inspiration for this photographic study from images of the Passion play staged about every tenth year in Oberammergau in southern Germany. The Soule Photographic Company of Boston then had for sale a series of thirty-six photographs of Oberammergau's 1890 reenactment of the crucifixion.

Day let his hair grow long, and fasted so as to appear an emaciated Christ. He chose for a site a low hill in his childhood town of Norwood which gave a view devoid of stone fences, barns, and other typical New England structures. There he brought wagon loads of paraphernalia, crosses, materials for a sepulcher, costumes designed with an eye to historical accuracy, and his players. Beginning July

Fred Holland Day. *Alvin Langdon Coburn, 1900. Platinum print, 7⅛ × 10⅜ inches. The Royal Photographic Society of Great Britain, London.*

1, 1898, he began acting out and photographing the Passion, apparently with the local population standing by aghast.

Day did not exhibit the complete series in America first; rather, he took it to London, where it was exhibited in 1900 in a show of the "New School of American Photography" that he organized. By this time he had become the friend of Alvin Langdon Coburn (1882–1966), a distant cousin. Coburn, like Day, was from an affluent Boston family and had virtually no financial worries. He had received his first camera at age eight, and by his late teens he had mastered the current varieties of printing processes to a degree unmatched by anyone. He was well on his way to becoming a leading photographer of the era.

The two techniques then popular were the platinum print and the gum bichromate print. The platinum print resembles the modern silver print but produces a more brilliant image: the whites are shinier and the darks have a soft gray appearance. Since the paper — sensitized to light with a coating of platinum salts — deteriorated from dampness before use, the purist (and the user of it today, as it is no longer commercially available) made his own by brushing drawing paper with a series of chemical solutions. It required strong light (the sun or carbon arc) for printing and was fixed in a series of weak hydrochloric acid baths.

The gum bichromate print is very similar to the old photomechanical gelatin relief wash-off process. Here, however, coloring pigment is added to the gum arabic that takes the place of the gelatin. Again, bichromate of potassium is used, which hardens the mixture in relation to the light passing through the negative and keeps that section from being soaked off in the developing water wash. The photographer could make changes in the final print by selectively removing unwanted detail with a stream of water directed at it to further wash away gum and pigment. Likewise, areas could be darkened by selectively coating that section with the gum mixture and repeating the whole process.

Some photographers, like Coburn, preferred to combine the two processes, superimposing a gum print over a platinum print. The overlay of gum and pigment gives the image a rich darkness, while the platinum image beneath shines through in the lighter areas of the print to give brilliant highlights.

In the summer of 1899, Day, Coburn, and Coburn's ever-present mother left Boston for a grand tour of Europe. During this trip, Day organized the London exhibition mentioned earlier. In addition to Day's and Coburn's work, the show included the prints of American Pictorialists Frank Eugene, Edward Steichen (who assisted in its preparation), Gertrude Käsebier, Clarence White, and others whose names would soon become famous in photographic circles. Predictably, Day's photographs outnumbered the others', and one whole wall was devoted to his "sacred subjects." The show itself proved an immense success. Day soon returned to Boston, but Coburn found England more stimulating than puritan New England, and after a few years of globetrotting settled in the British Isles.

Back in America, Day was met with less enthusiasm for his work, being dubbed "Jesus Christ Day" by his detractors. He soon was at odds with Alfred Stieglitz, master photographer and dour bohemian. Stieglitz took his own manifestos with such religious zeal that he created two great schools of photography: one that owed its photographic principles to his teachings, and one formed by those who banded together to revolt against his polemics.

Day could not conceive of acknowledging any master, especially Stieglitz, and Stieglitz objected to Day's dilettante attitudes to the serious art of photography.

The Bridge, Ipswich. *Alvin Langdon Coburn, 1903. Gravure from a gum bichromate over platinum print, 9¼ × 7½ inches. In the spring of 1903 Coburn returned for a short time to Boston, setting up a studio at 827 Boylston Street to exhibit his work. That summer he spent time in the Ipswich, Mass., area studying Japanese art and photographing in that style. From* Camera Work, *no. 6 (April 1904).*

(Day did not even bother to print his own pictures until taught the art by Coburn.) Their feud came to a head in 1902 with the forming in New York of the Photo-Secession, a group dedicated to the promotion of Pictorialist photographic ideals. When Day realized that Stieglitz, not himself, was to be its leader, he gradually began to cool his activities in artistic photography.

While Day remained aloof from the Photo-Secession, many of his associates and pupils joined, including Coburn, White, and a number of New Englanders: Mary Devens, Boston; Charles and Jeannette Peabody, Cambridge; William B. Post, Fryeburg, Maine; F. H. Pratt, Worcester; Sarah C. Sears, Boston; George H. Seeley, Stockbridge, Massachusetts; and Elizabeth R. Tyson, Boston. (See Checklist of Photographers.)

In 1904 a fire in Day's Boston studio destroyed the great mass of his work. Rather than build on the ashes, he turned away from photography, although he did continue to photograph intermittently until 1917. In that year Day, for some unaccountable reason, decided to become an invalid. In the grand tradition of Marcel Proust he took to bed and lived there, with servants answering his every need, until his death in 1933.

Among those encouraged by Day was George H. Seeley (1880–1955). Although he later joined the Photo-Secession, Seeley evolved his own style and subject matter long before his contacts with it. His first encounter with photography came as a youth with the gift of a camera from a relative, but his real enthusiasm for the craft did not begin until 1902. Until this time he produced realistic land-

Autumn. *George Seeley. Stockbridge, Mass.,*
ca. 1909. Gravure, 6¼ × 8 inches. From
Camera Work, *no. 29 (Jan. 1910).*

scape studies of his native Stockbridge. His attitude changed in 1902 when, as a
student at the Massachusetts Normal Art School, he made a visit to Day. Day
inspired Seeley with the concept of making artistic photographs which did not
rely on literal portrayal of subjects for their effect. Seeley returned to Stockbridge
with an 8 × 10 camera and began photographing in what was to become his char-
acteristic style: soft-focus images of women (usually his sisters) posed outdoors
under dappled sunlight and shadow, or indoors against carefully arranged back-
drops. Soon Seeley was able to transform these figures posed among trees, fields,
and flowers into his own images of ethereal fairylands — magic landscapes of
ancient legends in the manner of John Keats's poetic odes.

Seeley did his own printing in the family's kitchen at night. Unlike other pho-
tographers, he did little darkroom manipulation of his gum bichromate prints to
remove unwanted detail or to reinforce the brightness of some area of the print.
When he exhibited his work at the First American Salon in New York City in
1904, the judges were so skeptical of his claim of "printing straight" that they
secretly cut the mat on one print to remove it from its frame for closer examina-
tion. This exhibition brought Seeley to Stieglitz's attention, which quickly led to
his membership in the Photo-Secession. Seeley's work changed little from this
association. He declined a number of offers to work or teach elsewhere, preferring
to remain in Stockbridge, living in the close-knit family group of his parents and
three sisters. With their encouragement and aid, free from the influence of artists
with personalities stronger than his own, he created romantic images of worlds far

beyond the bounds of everyday life. He continued his photographic work until the 1920s, when gum bichromate and platinum print materials were in short supply. Unable to obtain the proper effect with other photographic materials, he abandoned photography for painting.

Another photographer to come in contact with Day was Clarence Hudson White (1871–1955) of Newark, Ohio. White had turned to photography after thirteen years as a clerk in a grocery store. In 1898 he and Day met at the Philadelphia Photographic Salon Exhibit and became fast friends. The next year Day organized an exhibit of White's work at the Boston Camera Club. In 1904 White and his family summered in Maine for a week at Day's home at Five Islands. White fell in love with the picturesque towns and rocky coastline, and every year thereafter returned to summer in the region. By 1906 he had moved to New York City to teach photography at Columbia. In addition to his own photographic work in New England, White's other great influence in the region was his establishment of a photographic summer school in 1910 at an old hotel in Georgetown, Maine. Here and in various other locations (including East Canaan, Connecticut, in 1916) White, along with other well-known photographers such as Gertrude Käsebier and Paul Anderson, taught the principles of pictorial photography.

As a teacher, the genial, soft-spoken White could deliver the severest criticisms without insult, inspiring students to renewed effort. His course consisted of two parts: aesthetic theory delivered in the field by himself, and photographic technique taught in darkroom and classroom, usually by photo instruction book writer Paul Anderson.

One student of White's school was Ralph Steiner (b. 1899), who had done some photography as an undergraduate at Dartmouth College. He recalls that he had taken a one-student course in photography given by a professor with a penchant for having a pet crow sit on his shoulder wherever he went. Steiner used some of his undergraduate photographs in *Dartmouth,* a book published, just after his graduation, by the Albertype Printing Company of Brooklyn. Interestingly, Steiner began losing his enthusiasm for Pictorialist ideals while at White's school, and his best known work from that time onward is sharply focused. He went on to become a successful commercial and free-lance photographer in New York City. Working also with film, he collaborated with Paul Strand in the filming of *The Plow That Broke the Plains* in 1935.

Another Photo-Secession member and well-known amateur of the 1890s was William B. Post (1857–1925), a New York financier who spent his summers in Fryeburg, Maine. His images of Victorian women floating lazily with parasols in rowboats, or swinging in hammocks, appeared frequently in photo magazines of the period (see page 147). In 1901 he moved permanently to Fryeburg and began

The Inn Bus. *Ralph Steiner. Hanover, N.H., ca.*
1922. Gravure, 4³⁄₁₆ × 5¼ inches. From Steiner's
Dartmouth. *By permission of Ralph Steiner.*

Julia Ward Howe and her Daughter Laura.
Photographer unknown. Boston locale, ca. 1890.
Platinum print, 6 × 8¼ inches. Julia Ward Howe,
best known for composing "The Battle Hymn of
the Republic," was prominent in Boston's intellec-
tual circles. At the turn of the century she became
a favorite portrait subject for Photo-Secessionist
Sarah Sears. Private collection.

to work extensively with two subjects, lily-padded ponds and snow scenes. The later subject forms his best known work. He used a soft-edged, warm-toned effect to portray the delicacy of snow. The rough surface texture of the prints give the feeling of snow while the low-key mottling of light and shadow give the snow substance and shape. Post usually kept the horizon high, with the mass of snow dominating all other areas of the print by a ratio of about five to one. *Wintry Weather,* one of his best photographs, shows a somewhat ungainly line of farm buildings across the top of the image, excellently balanced by a great mass of snow and the diagonal of a plowed road.

Two Boston women elected to the Photo-Secession were Sarah C. Sears and Mary Devens. Devens (active 1898–1905) was brought to the photographic world's attention by Day, who arranged for her photographs to be exhibited in shows in 1898 and 1900. She was soon described as "the strongest woman photographer of the day," [2] renowned for her unconventional portraiture in which the finished prints sometimes resembled etchings. An eye disorder, however, cut short her photographic career.

Sarah C. Sears (1858–1935) was an affluent Boston socialite who took up photography after success as a painter in oils and watercolors. Though widely known

in the first decade of the twentieth century for her photographic portrait studies
of women and girls, she later turned away from photography to devote herself to
her first love, watercolor. In addition to her own art, she was an active collector
of the work of her contemporaries, such as the watercolors of John Marin and
Charles Demuth. She was also a familiar figure in the salons of the Parisian art
world.

 In addition to the work of these noted photographers and other Photo-Seces-
sionists, there was a great body of work by amateurs who embraced Pictorialist
ideals and techniques. The results were usually uninspiring. Springfield profes-
sional Clifton Johnson encouraged amateurs to produce pictures with "gradations
full of mystery and charm" and "without a distracting definition of detail and
outlines" by pointing the camera into the sun and keeping the lens out of focus.[3]
Unfortunately, in amateur hands the finished image often resembled a coarse news-
paper halftone.

 One New England photographer who achieved quite beautiful images in the
Pictorialist style was William H. Thompson (active ca. 1903–1918), a commer-
cial photographer for the Hartford Engraving Co., printers specializing in gravure

The Fire Bell. *William H. Thompson. Hartford,*
1918. Gum-bichromate print, 9 × 13 inches.
Connecticut Historical Society, Hartford.

and halftone illustrations. Between 1903 and 1906, he made a series of about 180
photographs of Hartford streets, interesting for the most part only for local his-
torical value. They simply documented the streets in a straightforward manner,
with no artifice or photographic manipulation.

By 1912, however, Thompson was producing Hartford street scenes on soft,
blotting-type paper — ethereal and muted in the Pictorialist tradition. In all, he
completed a portfolio of twenty-two prints, dating from 1912 to 1918. While Hart-
ford was a rough-edged, industrial-commercial city, with sections rabbit-warrened
by immigrant tenements, Thompson's images transform it into a shimmering
Xanadu. Through his darkroom work, streets of office buildings became Parisian
avenues, the dirty riverfront, a gleaming monument of industry, and the drab ten-
ements, quaint Shakespearean haunts. Some (and possibly all) of this portfolio
was reproduced in gravure, full-sized, by Thompson's printing company employer.

In 1918 Thompson became ill and was forced to move elsewhere. He sold his
1903–1906 series of pictures to the Connecticut State Library, which bought them
for their informational value. He then faded into obscurity, leaving some of his
artistic prints of 1912–1918 to grace the walls of a few local civic buildings and
the rest to lie in the basements of the city's museums and libraries.

11 "The simple beauty of New England"

Site of John Thoreau's Pencil Mill in Minot Pratt's
Woods, Concord, Mass. *Herbert W. Gleason, June 19,
1901. Modern print from original 5 × 7 inch glass
negative. From the Roland Wells Robbins Collection of
Herbert W. Gleason Photography, Lincoln, Mass.*

*I*n the early decades of the twentieth century, there appeared in New England a number of extremely gifted photographers of nature and landscape. They differed from their nineteenth-century predecessors in that while the earlier photographers concerned themselves with obtaining scenic views or stereos of familiar locales, these later photographers worked to capture the essence of nature wherever it might be found. For this reason, they had more in common with the Sunday afternoon amateur photographing the countryside or the "naturalistic" photographer attempting to evoke mood and sentiment through the depiction of nature and the rural world.

What was unique about these nature photographers, however, was that their efforts were directed toward invoking a one-to-one response to the natural world, re-creating the same emotions and feelings that one would have if one were looking at the actual subject. They did not manipulate images of nature to invoke poetic sentiment, but rather leaned toward the vision of the soon-to-come "straight" photographers such as Berenice Abbott, Walker Evans, and Paul Strand (see chapter 14), using a sharply delineated portion of a scene to define the whole better than would an all-encompassing view.

Though these nature photographers sprang up in force around the turn of the century, they were not without their nineteenth-century antecedents. Soon after the perfection of the wet-plate ngative in the early 1850s, James Wallace Black returned to his native New Hampshire to take views in and around the White Mountains. His photographs depict the rocky and wooded New England countryside. To some degree they reflect the tastes of the schools of painting then current. What most shines through the images, however, is Black's pioneering attempt to convey a native New Englander's feeling for his rugged homeland. Unfortunately, the strength of his vision was not matched by the quality of his materials. The soft-textured salt prints are not capable of reproducing sharp, precise, natural detail. In many cases the picture has little sense of depth. One feels the natural disorder but not the artistic balance that an impression of perspective would im-

Head of Artist Falls. *James Wallace Black.
North Conway, N.H., ca. 1854–1858. Salt
print from wet-plate negative, 9½ × 12
inches. The Metropolitan Museum of Art,
The Robert D. Dougan Collection, Promised
Gift of Warner Communications, Inc.*

part. Only in the relatively shallow, two-dimensional compositions of a few rocks
and trees does one gain a real appreciation of Black's pioneer images of the com-
plex New England landscape.

Another artist to anticipate the early twentieth-century group was Elbridge
Kingsley (1842–1918), who lived and worked in the Connecticut River Valley
region surrounding Northampton, Massachusetts. Famous in his day as a wood
engraver in the style of the Barbizon School, he used photography to record inter-
esting bits of scenery which he would work into his engravings.

Kingsley first took up the camera in the winter of 1880–1881 when he was
taught its use by a retired photographer living in the same boarding house. "He
said it would be useful in getting quick detail, also I could reduce a large picture
to the size of [an engraver's] block and know beforehand the effect on the
engraving." [1]

Kingsley's photographs depict classic Barbizon subjects: fields, bridges, brush,
trees edging a field, streams, snowy landscapes, and tree stumps. In all these im-
ages there is little to attract attention. They are flat, with little depth — unorga-
nized jumbles of natural detail. Yet within this collection are a small number of
prints that stand on their own merits. These are primarily vistas taken from the
mountain cliffs that edge the flat river valley around Northampton.

They pose a problem in identification, however, as Kingsley was quite cavalier
in his use of the camera. His procedure was to set off in a specially built horse-
drawn van for weeks at a time to live and work in fields and woods. Sometimes
he took his camera with him (the van had a darkroom setup), and other times

Looking Down on the Connecticut River from the Heights near Northampton, Mass., *detail. Attributed to Elbridge Kingsley, probably ca. 1880s. Paper print, 5 × 7 inches. Forbes Library, Northampton, Mass.*

he left it with his brother L. H. Kingsley who, in the early 1880s, used it more than Elbridge. To complicate attributions further, by the 1890s Kingsley was accompanied by assistants who made side trips to catch choice bits of scenery on photographic plates for possible inclusion in a Kingsley engraving.

Artistically, however, these vistas are very much in the spirit of Kingsley, as they contain a strong sense of atmosphere — an effect that Kingsley diligently worked at obtaining in his engravings. No matter the actual photographer, they are some of New England's earliest successful attempts at photographically evoking nature and the open air.

Probably the greatest, and certainly the most prolific, New England nature photographer was Herbert Wendell Gleason (1855–1937). Gleason started his career as a Congregational minister after an education at Williams College and Andover and Union Theological seminaries. His religious calling first took him and his wife to Minnesota, where he made up for an uninteresting (at least to Gleason) preacher's life by covering the interior of his church with wood carvings and reading of the wonders of the New England countryside in the writings of Henry David Thoreau, especially his *Journals.*

The readings of these, with their vivid delineation of characteristic New England scenes, sacredly cherished in memory, aroused a passionate long-

ing to visit the region so intimately described by Thoreau and enjoy a ramble among his beloved haunts.[2]

Finally, after what Gleason termed "sixteen years of exile," he resigned from the ministry in 1899 for reasons of "ill health." It is uncertain whether his resignation led him to photography or whether his taking up photography in early 1899 led to his resignation, but it is certain that his "ill health" was a polite way for the robust, ever-active Gleason to leave his parish and return to his beloved New England. "There is an indescribable charm about the scenery of New England which is most keenly felt by those whose early life has been passed under its spell," [3] he wrote in speaking of his feelings during his Minnesota years.

> There was much of interest found in the new surroundings; but the fertility of the prairies ... did not prevent an occasional craving for the sight of a bit of New England barrenness — such as rocky pastures, bounded by stone walls and dotted with creeping junipers, or a few of New England's commonest flowers.[4]

Immediately upon setting up his household on Boston's Commonwealth Avenue, Gleason journeyed to Concord,

> lured thither by Thoreau's vivid descriptions of Nature's beauty in his home surroundings. Without purposely attempting to repeat Thoreau's "travels," there has been found a peculiar pleasure in seeking out his favorite haunts, identifying places with which he was so closely associated and which he named after a fashion of his own, and at the same time securing photographs of a great number of the actual scenes and phenomena in which he delighted.[5]

In 1906 a twenty-volume edition of Thoreau's complete works appeared, illustrated with over 120 photogravures from photographs taken by Gleason — by then the recognized expert on illustrating Thoreau. Ultimately, the search for locales described by Thoreau led him to explore and photograph virtually every corner of New England — not only Walden Pond and Concord, but Cape Cod, Mount Monadnock, the Massachusetts shore, and the Maine woods.

From 1899 to about 1920, Gleason devoted his efforts to making over 1,230 negatives of Thoreau's subjects. Yet it was not simply their association with the great New England naturalist that gained fame for these pictures. Gleason was a perfectionist, and his studies capture the diversity of the natural world even in the most confined spaces. His pictures do not resort to symmetry or bold design; rather, he composed his images for balance, but not at the expense of a feeling

Hoar Frost on Trees and Fence Rails, Road near Baker's Bridge. Concord, Mass. *Herbert W. Gleason, Feb. 11, 1918. Modern print from original 5 × 7 glass negative. Gleason's photographic interpretation of the Jan. 18, 1859, entry on hoarfrost in Thoreau's Journals: "Every man's woodlot was a miracle and surprise to him, and for those who could not go so far there were the trees in the street and the weeds in the yard . . . you might say that the scene differed from the ordinary one as frosted cake differs from plain bread. In some moods you might suspect that it was the work of enchantment. Some magician had put your village into a crucible and crystallized it thus." From the Roland Wells Robbins Collection of Herbert W. Gleason Photography, Lincoln, Mass.*

for the infinite particulars of the natural world. It is this ability of suggesting order while retaining chaos that is evident in the best of Gleason's nature studies.

As a man trying to sustain himself as a photographer, Gleason necessarily led a very active life, and this suited his disposition. He carried his large view camera with its standard Dagor lens virtually everywhere in search of the beautiful as well as the salable. In 1917, as a defense against potential accusations that his interests began and ended with Thoreau, he wrote,

> Lest any should assume the fondness for New England scenery . . . is due to a lack of acquaintance with other regions more famous for their grandeur, it may be stated that . . . the writer made two trips to Alaska, six to California and the Pacific Coast, three to the Grand Canyon of Arizona, seven to the Canadian Rockies, two to Yellowstone Park, and three to the Rocky Mountains of Colorado. Yet after every one of these trips, it was a genuine delight to return to the simple beauty of New England.[6]

Nevertheless, it was Gleason's Western wilderness photography that won him the greatest fame. With close ties to the Sierra Club movement of the day, and a stint with the U.S. Department of the Interior as inspector, seeking out and photographing locations under consideration as national parks, Gleason amassed an

Rock Pool on the Summit, Looking North-West. *Herbert W. Gleason. Mount Monadnock, N. H., ca. 1920. Platinum print, 5 × 7 inches. From Gleason's album,* Scenes from Mt. Monadnock. *The Boston Athenaeum.*

impressive collection of images of the rugged grandeur of America's western landscape. In the 1960s the Sierra Club brought out *The Western Wilderness of North America,* which republished many of his inspiring views, to reawaken America's consciousness of its duty to protect these wonders.

In his day Gleason's work appeared in many conservation-oriented books by John Muir and others. His Thoreau photographs were also reproduced in his own *Through the Year with Thoreau,* published in 1917. He had originally envisioned a new edition of Thoreau's works, each volume containing hundreds of his photographs. It never appeared, for no publisher saw it as a profitable venture. Gleason also free-lanced at flower shows, photographed estates of the rich, became "official photographer" for Harvard's Arnold Arboretum, illustrated a few books on New England, and sold beautiful bound volumes of original photographs taken of such locales as New Hampshire's Mount Monadnock and Maine's Mount Desert Island.

Gleason gave lectures on various scenic locales, illustrated with lantern slides quite realistically colored by his wife, Lulu Rounds Gleason. In 1915 he went cross-country to visit the San Francisco Exposition. Arriving at the front gate with a battery of photographic equipment, he saw a sign banning professional-size cameras and all tripods from the park grounds. The only such equipment allowed

belonged to a photographer who had paid $30,000 for such exclusive photographic rights. Gleason felt some sympathy for his fellow professional's monetary outlay, but not enough to offset the costs of his own cross-country trip. Gleason finally entered the grounds with only a small hand-held camera and spent the next few days propping it up on park benches to get steady exposures. All this was done under the glare of the official photographer, who constantly cruised by in a car, apparently in the hope of intimidating Gleason out of the park. Once satisfied with his work, Gleason returned to his Boston darkroom, and soon "At the Golden Gate. The Panama-Pacific Exposition of 1915" was included in his lantern-slide lecture series. He later published one of his few photographic articles, an illustrated essay in the November 1918 *Photo-Era* describing his exploits in San Francisco. He smugly titled the article, "How I Beat the Official Photographer."

Had it not been for the good fortune and perseverance of Roland Wells Robbins of Concord, Massachusetts, while researching and digging around the site of Thoreau's cabin at Walden Pond in the mid-1940s, perhaps Gleason's work might have gone unnoticed. In connection with getting some photographs processed in Boston, Robbins was told of a collection of "Thoreau-related" negatives that had been in storage at the photo lab for many years. Robbins purchased them and found that he had acquired Gleason's negative file. Except for Robbins's discovery and his later campaign to bring the images to the public's attention, Gleason's true artistic merit might have been known only to the fortunate few who possessed the books of Gleason's mounted prints. Virtually all of Gleason's published pictures appeared in coarse halftone, robbing them of the fine detail and sharp contrast that make the original prints so beautiful. Even the soft-edged gravures of the collected works of Thoreau that appeared in 1906 do not do justice to his photographic technique. While gravure suited the more ethereal Pictorialist work, it detracted from Gleason's literal images.

Two other photographers, also treated in chapter 8, who took intriguing nature photographs in the early twentieth century were Henry G. Peabody and Edwin Hale Lincoln. Peabody (1855–1951) was a professional photographer in the Boston area from 1886 to 1900. In 1900 he moved to California and spent the next twenty-five years as a traveling photographer and lantern-slide lecturer. Part of this time was spent in the employ of the Detroit Publishing Co., run by famed western photographer William H. Jackson. Many of Peabody's travels took him back to New England, where he photographed the landscape, famous sights, and local life for reproduction and sale in various sizes, from postcards to large framed prints, as well as lantern slides. At the time of his death at age ninety-five, he merited a *New York Times* obituary not for his photographic achievements, but for his having been the oldest Dartmouth alumnus.

Greylock Mountain. *Henry G. Peabody. North Adams, Mass., 1905. Modern print from original glass negative. Peabody had a varied career photographing yachts, city views, locomotives, and land-scapes. By the 1900s he was traveling the country photographing scenic views for the Detroit Publishing Co. Library of Congress.*

Edwin Hale Lincoln (1848–1938) paralleled Peabody in longevity, photographic work, and non-photographic recognition in old age. Lincoln had served as a drummer boy in the Civil War, enlisting at age fourteen, and in later life was quite renowned for his activities in the Grand Army of the Republic veterans' group. A strong-willed, outspoken individual, Lincoln never shirked from public debate. Once, without consulting him, local officials removed from a Pittsfield public building a painting of the first hometown soldier to fall in the Civil War. This was done to make room for a picture of the grand Boston politico, then governor, James Michael Curley. Though by now in his eighties, Lincoln was still able to mount a campaign of public indignation so well publicized that his adversaries beat a quick retreat, reinstalling the fallen soldier's portrait to its original location.

Lincoln took up photography in 1877, later achieving great success for his dry-plate views of famous yachts in the Boston area. In the late nineteenth century he made friends with Oliver Wendell Holmes, who induced him to consider tree

Echinocytis Lobata. Fruit of Balsam-Apple. *Edwin H. Lincoln. Pittsfield, Mass., 1910. Platinum print, 8 × 10 inches. The Boston Athenaeum.*

Nymphaea Advena. Yellow Pond Lily. Spatter-Dock. Cow Lily. *Edwin H. Lincoln. Pittsfield, Mass., 1910. Platinum print, 8 × 10 inches. The Boston Athenaeum.*

photography. In 1883 he went to the Berkshires to photograph the grounds, as well as the interiors, of the great estates there. At that time he also began photographing flowers. In 1893 he and his family moved to the Berkshires permanently, where he started a systematic photographic study of the region's wildflowers. In 1904 he published a three-volume set, *Wild Flowers of New England,* containing 75 tipped-in platinum prints; by 1914 this work had been revised and expanded to eight volumes, with 400 prints in all. Lincoln himself printed the photographs and assembled each set by hand, selling them to individuals and institutions. The number of volumes per set varied from subscriber to subscriber, depending on how many volumes Lincoln had completed by that time. It is estimated that he ultimately produced only about fifty copies of the work, many of which were not complete eight-volume sets. By now noted for this work, he became a charter member of the American Orchid Society, received numerous awards for his flower pictures, and saw his photographs published in *National Geographic.*

Lincoln also photographed local Berkshire landmarks, special events, and landscapes. For his nature studies he used a number of cameras, none using a negative smaller than 8 x 10 inches. His lens had no shutter; he used a blanket covering the whole camera to make his exposure, simply lifting a corner to let light through the lens and dropping it again to end the exposure. He printed his work on platinum paper only, adamantly extolling its beautiful effects and vehemently denouncing other varieties of photographic paper. Because of the long exposures needed, he often carried his flower subjects, their roots wrapped in moss, back to his studio. There, by natural light, he could compose them and photograph them unhindered by breezes.

Lincoln remained quite active in his later years, and in 1931 began distributing his two-volume *Orchids of the North Eastern United States,* assembled by hand in the same manner as *Wild Flowers.* He also photographed varieties of trees, apparently envisioning a third work, but this never reached publication.

Of all New England's nature photographers, perhaps the most famous in his day was Wallace Nutting (1861–1941). Another minister-turned-photographer, he is best known for his hand-tinted pictures of colonial rooms and rural scenes. He also devoted his efforts to restoring colonial homes and advertised himself as an expert in early American furniture. In 1922 he began publishing his "States Beautiful" books. These contained short essays on the wonders of the particular state along with many similar photographs of brooks, vine-covered walls, country lanes, blossoming trees, and curving lakeshores. The first of the series was *Vermont Beautiful,* and its popularity soon inspired comparable works by Nutting on most of the northeastern states as well as a few European countries. In seeking to explain the public's enthusiasm for Nutting's images, William C. Lipke observed:

A page from Wallace Nutting's 98-page catalogue
of photographs, 1912. The public found the homey,
bucolic scenes of this prolific photographer just
right for hanging on their parlor walls. The Boston
Athenaeum.

the [books'] accompanying illustrations were photographed either from or by the road. Rarely do we get a feeling that the photographer walked into the landscape. Seen in this way, Nutting's work established an important precedent in changing the point of view of a photographer walking in the landscape to the viewpoint of the twentieth-century motorist in search of scenery on the road. Nutting used a formula which resulted in the sameness of his imagery. But the saleability of those same photographs as individual hand-tinted prints attests to the popularity of Nutting's images.[7]

In 1912 Nutting issued a 98-page, 2,905-item catalogue. Each page reproduced, in postage-stamp size, many images from which the public could choose and order their favorites by mail. By 1930, many a "Wallace Nutting" had replaced the old hand-sewn samplers on the parlor wall. Nutting produced his books and tinted prints through his Old America Company publishing house in Framingham, Massachusetts. The prints were made and hand colored in a cottage-industry assembly line that grew so large that even Nutting's signature at the bottom of the pictures was done by several staff members.

In all, Nutting photographed landscapes, quaint locales of the Old World, colonial interiors with women posed in period costumes (if a woman wanted to work tinting prints, she had to pose in the pictures, and if she wanted to pose, she had to provide her own costume), and sentimental scenes such as *The Letter* or *The Parting*. By the late 1920s he was the public's favorite for New England photography. He wrote a third-person autobiography, *Wallace Nutting's Biography*, and a photo instruction book, *Photographic Art Secrets*.

In this latter work, Nutting combined his aesthetic credo with practical hints for the aspiring photographer:

— Carry an ax in case you need to "rearrange" the foreground shrubbery.
— Youngsters who insist upon having their pictures taken should be posed just outside the area included in the ground glass.
— In more populous locales, the scene can be emptied of people by telling onlookers there will be a small charge for being in the picture.

With advice like this, plus the exhaustive delineation of his own theories of subject and composition, Nutting felt the photographer could now emulate him in capturing the bucolic image.

Scarcely any valley, across which we look, lacks a fine spot, a noble tree, a cozy cottage, a little path, a rippling turn of the brook, the curve of an old wall. There is something before us; let us find it.[8]

The Coming Out of Rosa. *Wallace Nutting, ca. 1902. This picture combines three elements often employed by Nutting in his photographs: women in fine dress, doorways, and bowers. Halftone from Nutting's* Massachusetts Beautiful.

12 "The most attractive form in its proper setting"

Portrait of Garo. *Morris Burke Parkinson. Boston, 1903. For the first three decades of the twentieth century, John Garo was Boston's leading portrait photographer. Halftone from* Photo-Era, *Oct. 1903.*

A lthough most turn-of-the-century photographers in New England, as elsewhere, interpreted the ideal of "artistic photography" through the medium of the soft-focus lens and the ethereal image, others sought a quite different result. These photographers applied classic rules of painting to the camera image:

> The art of photography is ruled by the same laws as govern the art of painting. Almost word for word the same teaching might be given. Color, light, shadow, drawing, grouping, proportion, selection, atmosphere, treatment are all to be considered as much a part of photography as of painting. As in painting, so in a photograph, the subject is the chief thing and composition next. How to present this subject in its most attractive form, how to give it a proper setting, how to select and present it with proper accessories, how to compose it — this is the technique, the science of the art.[1]

So wrote one proponent of art photographs in a 1902 issue of Boston's *Photo-Era* magazine. This outlook differed from that of the Photo-Secessionists and Pictorialists in that while these photographers placed personal artistic creation foremost, the art photographers emphasized technical mastery (and often imitation) in producing images that appear to be exact reproductions of paintings.

Art photography had its greatest impact on commercial studio portrait photographers. Beginning around the 1890s, a number of gifted portrait photographers started to turn away from the standardized techniques and stock props of the nineteenth-century studio photographers:

> The high back chair, potted palms, the fluted column, and head-rest are no longer in evidence . . . and the awkward poses, the top light, and the affectations of days gone by are gradually being forgotten.[2]

In their place came a set of principles based on a thorough study of the portrait

The Cigarette. *Will Armstrong. Boston, 1903. Halftone from a platinum print, 5 × 7 inches. The portrait was lighted by means of a mirror held on the sitter's lap which reflected light up into his face. From* Photo-Era, *Nov. 1904.*

techniques of Old Master painters who made strong use of light and shade, such as Velasquez or Rembrandt.

One such portraitist was Will Armstrong (b. 1867). He was born in a photo studio in Saginaw, Michigan, where his father and grandfather were also photographers. A precocious photographic artist, he spent his teens apprenticed to a number of fashionable midwestern photographers. He came to Boston in 1898, by this time internationally acclaimed for his portrait work, and soon set up his own studio. Boston had a quite active group of photographers and artists among its population. Their common meeting ground was the city's Lens and Brush Club, which Armstrong headed in the early years of the twentieth century, and the Boston Art Club, founded in 1854. By the turn of the century both these clubs looked upon photography as equal in stature to a number of the more traditional arts. "Photography has already been recognized as a sister art, taking its place beside etching and engraving and erelong may rank next to painting,"[3] wrote one member of the Boston Art Club in 1904.

Just as some artists, such as Elbridge Kingsley, freely based their work on photographs, so did art photographers as well as Photo-Secessionists feel free to adapt sketches and hand drawings into their photographs — for instance, in "manipulated" gum prints in which the photographer streaked lines over the photographic print in an attempt to make it appear to be an etching.

In some of Armstrong's portraits one sees this blend of media, with the face

reproduced photographically and the rest of the image simply a sketch of the person seated in an artistic pose, such as musing at a writing table. Armstrong's best work, however, was his dramatic portraiture, which was characterized by unconventional lighting techniques.

While the art photography portraitists and the Photo-Secessionists had a common technique in the hand manipulation of photographic prints, the portraitists took their imitation of art one step further: they literally re-created paintings by Rembrandt, Reynolds, Gainsborough, Hals, Holbein, Raphael, Dürer, or Rubens (among other favorites).

> It only requires a rearrangement of the hair, a little different coiffure or head-dress, a few pleats and flounces, and the up-to-date maid of today may become a maid of ancient Greece. . . . And what a joy to the feminine heart! What lady would not feel flattered to be posed after some famous painting of antiquity and be reproduced a Cleopatra, a Marie Antoinette, a Queen Louise, or any of the other great women of history.[4]

Not everyone applauded this new style of portraiture. Art critic Sadakichi Hartmann (who sometimes wrote under the name Sidney Allan) complained:

> Without a slouch hat or a big all-hiding mantle, a peculiar patterned gown, a shawl, or a piece of drapery they are unable to construct a portrait . . . and are as dependent on accessories, only of a different kind, as the old-fashioned photographer. . . . Why should an ordinary citizen be made to look like an old master? . . . It should be the portrayal of *character,* and not of pictorial effects, if portraits are to be generally interesting and ultimately prized.[5]

In actual practice, more than costumes were required to effectively create an "Old Master" photograph. The photographer needed an understanding of the lighting techniques of these painters as well as insight into how to keep the costume from dominating the real subject of the portrait — the sitter's face.

Boston photographer John Garo (1870–1939) complained that many of his fellow portraitists lacked this ability and relied solely on props. He observed that the arrival of one photographer to another's studio was the occasion for a hurried shifting of backgrounds, dropping of curtains, and the hiding of reflectors and screens lest the visiting professional "rob him of what little he knows."[6]

Garo was one of the masters of this type of portraiture. Where others only imitated poses and costumes, he could re-create a painter's lighting effects with such precision that, upon first glance at a Garo portrait, an observer would be unable to tell if he was looking at a photograph from life or a photographic copy of a

Portrait. *John Garo. Boston, 1904. Halftone from* Photo-Era, *June 1904.*

Portrait. *John Garo. Boston, 1907. Halftone from* Photo-Era, *Dec. 1907.*

Henry Frederick Prince, Banker. *John Garo. Boston, 1910. While most portrait photographers of the day chose to depict "captains of industry" in sharp, hard focus with eyes staring off in the visionary distance, Garo made his subject real and human. Halftone from* Men of Boston and New England, *1913.*

painting. When Old Master portraiture finally went out of fashion, Garo did not fade into obscurity as did many other exponents of the style. His extensive understanding of lighting and composition kept him in the forefront of the great portrait photographers of his day.

Born John Garonian in Armenia, he immigrated to America as a teenager. He first became acquainted with portrait photography as an assistant to a Worcester studio photographer in 1887. He later worked for a number of accomplished Boston photographers before opening his own studio on Boston's fashionable Boylston Street in March 1902. At that time it was the largest and best equipped studio in the city. Boston society soon flocked to have a "portrait by Garo." He had already gained attention from the exhibition of his photographs at the Museum of Fine Arts and elsewhere.

Garo is today best remembered for having taught the craft of photography to Yousuf Karsh of Ottawa. Karsh studied under Garo from 1928 to 1931, working in the darkroom and gaining insight into Garo's techniques of lighting and composition. Though Karsh uses flood and spotlights for his portraits whatever the location, Garo always relied on sunlight at his Boylston Street studio. Garo favored large, often life-sized images (some portraits are 70 x 50 inches) printed in soft-edged, warm-toned gum processes. His sitters were often the social, literary, and artistic leaders of Boston. Many of them were part of a lively social circle that met at his studio. Karsh relates how, after a day of assisting at the camera and in the darkroom, he would take up his position behind a makeshift bar in the

B. J. Lang, Pianist. *Henry Havelock Pierce. New-port, 1905. Halftone from* Photo-Era, *May 1905.*

studio, dispensing drinks named for darkroom chemicals to the elite of Prohibition-era Boston.[7] The Depression, however, ruined Garo's business — dependent as it was on an affluent clientele — and, by the time of his death, he no longer shone as the leading Boston portrait photographer.

Just as Garo was photographing the intellectual and social elite of Boston, Henry Havelock Pierce was doing the same for Newport society. He too was an expert at the Old Master style, later abandoning the costumes but retaining the brilliant lighting and composition.

Garo, Armstrong, Charles W. Hearn, Morris Burke Parkinson, all of Boston; the Kimballs of Concord, New Hampshire; Pierce of Newport; and Sabine of Providence epitomized the ideals of early twentieth-century portrait photographers in both the pictures they produced and their clientele. Everyone wanted to be a society photographer. Wrote one critic:

> There are a few city photographers that cater to an exclusive trade and succeed. . . . The exclusive trade is small, and a city must be made up of a sufficient number of people of wealth that want this work, to support a studio. . . . There are too many exclusive photographers in localities that

Aram Pothier, Governor of Rhode Island. *Sabine Studio. Providence, 1912. While the standard nineteenth-century "Rembrandt lighting," with light coming from above and to the side, still is used here, the photographer shows the influence of the new techniques in twentieth-century portraiture in his dramatic use of shadows and subdued collar and tie. Halftone from* Men of Boston and New England, *1913.*

cannot support them. A man in a city of forty thousand population made up of mill operatives or a class of people whose wages are comparatively low, and charges five dollars for his cheapest work, is far more exclusive than the man in our largest cities that makes pictures for twenty-five to fifty dollars for his cheapest work.[8]

Although Old Master photography lasted as a "high art" only into the first decade of the twentieth century, it laid the groundwork for the portraiture to come. Its posing and costumes recalled nineteenth-century styles, but its emphasis on the study of painted portraits made photographers think in terms of sophisticated lighting techniques and made them more aware of the possibilities of the camera in creating delicate tones and dynamic effects undreamed of by the late nineteenth-century studio photographers.

13 *"God bless America"*

Brattleboro, Vt. *Marion Scott Post (Wolcott), ca. 1939.*
Modern print, 8 × 10 inches. Library of Congress
(FSA).

By the 1930s, the most characteristic photography emerging from New England could be called "wonders of the rural world" — the town meeting, the farmer at his plow, New England autumn colors (in black and white), general store, youths bicycling on a country road, and the like. Stylistically, it was very much a continuation of the rural and rustic photography of the turn-of-the-century amateurs, and it lasted well into the 1950s. A few of its most accomplished proponents were Kosti Ruohomaa, George French, and W. D. Chandler. Photographers like these were predominantly free-lancers, selling their better pictures for publication in books, magazines, advertising brochures, and calendars.

Kosti Ruohomaa (1914–1961) was a Maine free-lancer who took up the still camera professionally in 1943. His photo-essays on the Maine landscape and people appeared in *Life* and other national magazines. His portrait work abounded in rural character or village patriarch pictures. Like many of his fellow photographers, he rose above genre in depicting New Englanders pitted against their rugged environment: a figure dark against a blinding snowstorm on his way through the barnyard, or a fisherman leaning over the side of a trawler pulling in the nets as the sea washes over the deck.

Another prominent New England photographer of the time was Frank Roy Fraprie (1874–1951), who worked photographing during virtually all of the first half of the twentieth century and much of the last part of the nineteenth as well. His American Photographic Publishing Company of Boston and his magazine *American Photography* made him well known to the photographic community. Besides his photo instruction manuals, he published a number of books containing his own photographs. Almost all these books, however, depict European subjects. The best known of the New England images that Fraprie produced, a modest amount compared to his foreign work, were his studies of water, relying for much of their effect on the lights and shapes of objects reflected off water.

Although his work was not actually done in the region, the photography of Clarence Kennedy (b. 1892) must be mentioned. Until his retirement in 1960,

This page: The Lip of the Dam. *Frank Roy Fraprie. Boston, ca. 1926. Modern print, 10½ × 13 inches. Boston Camera Club, Permanent Print Collection.*

Opposite: Barn of a Dairy Farmer. *Arnold Rothstein. Windsor County, Vermont. Modern print, 8 × 10 inches. 1936. Library of Congress (FSA).*

Kennedy taught art at Smith College. Around 1920 he began photographing Italian Renaissance sculpture and other works of art, having found the commercially available photographs lacking in quality. While originally intended simply for use by students in the classroom, the photographs quickly became recognized as works of art. In Kennedy's images, marble statues and other sculpture take on a luminous, transparent quality. A number of his pictures were assembled into six different portfolios of Italian Renaissance sculpture, with accompanying text designed and printed by Kennedy at his own press.

Canadian-born Clara Sipprell (ca. 1880–1975) was a globe-trotting photographer based in New York who had a photographic summer school in Thetford, Vermont. She later moved to that state permanently, setting up operations in Manchester. She is best known for her portraiture, which displays elements of her earlier strongly Pictorialist phase.

In addition to such self-employed photographers, the 1930s saw the appearance of government-employed photographers. With the coming of the Depression, the federal government created a great number of new agencies, some of which specifically provided jobs for unemployed artists, writers, and photographers.

In 1935 the Resettlement Administration (later the Farm Security Administration, or FSA) was organized to aid farmers left destitute by the effects of the Depression. One part of the agency, the Division of Information, Historical Section, was headed by former Columbia professor Roy E. Stryker.

Stryker believed that history was not the past, but the here and now events

of the Great Depression. Consequently, he organized a staff of photographers to document the condition of America's poor farmers. In the words of one of the group's photographers, Arnold Rothstein, the staff was "dedicated to the idea of recording what was happening in the United States in this critical period of our history." [1] In its goals and direction, the FSA was very much a return to the turn-of-the-century social documentary photography of Riis, Johnston, and Hine.

Stryker equipped his staff with 35mm cameras rather than the standard Graflex press cameras. The smaller cameras, he believed, allowed his photographers to get closer to their subjects to capture the fleeting scenes and expressions that would illustrate the plight of Dust Bowl refugees, migrant laborers, tenant farmers, and other victims of the Depression.

In the first year of its existence, the agency employed Arnold Rothstein, Carl Mydans, Walker Evans, and Dorothea Lange as photographers. It did its most hard-hitting work in the next few years, vividly portraying the hardship of the poor to the American public. Most FSA pictures were taken in the South and West, regions less well off than New England.

The earliest New England FSA work was done in 1936, when Rothstein (b. 1915) and Mydans (b. 1907) visited the region. Mydans documented the closing of the great Amoskeag Mills in Manchester, New Hampshire. He also covered the abandoned farms in the rural uplands of Vermont. Rothstein also worked in Vermont, taking interesting photographs of farms and town buildings, more from an architectural than a social documentary viewpoint. He returned over the next

Winter Set. *Marion Scott Post (Wolcott), ca. 1939. Vermont. Modern print, 8 × 10 inches. Library of Congress (FSA).*

few years to photograph Vermonters going about their work — at a blacksmith's forge, cutting hay, or working at local factories.

New England, at least in the eyes of Stryker, was simply too well ordered and self-reliant to be used to bring home to Americans the ravages of the Depression. The farmers had for centuries faced economic hardships in working their land. True, most of the mill laborers had lost their jobs, but the fact that they lived in towns made it easier to organize local relief. Nowhere were there the homeless, malnourished, and destitute found in the West.

Ultimately, this very quality soon brought a great number of FSA photographers to New England. By 1937 public backlash and political pressure over the widely published, heart-rending Dust Bowl photographs caused Stryker to soften his hard-hitting images. In 1937 and 1938 he adopted the policy of showing the positive side of America's reaction to the Depression. This was to be done through an exhaustive study of rural and small-town America, and New England seemed to fit the bill for such photography. Vermont received the greatest attention with

its beautiful countryside as a backdrop and its relatively stable rural economy, unaffected by the shutdown of urban factories as in other New England states.

Around 1938 Stryker hired Marion Scott Post (b. 1910; later Marion Post Wolcott). Raised and educated in New York in an affluent home and quality schools, Post had a more idealized view of the rural world than did her coworkers, who had seen its harsh side in the Dust Bowl. Sent to Vermont, she saw only the ordered and the romantic in her surroundings, and her photographs evoke these sentiments well. Although she did "Depression victim" images as well, her best work is still in these homey scenes of small-town New England (page 184).

By the late 1930s, the assignment of photographing New England had become the basic test for a permanent position on the FSA photo staff. This tour also assured a gentle breaking-in period for the photographer. The usual working procedure for all staff photographers, as well as newcomers, was as follows: the photographer set off with car, camera, and an incredibly detailed scenario from Stryker of subjects to photograph — from cars laden with a migrant farm family's belongings to people of various ages drinking Cokes. However, the photographer was instructed to ignore the list if something better came in view.

In 1940 and 1941, two other FSA photographers did extensive work in New England, Jack Delano and John Collier, Jr. Delano (b. 1914) spent September 1940 through January 1941 on the road from Maine to Connecticut. His assignment was to capture the feeling of New England's fall. Much had changed since Dorothea Lange and others had made their haunting images of Dust Bowl refugees in the mid-1930s. Despite Stryker's requests for unoffending calendar-type pictures, Delano produced a number of excellent photographs. Interspersed with river valley vistas shaded by broken clouds and interior shots of sideboards laden with pies (the mirror above reflecting the family at Thanksgiving dinner), Delano came back with *Laughter in a Tobacco Shed, Stonington, Connecticut,* and other images that stand on their own merits. He also stopped off at East Hartford's Pratt and Whitney Aircraft Company to record the beginnings of America's war footing.

In the fall of 1941, John Collier, Jr. (b. 1913), became an FSA photographer and took his first assigned tour of New England. With America expecting at any moment to be drawn into the European conflict, Collier was directed to give the defense industry his full attention. He visited Pratt and Whitney as well as other defense plants, making photographs to be used in patriotic government publications.

With the coming of World War II, the FSA's end was near. Reorganized for wartime assignments, it fell under the supervision of the U.S. Office of War Information, with the task of covering the domestic front in wartime America. No longer photographing the poor, oppressed, and forgotten, it became a propaganda

Laughter in a Tobacco Shed. *Jack Delano, Connecticut, 1940. Modern print, 8 × 10 inches. Library of Congress (FSA).*

Stonington, Connecticut. *Jack Delano. 1940. Modern print, 8 × 10 inches. Library of Congress (FSA).*

Worldly Possessions. *Ernst Halberstadt, ca. 1934–*
1940. Modern print, 8 × 10 inches. Taken by
Halberstadt during a photographic study of the
Boston slums. Collection of and copyright © Ernst
Halberstadt.

machine showing America at its best. As FSA member John Vachon put it, "To photograph defense plants and shipyards and God Bless America."[2]

In 1943 Stryker left to work for Standard Oil. By 1946 the FSA was disbanded, and its papers, together with approximately 150,000 mounted prints and nearly 272,000 negatives, were transferred to the Library of Congress.

The FSA staffers were not the only photographers doing social documentary work in New England. In 1934 painter Ernst Halberstadt (b. 1910) began a long association with the camera when he undertook a self-assigned project photographing slum conditions in Boston. Originally working with brush and colors, he turned to photography to counter accusations of artistic license in his portrayal of poverty. His Boston work, done from 1934 to 1940, ultimately resulted in the creation of the first low-rent federal housing project in the United States.

Halberstadt later photographed slums in a number of New England mill towns. During a lawsuit in Holyoke brought by opponents of a slum clearance plan, his photographs appeared as evidence to repudiate claims that Holyoke didn't have any slums. The suit was quickly dropped.

In addition to this kind of photography of the 1930s and 1940s, several make-work government agencies employed photographers to show another, more positive side of America. The greatest number fell under the supervision of the Works Progress Administration. The WPA organized a Federal Writers' Project (or FWP) in each state, hiring artists, writers, photographers, and researchers to work on various publication projects envisioned by the WPA. The most famous of these were the State Guides published in the 1930s and 1940s, giving a road by road, mile by mile tour of a state's most interesting attractions.[3] The photographs included in these guides were made by both WPA and FWP staff photographers. Another, unfinished project of the FWP was *Noted American Architects,* a massive photographic and technical study of virtually every prominent American architect. In Connecticut this project extended to a comprehensive study of the state's colonial homes and buildings. In 1940, however, it was shelved and the photographs and papers transferred to the Library of Congress.

In Rhode Island, the Federal Works Agency of the WPA authorized a study of the state's mills and mill villages. Undertaken by photographer Joseph McCarthy, this group of 179 photographs is similar in effect to the early work of Walker Evans (see chapter 14). McCarthy depicts the architecture from both a reportorial and sociological point of view. His photos show how the often ornately detailed structures had slowly deteriorated as the towns' industries closed. Yet these images do not aim to inspire social change, as did the FSA work, but rather simply to capture the shabby dignity of these once prosperous mill villages.

A number of local architectural surveys were made during the Depression, some privately, some government funded. One collection of note is a privately commissioned survey of the old homes of Windsor, Connecticut, done by David Broderick in 1933, now at the Connecticut Historical Society.

Many of the photos taken by government photographers went into the book *Fair Is Our Land.* Published in 1942 as a patriotic effort, it created an idealized view of America, one diametrically opposite to that of the Dust Bowl pictures. Many of its photographs were taken in New England. Although the work included pictures by leading photographers such as Cedric Wright, Ansel Adams, Minor White, Brett Weston, and Frances Benjamin Johnston, they were in the minority. Most of the photographs were by Samuel Chamberlain (the book's editor), Ewing Galloway, or New Englanders such as Pierson Studios and Eleanor Parke Custis. *Fair Is Our Land* marks a transition in photography; with the coming of the war (as the Graflex press camera suddenly became Military Issue: Camera, Hand, 18-C-392) photographers turned from the documentation of social wrongs to the artistic depiction of America's rights.

The war-era photography of Samuel Chamberlain (1895–1975) met with un-

Top: Pawtucket. Mill Houses, ca. 1815–1820. (Probably Connected with Old Dexter Mill). *Joseph McCarthy. Pawtucket, R.I., 1940. Modern print, 9 × 6¾ inches. Providence Public Library (WPA).*

Bottom: Fiskeville. Free Reading Room, ca. 1840. *Joseph McCarthy. Fiskeville, R.I., 1940. Modern print, 9 × 6¼ inches. Providence Public Library (WPA).*

expected problems. Chamberlain had started his successful artistic career as an expatriate etcher roaming France. He began using the camera in 1935 to make a series of picture postcards of Connecticut. While overseas he developed not only the precise style that he later carried over to his photographs, but also an appreciation for the Gallic beret. No matter how patriotic the intent, at a time when "loose lips sink ships," a stranger in "foreign costume" (the beret) who scrutinized an area by slow-moving car before stopping to quickly set up a suspicious-looking device should not have been too surprised when he was reported to the police as an enemy agent. Chamberlain apparently became quite adept at explaining just who he was, and what he was doing, to the local constabulary.[4]

By the 1950s, Chamberlain's name was sufficient explanation to curious New Englanders who saw him about with his old-fashioned camera, as by then his books and calendars depicting New England's scenic architecture and landscapes enjoyed great popularity. On New England alone he produced forty-five books. Chamberlain's technique was to take the well-balanced view of a housefront or street scene — in the best architectural photography tradition — and add a third dimension by including a strong foreground in the composition. His images almost always lead the onlooker into the picture by means of a nearby tree limb, or a fence or road running into the center of the scene. Chamberlain also tried to photograph on sunny, fleecy-clouded days to impart a bucolic sentiment to his images.

Chamberlain's depiction of a well-ordered world of fair skies, graceful colonial homes, and dignified old streets was met with enthusiastic response by an American public in search of a visual escape from the Depression and World War II, and for postwar normalcy.

Manuring the Fields, Holyoke, Mass. *Ralph Day, 1939. Gravure from Marion Hooper,* Life along the Connecticut River. *Containing photographs by Lewis Brown, Ralph Day, Newell Green, R. D. and* *M. E. Snively, and Cortlandt Luce, this book depicted the positive aspects of the life and landscape of the Connecticut River Valley in much the same style as the FSA photographers.*

14 A "frail and stubborn loveliness"

Butler Exchange. *Photographer unknown, ca. 1920s. Modern print,* $6^{15}/_{16} \times 8^{13}/_{16}$
*inches. Newsstand and lunch counter in the lobby of a Providence office building,
which was demolished in 1928. Providence Public Library.*

*A*round 1920 there began a reaction to the soft-focus romanticism of the Photo-Secession. Some photographers took what was later to be called a "straight" approach to the photographic image: advocating the use of a basic view camera, an overall sharp focus, everyday subjects, and richly detailed prints with no darkroom trickery or "artistic effects." In a sense they elevated the straightforward approach of such commercial photographers as Charles Currier to a high art (opposite page).

For the most part, this type of photographic work took place in New York and on the West Coast. "Straight" images produced by New England photographers were usually made by commercial photographers with the ability, like Charles Currier, to sometimes transform literal representation into artistic effect.

Two well-known photographers who visited New England to do some of their work were Paul Strand and Walker Evans. Their images of the region are plain, unadorned, starkly beautiful, and strike to the heart of anyone who knows the region.

While not a New Englander by birth, Walker Evans (1903–1974) was one by education, receiving upper-class schooling at Phillips Academy, Andover, and Williams College. After one year at Williams, study in Europe, and a try at a nine-to-five job, Evans found himself living with a few fellow artists in New York in what they described as utter poverty. During this time he began to take photographs.

He made his first serious effort around 1930 on a summer vacation with artist Ben Shahn at Truro, on Cape Cod: a study of the Portuguese fishing colony in nearby Provincetown. Soon afterward he was invited by Lincoln Kirstein, editor of the literary magazine *Hound and Horn* (later to establish the School of American Ballet), to accompany him on a survey of nineteenth-century architecture in New York and New England. Evans, though the assistant, soon dominated the project by refusing to be rushed in his utterly methodical photographic methods — studying the scene to obtain just the image that is not so much an artistic interpretation as a summation of the original subject. In November and December of 1933 these photographs formed the basis for a one-man show at the Museum of

Maine Pump. *Walker Evans, 1931. Modern print,*
8 × 10 inches. Detail of the attached barn of the
ornate Wedding Cake House in Kennebunkport,
Maine. Courtesy Estate of Walker Evans.

Modern Art in New York: "Walker Evans: Photographs of 19th Century Houses," directed by Kirstein.

Evans's vision and style were apparent even in these early pictures. He saw photography not so much as an application of styles and techniques learned by the emulation of others, but as an attempt to capture what truly is. The photographer, according to Evans, "learns to do his looking outside of art museums; his place is in the street, the village, and the ordinary countryside." [1]

After his architectural work, Evans photographed in Cuba, emphasizing the poverty of its people, then joined the Farm Security Administration, for which he worked from 1935 to 1937. During this time, according to those who knew him, he worked prodigiously and lived precariously.

One person to come in contact with Evans was James Thrall Soby, of West Hartford, Connecticut: collector, critic, champion of modern art in America, and one of the guiding forces of the Museum of Modern Art. Soby had asked Lincoln Kirstein to recommend someone who could teach him photography. Kirstein sent Walker Evans.

> Evans arrived with a battered view camera, equipped with an old and extremely slow lens [i.e., of very small diameter, thus requiring long exposures], and a simple glass negative holder with which he made contact prints by the light of a mazda bulb. [2]

Descending into Soby's deluxe darkroom, Evans "moved everything into a corner except the necessary trays and *one* bottle of developer and *one* bottle of hypo solution." [3] Soby mourned, "By the end of the day, watching the prints emerge from the trays, I was certain of two things: I was not a photographer; and Walker Evans was a great one." [4] For Soby, the greatest thrill of Evans's tutelage came with their field trips in Soby's car.

> I was beginning to know what would interest him; homemade and wry fenestrations as opposed to the classicism of our colonial past; our highways' billboards, with peeling scars of neglect where once public covetousness had been urged. Evans had a romantic ardor for ruins and abandoned vestiges of glory. He had, in brief, a strong and probably incurable sense of *noblesse n'oblige pas*. I took him to old industrial towns like Collinsville, and to Charter Oak Park in Hartford, once the scene of the Connecticut State Fair and now desolate. [5]

Evans and Soby photographed workers' houses, town dumps, slums, old signboards — anything but colonial New England.

In 1941 Evans returned again to New England to do a photographic study of Wheaton College, a women's school in Norton, Massachusetts. By 1945 he had taken a position with *Fortune* magazine, and over the next twenty years he produced over two dozen photo essays for *Fortune* in both black and white and color. A number were done in New England, such as "Summer North of Boston," on the grand Victorian hotels; "The U.S. Depot," depicting picturesque, small railroad stations; "Those Dark Satanic Mills," showing the variety of textile mill architecture; and "Collins Co., Collinsville, Connecticut," illustrating the old factory town Soby had shown him. In 1965 Evans left *Fortune* to teach photography at Yale University. He died in 1974.

The second great "straight" photographer of New England was Paul Strand (1890–1976). A master at evoking a feeling for the region's land, people, and architecture, like Evans he avoided the "colonial landmarks" and trained his lens on the common and simple. His New England studies culminated with the publication in 1950 of *Time in New England,* containing 106 of his photographs.

Strand grew up in New York, where he first studied under Lewis Hine. He became acquainted with the Photo-Secession around 1910 and by 1914 was producing high-quality, soft-focus images. He soon abandoned this style, and in 1916 and 1917 the last issues of *Camera Work* reproduced photographs of his that depicted sharply focused subjects. Once Strand had adopted this new technique, he lectured to photographers and the public, deploring the aesthetics of the soft-focus "artistic style."

> By introducing pigment texture [a photo-artistic trick] you kill the extraordinary differentiation of textures possible only to photography. And you destroy the subtlety of tonalities. With your soft-focus lens you destroy the solidity of your forms, likewise all differentiation of textures.[6]

While a commercial photographer in New York during the early 1920s Strand apparently took a number of trips to photograph outside the city, the best results of which are pictures of the Twin Lakes area in Salisbury, Connecticut, of 1922.

In the summers of 1927 and 1928, finances allowed Strand to vacation near artist friends at Georgetown, Maine. Here he began to concentrate on nature:

> In 1927 I did for the first time things like the cobweb with rain, iris leaves growing, the big toadstool with grasses, things of that sort. I did driftwood and other aspects of life on that island. In this first experimentation with things growing I discovered an interesting natural law by sheer chance.[7]

This "law" is that plants will always return to one position of rest after being blown by the wind. To get his pictures Strand simply waited for a lull in the wind, opened the shutter, and quickly closed it if he saw a breeze coming, "sometimes opening and closing the shutter maybe ten times during a total exposure, so that at least, when I was photographing, the object was motionless." [8] This technique had been used a great deal in the nineteenth century by nature photographers, who built up ten-minute exposures out of innumerable short portions.

During the 1930s and 1940s Strand did no photography in New England, his main efforts being motion picture work and still camera work in the West and on the Gaspé Peninsula.

> In 1944 I renewed my connections with New England, which I love so much, and became acquainted with parts of it which I hadn't known before, especially in Vermont. My friends, Genevieve Taggard, the poet, and Kenneth Durant, her husband, had a house in the West River Valley in Vermont. It's not too far from Brattleboro in southern Vermont.[9]

Deciding to spend more time in the area, Strand moved in as a boarder on a neighboring farm. Here he stayed for the winter of 1943–1944, taking some of his first still pictures after ten years of motion picture work. These new images, showing bare-wood farm building walls, stone fences, and churches — in contrast to his delicate nature close-ups of 1927 and 1928 — are full of dark portent. His portraiture is more restrained but equally powerful. The faces show warmth and kindness but, like New England weatherboards, they are lined and worn by their harsh setting.

One New Englander to respond strongly to Strand's photographs of the region was Swampscott-born Nancy Newhall, wife of Beaumont Newhall, curator of photography at the Museum of Modern Art (she herself served as acting curator of photography during her husband's World War II military service). She later wrote about her first look at Strand's New England images: "Here was what I had known and felt as a child close to the same earth and had never found expression in any medium." [10] These pictures later appeared at the Museum of Modern Art in the 1945 exhibition "Paul Strand: Photographs 1915–1945."

Nancy Newhall convinced Strand to collaborate with her on a book about New England.

> We began very consciously and deliberately with a chronological sequence of text limited to people who had written about New England and most of whom, not all, were New Englanders. The subject of the book is three hundred years of writing about life in New England accompanied by photographs which were made to fulfill the spirit and feeling of the writing. [11]

In 1945 and 1946 Strand traveled throughout New England, photographing a variety of subjects for the book — ships, the sea, farming, churches, factories, the landscape. At the same time, Nancy Newhall was, in her own words, "ransacking libraries" for apt quotations. Finally, in 1950, *Time in New England* appeared in print in an edition of 10,000. Unfortunately, the coarse halftone images in the book do Strand's photographs an injustice, yet still they conjure up a somber, strong-backed image of New England. In the words of Nancy Newhall:

> The shuttered white church stands on patches of snow like the terrifying grip of an ideal. In the worn doorlatch, the tar-paper patch, the crazy window among the rotting clapboards, appear the ancient precision and mordant decay of New England. In the glimpse of delicate woods in snow through the side of a shed, he expresses its frail and stubborn loveliness. [12]

Church, Vermont. 1944. *Paul Strand. Copyright © 1950 by the Estate of Paul Strand and Hazel Strand.*

Notes

1 "ONE OF THE MOST BEAUTIFUL DISCOVERIES OF THE AGE"

1. *Boston Mercantile Journal,* March 1, 1839.
2. Ibid.
3. Ibid.
4. "The camera was a little camera made for the convenience of draughtsmen, with a common lens of an inch and a quarter." Mrs. D. T. Davis, "The Daguerreotype in America," *McClure's* 8 (1896): 10.
5. C. W. Canfield, "Notes on Photography in Boston in 1839–40," *The American Annual of Photography,* 1894, pp. 261–262.
6. William Francis Channing, "Observations on Photographic Processes," *American Journal of Science and Arts* 43 (1842): 73–76.
7. Quoted in ibid.
8. Oliver Wendell Holmes, "The Stereoscope and the Stereograph," *The Atlantic Monthly,* June 1859.
9. Marcus A. Root, *The Camera and the Pencil* (New York, 1864), p. 353.
10. Davis, "Daguerreotype," p. 10.
11. "The Daguerreotype," *Boston Evening Transcript,* March 28, 1840.
12. Albert Sands Southworth, "An Address to the National Photographic Association," *The Philadelphia Photographer,* 1871, p. 316.
13. François Gouraud, *Description of the Daguerreotype Process . . .* (Boston, 1840).
14. Canfield, "Photography in Boston," p. 262.
15. Letter from Edward Everett Hale to his brother Nathan. Quoted in James F. Clarke, *Autobiography . . . by Edward Everett Hale* (Boston, 1891), pp. 72–73.
16. Davis, "Daguerreotype," p. 3.
17. *Providence Journal,* May 19, 1840.
18. *Niles' Register,* Feb. 11, 1843, p. 384.
19. Robert Taft, *Photography and the American Scene* (New York, 1938), p. 39.
20. Gilman and Mower, *The Photographer's Guide* (Lowell, 1842), p. 6.
21. William G. Lathrop, *The Brass Industry* (Mt. Carmel, Conn., 1926), p. 64.

2 "PICTURES TAKEN...EXCEPT SMALL CHILDREN"

1. Albert Sands Southworth, "An Address to the National Photographic Association," *The Philadelphia Photographer*, 1871, p. 320.
2. Nathaniel Hawthorne, "The Daguerreotypist," in *The House of the Seven Gables*.
3. Quoted in Louis L. Noble, *The Course of Empire...Thomas Cole...His Letters and Miscellaneous Writings* (New York, 1853), pp. 281–282.
4. Oliver Wendell Holmes, "Sun-Painting and Sun-Sculpture," *The Atlantic Monthly*, July 1861, p. 14.
5. *Hampden Post* (Springfield, Mass.), May 15, 1844.
6. *The Plumbeian*, vol. 1, no. 1 (Jan. 1847).
7. *Boston Observer*, March 14, 1841.
8. *Hartford Daily Courant*, April 29, 1841.
9. James Wallace Black, "Days Gone By," *St. Louis Practical Photographer*, 1877, p. 220.
10. *Hartford Daily Courant*, June 12, 1843.
11. Holmes, "Sun-Painting," pp. 13–14.
12. *The Photographic Art-Journal*, 1851, p. 358.
13. Anson Clark, unpublished letter, 1842. Stockbridge (Mass.) Library.
14. Black, "Days Gone By," p. 220.
15. *Hillsborough County Record* (Nashua, N.H., 1853).
16. Ibid.
17. *Waterbury Almanac...for 1858* (Waterbury, Conn., 1857), p. 48.
18. Timothy Shay Arthur, "The Daguerreotypist," in *Sketches of Life and Character* (Boston, 1853), p. 122.
19. H. J. Rodgers, *Twenty-Three Years under a Sky-Light* (Hartford, 1872), p. 25.
20. Black, "Days Gone By," p. 221.
21. Ibid.
22. Ibid.
23. N.-M. P. Lerebours, *Treatise on Photography*, 4th ed. (London, 1843), pp. 76–77, 79.
24. Quoted in Edward L. Wilson, *Wilson's Photographics* (New York, 1881), p. 63.
25. Ibid., p. 61.
26. Albert Sands Southworth, "On the Use of the Camera," *The Photographic News* (London) 18 (March 6, 1874): 111.
27. Ibid., p. 109.
28. *Boston Evening Transcript*, Nov. 27, 1888.
29. Rachel J. Homer, *The Legacy of Josiah Johnson Hawes* (Barre, Mass., 1972), p. 11.
30. Undated Southworth and Hawes advertisement at George Eastman House, Rochester, N.Y.
31. *Boston Evening Transcript*, Nov. 27, 1888.
32. *Worcester Spy*, Jan. 6, 1886.
33. Ibid.

3 THE HEAVENS FROM EARTH AND EARTH
FROM THE HEAVENS

1. *Trial and Imprisonment of Jonathan Walker at Pensacola, Florida, for Aiding Slaves to Escape from Bondage* (Boston, 1845). Also known as *The Branded Hand.*

2. "General Remarks on the Use of the Camera-Obscura," *The Photographic Art-Journal,* 1853, p. 277.

3. Ibid., p. 353.

4. Ibid.

5. Albert Sands Southworth, "An Address to the National Photographic Association," *The Philadelphia Photographer,* 1871, p. 317.

6. *The Photographic Art-Journal,* July 1853. Quoted in John Werge, *The Evolution of Photography* (London, 1890), p. 197.

7. Dorrit Hoffleit, *Some Firsts in Astronomical Photography* (Cambridge, Mass., 1950), p. 25.

8. *The Photographic Art-Journal,* July 1853. Quoted in Werge, *Evolution,* pp. 197–198.

9. Ibid.

10. G. P. Bond, "Stellar Photography," *American Almanac . . . 1858,* p. 81.

11. Hoffleit, *Astronomical Photography,* p. 27.

12. Ibid., p. 28.

13. William Francis Channing, "Observations on Photographic Processes," *American Journal of Science and Arts* 43 (1842): 73.

14. Marcus A. Root, *The Camera and the Pencil* (New York, 1864), pp. 364–365.

15. *Hartford Daily Courant,* Feb. 2, 1855.

16. *Hartford Daily Courant,* April 2, 1856.

17. John Collins Warren, *Remarks on Some Fossil Impressions* (Boston, 1854), p. 54.

18. Hoffleit, *Astronomical Photography,* p. 28.

19. Bond, "Stellar Photography," p. 81.

20. Hoffleit, *Astronomical Photography,* p. 7.

21. Oliver Wendell Holmes, "Sun-Painting and Sun-Sculpture," *The Atlantic Monthly,* July 1861.

22. "Photographing from a Balloon," *Providence Journal,* Aug. 21, 1860.

23. Ibid. Prints at the Museum of Modern Art, New York.

24. "A Balloon Excursion from Rhode Island to New Hampshire," *Providence Journal,* Oct. 6, 1860.

25. Samuel King, "The Late Balloon Photographic Experiment," *Boston Herald,* Oct. 16, 1860.

26. Ibid.

27. *"Boston as the Eagle and Wild Goose See It"*: Boston Public Library, Library of Congress, and other locations; second view of Boston taken from the tethered balloon: Huntington Library, San Marino, Calif.; Boston as seen from balloon in free flight, and North Weymouth view: Metropolitan Museum of Art, N.Y.; Hingham view: Princeton University Art Museum; two views of Providence: Museum of Modern Art, N.Y.

28. "Aerial Photography," *Photo-Miniature,* July 1903.

29. Oliver Wendell Holmes, "Doings of the Sunbeam," *The Atlantic Monthly*, July 1863.
30. Oliver Wendell Holmes, "The Human Wheel, Its Spokes and Felloes," *The Atlantic Monthly,* May 1863, p. 568.
31. Ibid., p. 571.
32. Ibid.

4 "SUCH A FRIGHTFUL AMOUNT OF DETAIL"

1. *The Photographic Art-Journal,* May 1853, p. 276; ibid., March 1853, p. 139.
2. *Hartford Daily Courant,* June 7, 1853.
3. Oliver Wendell Holmes, "The Stereoscope and the Stereograph," *The Atlantic Monthly,* June 1859.
4. *The Crayon,* Jan. 1861, p. 22.
5. Oliver Wendell Holmes, "Sun-Painting and Sun-Sculpture," *The Atlantic Monthly,* July 1861.
6. Oliver Wendell Holmes, "History of the American Stereoscope," *The Philadelphia Photographer,* Jan. 18, 1869.
7. Letter from Edwin Hale Lincoln, Dec. 26, 1932, relating an account of the invention of the stereoscope given to Lincoln by Holmes in 1880. Oliver Wendell Holmes Library, Phillips Academy, Andover, Mass.
8. Holmes, "American Stereoscope."
9. Ibid.
10. Joseph L. Bates and Oliver Wendell Holmes, *History of the American Stereoscope* (Boston, 1869).
11. Holmes, "Sun-Painting and Sun-Sculpture."
12. See William C. Darrah, *The World of Stereographs* (Gettysburg, Pa., 1977), esp. pp. 197–214.
13. James R. Jackson, *History of Littleton, N.H.* (Cambridge, Mass., 1905), p. 43.
14. Ibid., p. 14.
15. Edward L. Wilson, *Wilson's Quarter Century in Photography* (New York, 1887), p. 187.
16. William B. Sweet, *Adventures of a Deaf Mute* (Marblehead, Mass., 1875), p. 21.
17. Ibid.
18. Ibid., p. 22.
19. Ibid.
20. Ibid., p. 24.

5 "WHAT BETTER 'VEHICLE OF EXPRESSION'... THAN A *CARTE VISITE?*"

1. *Springfield Directory ... for 1859–60* (Springfield, Mass.), 1859.
2. *Hartford Daily Courant,* May 13, 1862.

3. Oliver Wendell Holmes, "Doings of the Sunbeam," *The Atlantic Monthly,* July 1863, p. 8.

4. Ibid., p. 9.

5. *Hartford Daily Courant,* March 7, 1862. The first patents for photograph albums were issued in May 1861.

6. Holmes, "Doings of the Sunbeam," p. 2.

7. *Hartford Daily Courant,* Feb. 24, 1864.

8. *Hartford Daily Courant,* Aug. 7, 1862.

9. *Hartford Daily Courant,* Jan. 23, 1865.

10. "A Photographer among the Last Men of the Revolution," *Hartford Daily Courant,* Aug. 11, 1864.

11. Ibid.

12. E. B. Hilliard, *The Last Men of the Revolution* (Hartford, 1865).

13. Ibid.

14. H. P. Robinson, *The Photographic Times* 14 (1884) : 590.

15. Ibid.

16. J.H.H., "Photography in Boston," *The Photographic Times* 2 (1872) : 53.

17. H. J. Rodgers, *Twenty-Three Years under a Sky-Light* (Hartford, 1872), p. 150.

18. Albert Sands Southworth, "Address to the National Photographic Association," *The Philadelphia Photographer,* 1871, p. 315.

19. Holmes, "Doings of the Sunbeam," pp. 14–15.

6 SCENIC GEMS AND EMINENT CITIZENS

1. Other photolithographs by Cutting and Bradford, ca. 1858, are at The Boston Athenaeum and the American Antiquarian Society, Worcester.

2. Advertising brochure, "Albertype Printing Co., Boston. 1872. Office 22 Tremont St." Boston Public Library.

3. Charles Bierstadt, letter to *The Philadelphia Photographer,* 1879, p. 190.

7 "KEEPING PACE WITH THE VERY MOTION OF LIFE"

1. Quoted in Charles Hitchcock, *Mt. Washington in Winter* (Boston, 1871), p. 134.

2. Caption on back of stereo card: "Views taken on Moosilauke during the winter of '69 and '70 . . . by A. F. Clough, Warren, N.H."

3. A. F. Clough, "Up Mt. Washington in Winter," *The Philadelphia Photographer,* 1871, p. 73.

4. Ibid.

5. Ibid.

6. Hitchcock, *Mt. Washington,* p. 141.

7. Ibid.

8. Ibid., pp. 142–143.
9. John G. Doughty, "Balloon Experiences of a Timid Photographer," *The Century*, Sept. 1886, p. 680.
10. Ibid.
11. Ibid., p. 684.
12. Ibid., p. 601.
13. Caption on back of stereo card series: "Photography from a Balloon . . . Copyright 1886, by John G. Doughty and Alfred E. Moore, Winsted, Conn."
14. William Blake Luce, *Kites and Experiments in Aerial Photography* (Hingham, Mass., 1898).
15. John T. Stoddard, "Composite Photography," *The Century* 33 (1887): 750–757; idem, "College Composites," *The Century* 35 (1888): 121–125.
16. Stoddard, "Composite Photography," p. 757.
17. Adela Haberski French, ed., *The Social Reform Papers of John James McCook* (Hartford, 1977), p. 5.
18. Ibid., p. 31.

8 "WANDERERS WITH A CAMERA"

1. Rachel J. Homer, *The Legacy of Josiah Johnson Hawes* (Barre, Mass., 1972), p. 18.
2. *Beckwith's Almanac . . . for . . . 1867* (New Haven, 1866).
3. *Hartford Daily Courant*, July 16, 1868.
4. Thomas H. Cummings, "Historical Record Work," *Photo-Era*, April 1905, p. 121.
5. *The New York Clipper Almanac for 1880* (New York, 1879), p. 60.
6. William Bunting, *Steamers, Schooners, Cutters and Sloops* (Boston, 1974), p. 8.
7. Manuscript account book in the author's collection. The photographer may be Mrs. Alice Hardy of Warner (Davisville), N.H.

9 "A PICTURE THAT WILL LIVE"

1. Oliver Wendell Holmes, "Doings of the Sunbeam," *The Atlantic Monthly*, July 1863, p. 5.
2. W. I. L. Adams, *Woodland and Meadow: Out of Door Papers Written on a New Hampshire Farm* (New York, 1901), pp. 104–105.
3. *Photo-Era*, May 1898, p. 9.
4. "Third Annual Exhibition of the Boston Society of Amateur Photographers," *The Photographic Times*, 1885, p. 711.
5. Marion Kemble, ed., *Art Recreations* (Boston, 1884), pp. 325–326.
6. Henry C. Price, *How to Make Pictures* (New York, 1882), p. 69.

7. Ibid., p. 67.
8. Benjamin Kimball, "The Boston Camera Club," *New England Magazine,* April 1893.
9. *Photograms of September 1899* (vol. 6, no. 69).
10. See John Coleman Adams, *Nature Studies in Berkshire* (New York, 1899), for Scott's gravures.

10 "A SHIMMERING XANADU"

1. A. J. Anderson, *The Artistic Side of Photography* (New York, 1911), pp. 15–16.
2. Sadakichi Hartmann, in Weston J. Naef, *The Collection of Alfred Stieglitz* (New York, 1978), p. 339.
3. Clifton Johnson, "Photography and Art," *American Amateur Photographer* 13 (1901): 80.

11 "THE SIMPLE BEAUTY OF NEW ENGLAND"

1. Elbridge Kingsley's unpublished manscript autobiography, p. 130. Forbes Library, Northampton, Mass.
2. Herbert Gleason, *Through the Year with Thoreau* (Boston, 1917), p. xxviii.
3. Ibid., p. xxvii.
4. Ibid., p. xxviii.
5. Herbert Gleason, "Winter Rambles in Thoreau's Country," *National Geographic,* Feb. 1920, p. 169.
6. Gleason, *Through the Year,* pp. xxviii–xxix.
7. William C. Lipke and Philip N. Grime, eds., *Vermont Landscape: Images 1776–1976* (Burlington, Vt., 1976), p. 44.
8. Wallace Nutting, *Photographic Art Secrets* (New York, 1927), p. 66.

12 "THE MOST ATTRACTIVE FORM IN ITS PROPER SETTING"

1. Thomas H. Cummings, "A Plea for Training in Art Photography," *Photo-Era* 8 (April 1902).
2. Thomas H. Cummings, "New Photography after the Old Masters," *Photo-Era* (Oct. 1904): 180.
3. W. A. French, "The Boston Art Club Anniversary," *Photo-Era* 13 (Nov. 1904): 203.
4. Cummings, "New Photography," p. 182.
5. Sidney Allan [Sadakichi Hartmann], "The Unconventional in Portrait Photography," *Photo-Era* 13 (Aug. 1904).

6. Letter from John Garo, in *The Association Review: Convention Annual* (Boston: The Photographers' Association of America, 1905), p. 31.
7. Yousuf Karsh, *In Search of Greatness* (New York, 1962), p. 29.
8. H. A. Collins, "Photography as a Business," in *The Association Review,* p. 45.

13 "GOD BLESS AMERICA"

1. Thomas Garver, ed., *Just before the War* (New York, 1968).
2. Ibid.
3. For a complete list of the New England guides, see page 218.
4. Samuel Chamberlain, *Etched in Sunlight* (Boston, 1968), pp. 101–102.

14 A "FRAIL AND STUBBORN LOVELINESS"

1. Quoted in Louis Kronenberger, ed., *Quality* (New York, 1969), p. 171.
2. James Thrall Soby, *Modern Art and the New Past* (Norman, Okla., 1957), p. 169.
3. Ibid.
4. Ibid., p. 170.
5. James Thrall Soby, "The Muse Was Not for Hire," *Saturday Review,* Sept. 22, 1962, p. 68.
6. Paul Strand, "The Art Motive in Photography," *British Journal of Photography,* Oct. 5, 1923, pp. 147–148.
7. Transcript of interview with Strand, Nov. 1971, for Archives of American Art, Washington, D.C.
8. Ibid.
9. Ibid.
10. Nancy Newhall and Paul Strand, *Time in New England* (New York, 1950), p. v.
11. Ibid.
12. Nancy Newhall, *Paul Strand: Photographs 1915–1945* (New York, 1945).

Bibliography

GENERAL WORKS

American Heritage, Editors of. *American Album*. New York, 1968. Picture book.

Beaton, Cecil, and Buckland, Gail. *The Magic Image: The Genius of Photography from 1839 to the Present Day*. Boston, 1975.

Dexter, Lorraine. *Photograph Collection*. South Woodstock, Vt., 1962–1963. Sections 1–11. Catalogues of photographs for sale, with much historical information. Copy at American Antiquarian Society, Worcester, Mass.

Gernsheim, Helmut and Alison. *The History of Photography*. New York, 1955.

Hartford Daily Courant, 1839–1870s. Transcription of all articles and advertisements pertaining to photography, researched by Miss Frances Hoxie. On file at Connecticut Historical Society.

Hill, Ralph, ed. *Vermont Album: A Collection of Early Vermont Photographs*. Brattleboro, 1974. Picture book.

Hoffleit, Dorrit. *Some Firsts in Astronomical Photography*. Cambridge, Mass., 1950.

Holmes, Oliver Wendell. *Soundings from The Atlantic*. Boston, 1864. Reprint of Holmes's photography articles from *The Atlantic Monthly*.

Hoyle, Pamela. *The Development of Photography in Boston 1840–1875*. Boston, 1979. The Boston Athenaeum exhibition catalogue.

Jenkins, Reese. *Image and Enterprise: Technology and the American Photographic Industry, 1839–1925*. Baltimore, 1975.

Johnson, William, ed. *Boston Photography Survey Newsletter*. 1973 (3 issues). Copy at Fogg Art Museum, Cambridge, Mass.

Lewis, Steven, et al. *Photography: Source and Resource*. Rochester, 1973.

Lipke, William C., and Grime, Philip N., eds. *Vermont Landscape: Images 1776–1976*. Burlington, 1976. Illustrated essays.

Naef, Weston J. *The Collection of Alfred Stieglitz: Fifty Pioneers of Modern Photography*. New York, 1978. Bibliographies on Photo-Secessionists.

Newhall, Beaumont. *The Daguerreotype in America*. New York, 1961.

———. *The History of Photography*. New York, 1964.

Newhall, Beaumont and Nancy. *Masters of Photography*. New York, 1958.

Photographs from The Boston Public Library. May 1977. 26-pp. mimeo checklist.

Price, Henry C. *How to Make Pictures*. New York, 1882. A Scovill publication.

Resch, Tyler, ed. *Berkshire: The First Three Hundred Years, 1676–1976.* Pittsfield, Mass., 1976. Picture book.

Root, Marcus A. *The Camera and the Pencil.* New York, 1864.

Sandler, Martin W. *This Was New England.* Boston, 1977. Picture book.

Sipley, Louis W. *Collector's Guide to American Photography.* Philadelphia, 1957.

Snelling, H. H. *The History and Practice of the Art of Photography.* New York, 1849. Reprint, New York, 1970.

Stenger, Erich. *The History of Photography.* Easton, Pa., 1939.

Taft, Robert. *Photography and the American Scene.* New York, 1938. Reprint, New York, 1964.

Thornton, Gene. *Masters of the Camera.* New York, 1976.

Waterbury, 1674–1974: A Pictorial History. Waterbury, Conn., 1974.

Welling, William. *Photography in America.* New York, 1978.

Werge, John. *The Evolution of Photography.* London, 1890.

Whitehill, Walter M. *Massachusetts.* New York, 1976. Picture book.

Wilson, Edward L. *Wilson's Photographics.* New York, 1881.

———. *Wilson's Quarter Century in Photography.* New York, 1887.

Witkin, Lee D., and London, Barbara. *The Photograph Collector's Guide.* Boston, 1979.

WORKS RELATING TO SPECIFIC TOPICS
OR ERAS OF PHOTOGRAPHY

Early Experiments (chapter 1)

Boston Mercantile Journal. Feb. 23, 1839, and March 1, 1839. Reports on Daguerre and Talbot.

Gilman and Mower. *The Photographer's Guide: In Which the Daguerrian Art is Familiarly Explained.* Lowell, 1842. 16 pp. Copy at American Antiquarian Society, Worcester, Mass.

Goode, W. H. "The Daguerreotype..." In *American Journal of Science and Arts* 40 (1840): 137.

Gouraud, François. *Description of the Daguerreotype Process...* Boston, 1840. 16 pp. The first American photo manual. Copy at The Boston Athenaeum. Reprinted in *Image,* March 1960.

Hunt, Robert. *A Popular Treatise on the Art of Photography.* Glasgow, 1841.

Stone, Zina E. "The Telegraph, Telephone, and Daguerreotype." In *Old Residents' Historical Association* (Lowell) 5 (1894): 165. Use with discretion.

Daguerreotypy (chapter 2)

Arthur, Timothy Shay. *Sketches of Life and Character.* Boston, 1853. Humorous chapter on "The Dageurreotypist."

Bogardus, Abraham. "The Lost Art of the Daguerreotype." *The Century,* n.s. 68 (1904): 81.

Davis, Mrs. D. T. "The Daguerreotype in America." *McClure's* 8 (1896) : 3.

Haley, W. S. *The Daguerreotype Operator.* New York, 1854.

Hawthorne, Nathaniel. *The House of the Seven Gables.* First published 1850. Central character is a daguerreotypist.

Hill, Levi. *A Treatise on Daguerreotypy.* 2d ed. Lexington, N.Y., 1850.

Lerebours, N.-M. P. *Treatise on Photography.* 4th ed. London, 1843. Translated from French.

New England Mercantile Union Business Directory . . . for the Year 1849. New York, 1849. Lists 109 of the more prominent "daguerrian artists."

The Photographic Art-Journal. Monthly periodical established in January 1851. Continued 1854–1860 as *The Photographic and Fine Art Journal.* New York. Rich in up-to-the-minute and first-hand accounts of activities of many New England photographers.

Rudisill, Richard. *Mirror Image: The Influence of the Daguerreotype on American Society.* Albuquerque, 1971.

Inventions and New Uses (chapter 3)

Barnard, E. E. "The Development of Photography in Astronomy." *Popular Astronomy.* Vol. 6, no. 8. Oct. 1898.

Brown, Buckminster. *Cases in Orthopedic Surgery.* Boston, 1868. Mounted photographs.

Dean, John. *The Gray Substance of the Medulla Oblongata and Trapezium.* Smithsonian Contributions to Knowledge #173. Washington, D.C., 1864. Mounted micro-photographs. Copy at Countway Medical Library, Boston.

Deane, James. *Ichnographs of the Sandstone of the Connecticut River.* Boston, 1861. Mounted photographs.

Hitchcock, Edward. *Ichnology of New England: Supplement.* Boston, 1865. Mounted photographs.

Jackson, J. B. S. *Harvard University: A Descriptive Catalogue of the Warren Anatomical Museum.* Boston, 1870. Catalogues many early medical photographs.

Warren, John C. *Remarks on Some Fossil Impressions . . .* Boston, 1854. The earliest book to include a scientific photograph.

Stereos and Scenics (chapter 4)

Brewster, David. *The Stereoscope.* London, 1856.

Darrah, William C. *Stereo Views: A History of Stereographs in America and Their Collection.* Gettysburg, Pa., 1964.

―――. *The World of Stereographs.* Gettysburg, Pa., 1977. Exhaustive study, including checklists of stereo photographers and bibliography.

Earle, Edward W., ed. *Points of View: The Stereograph in America — A Cultural History.* Rochester, N.Y.: Visual Studies Workshop Press, 1979.

Schofield, Everett A. *Town of Mystic.* Mystic, Conn., 1976. Work of a typical local stereo photographer.

Stereo World. Periodical, 1974–. Published by National Stereo Association, Fremont, N.H. Copies at American Antiquarian Society, Worcester, and Society for the Preservation of New England Antiquities, Boston.

Wilson, Edward L. *Wilson's Lantern Journeys*. Philadelphia, 1874.

The Portrait Studio (chapter 5)

Estabrooke, Edward M. *The Ferrotype and How to Make It*. Cincinnati and Louisville, 1872.

Moffitt, Arthur L. *Moffitt's Advice to His Patrons before Visiting His Photographic Studio*. New Britain, Conn., ca. 1884–1887. Copy at Connecticut Historical Society. (Similar, but untitled, pamphlets are among "photo-history" papers at Rhode Island Historical Society.)

Rodgers, H. J. *Twenty-Three Years under a Sky-Light, or Life and Experiences of a Photographer*. Hartford, 1872. Reprint, New York, 1973.

Photography and the Printed Page (chapter 6)

Albertype Printing Co. *Description of . . . Process*. Boston, 1872. Copy at Boston Public Library.

Edwards, Ernest. *The Heliotype Process*. Boston, 1876.

Flader, Louis. *Achievement in Photo-Engraving and Letter Press Printing*. 1927. Published by the American Photo-Engravers Association.

Haaften, Julia van. " 'Original Sun Pictures': A Check List of the New York Public Library's Holding of Early Works Illustrated with Photographs, 1844–1900." *Bulletin of the New York Public Library* 80 (Spring 1977) : 355–415.

Jussim, Estelle. *Visual Communication and the Graphic Arts*. New York, 1974.

New England Manufacturers' and Mechanics Institute. *Catalogue of the Art Department*. Boston, 1883.

Photographic Innovations (chapter 7)

Mees, C. E. K. *From Dry Plates to Ektachrome Film*. New York, 1961.

Popular Astronomy. Northfield, Minn., 1893–.

Wilson, Edward L. *Wilson's Cyclopaedic Photography*. New York, 1894.

Commercial Photography (chapter 8)

Tennant, John A. "Panoramic Photography." *Photo-Miniature*. No. 73. Oct. 1905.

Amateur Photography (chapter 9)

Beach, F. C. "Modern Amateur Photography." *Harper's Monthly*. Jan. 1889, p. 288.

Camera club literature: member lists, records, and exhibition catalogues of various camera clubs, ca. 1890s. At The Boston Athenaeum (Boston Camera Club), Boston Public Library, and Connecticut Historical Society.

Cummings, Thomas H. "The Portland, Maine, Camera Club." *Photo-Era*. Nov. 1905.

Fraprie, Frank R. "The Boston Camera Club." *The American Amateur Photographer*. May 1907, p. 243.

Kimball, Benj. "The Boston Camera Club." *New England Magazine*. April 1893, p. 185.

Sandler, Martin W. *This Was Connecticut*. Boston, 1977. Picture book of work by T. S. Bronson of New Haven, an early amateur.

Pictorialism and the Photo-Secession (chapter 10)

Anderson, A. J. *The Artistic Side of Photography*. New York, 1911.

Camera Notes (New York, 1897–1903); and *Camera Work* (New York, 1903–1917). Periodicals of the Photo-Secession movement.

Coburn, Alvin L. "American Photographs in London." *Photo-Era*. Jan. 1901, p. 209.

Deerfield Academy. Deerfield, Mass., 1929. Photographs by Horace Scandlin.

Doty, Robert M. *Photo-Secession: Photography as a Fine Art*. Rochester, 1960. Reprint, New York, 1978.

Emerson, Peter H. *Naturalistic Photography*. London, 1889.

Green, Jonathan. *Camera Work: A Critical Anthology*. Millerton, N.Y., 1973. Bibliography.

Hartmann, Sadakichi. "Aesthetic Activity in Photography." *Brush and Pencil* 14 (April 1904): 24.

———. "The Photo-Secession: A New Pictorial Movement." *The Craftsman* 6 (April 1904): 30.

———. *The Valiant Knights of Daguerre*. Berkeley, Calif., 1978. Selected articles published by this critic and exponent of artistic photography, edited by Harry W. Lawton and George Know.

Holme, Charles, ed. *Art in Photography*. London, 1905.

———. *Colour Photography*. London, 1908.

Nature Photography (chapter 11)

Massachusetts Audubon Society. *Man and Nature: Land Use*. Lincoln, Mass., 1975. Picture book.

See also the Selected List of Books with Photo-Mechanical Illustrations on pp. 220–221.

Twentieth-Century Portraiture (chapter 12)

Fraprie, Frank R. *How to Make Portraits*. Boston, 1902. 5th ed., 1917.

The Depression to 1950 (chapters 13, 14)

American Guide Series: *Berkshire Hills* (New York, 1939); *Cape Cod Pilot* (Provincetown, 1937); *Connecticut* (Boston, 1938); *Here's New England!* (Boston, 1939); *Maine* (Boston, 1937); *Maine's Capital* ... [Augusta] (Augusta, 1939); *Massachusetts* (Boston, 1937); *New Hampshire* (Boston, 1938); *Portland* (Portland, 1940); *Rhode Island* (Boston, 1937); *Vermont* (Boston, 1937).

American Pictorial Guide Series. *Vermont: A Profile of the Green Mountain State.* New York, 1941. FSA photographs.

Anderson, Sherwood. *Home Town.* New York, 1940. FSA photographs.

Chamberlain, Samuel, ed. *Fair Is Our Land.* New York, 1942. FSA and other well-known photographers of the 1930s. Also includes etchings.

Garver, Thomas, ed. *Just before the War: Urban America from 1935 to 1941 as Seen by Photographers of the Farm Security Administration.* Balboa, Calif.: Newport Harbor Art Museum, 1968.

Hooper, Marion, et al. *Life along the Connecticut River.* Brattleboro, Vt., 1939. Picture book.

Hurley, Jack F. *Portrait of a Decade: Roy Stryker and the Development of Documentary Photography in the Thirties.* Baton Rouge, 1972.

Jennison, Keith. *Vermont Is Where You Find It; The Maine Idea; New Hampshire; Green Mountains and Rock Ribs.* New York, 1941–1954. Picture books with photographs by WPA, FSA, and New England commercial photographers.

MacLeish, Archibald, ed. *Land of the Free.* New York, 1938. FSA photographs.

Orton, Vrest. *And So Goes Vermont.* Weston, Vt., 1937. Picture book.

Steichen, Edward, ed. *The Bitter Years, 1934–1941: Rural America as Seen by the Photographers of the Farm Security Administration.* New York, 1962.

Stryker, Roy E., and Wood, Nancy. *In This Proud Land.* Greenwich, Conn., 1973.

SELECTED LIST OF BOOKS
WITH PHOTO-MECHANICAL ILLUSTRATIONS

This checklist includes a selection of books with general artistic and scenic content. It does not list the multitude of books published on individual towns, cities, or institutions.

Adams, John Coleman. *Nature Studies in Berkshire.* New York, 1899. Gravures by Arthur Scott.

Bacon, Edwin M. *The Connecticut River and the Valley of the Connecticut.* New York, 1911. Gravure frontispiece.

Calhoun, Newell Meeker. *Picturesque Litchfield County* [Connecticut]. Chicago, 1900. Portfolio in nine parts.

Carter, George H. *Carter's Illustrations of the Old Oaken Bucket.* Orange, Mass., 1900. Gravures by Marie H. Kendall of Norfolk, Conn.

Dame, Lorin L. *Typical Elms and Other Trees of Massachusetts.* Boston, 1890. Heliotypes by Henry Brooks.

Drake, Samuel Adams. *Historic Fields and Mansions of Middlesex*. Boston, 1873.

Dunham, H. C. *Picturesque Places in Old Plymouth*. Plymouth, Mass., 1887. Portfolio.

Flagg, Wilson. *Birds and Seasons of New England*. Boston, 1875.

———. *Woods and By-Ways of New England*. Boston, 1872.

Forbes Co. *White Mountain Series*. Boston, 1884. Portfolio.

Harroun and Bierstadt, [Edward]. *Gems of American Scenery*. New York, 1878.

Jones, Alvin Lincoln. *Under Colonial Roofs*. Boston, 1894. Gravures by Charles B. Webster.

King, Moses. *Harvard and Its Surroundings*. Cambridge, 1884.

King, Thomas Starr. *The White Hills*. Boston, 1887.

Luce, William Blake. *Picturesque Studies in Boston*. Boston, n.d. (ca. 1890).

Mabie, Hamilton Wright. *Our New England*. Boston, n.d. (ca. 1890).

Picturesque Charles. Auburndale, Mass., n.d. (ca. 1895).

Pollock, Charles. *Souvenir of the White Mountains*. Boston, 1892.

Stillman, William James. *Poetic Localities of Cambridge*. Boston, 1876.

Sweetser, M. F. *Picturesque Maine*. Portland, 1880.

———. *Views of the White Mountains*. Portland, 1879.

White, C. R. *By the Sea*. Portland, 1889.

Checklist of Photographers
and Their Work

This selective list includes material for further research and reading on most of the photographers treated in the text. Following brief biographical data, the entries are divided into public collections (COLL.), publications by the photographer (PUBL.), and publications about the photographer and his or her work (BIBL.). Page numbers refer to the first pages of an article. Short-title references can be found in full in the General Works portion of the Bibliography. The following abbreviations are used:

AAS	American Antiquarian Society, Worcester
BA	The Boston Athenaeum
BMFA	Museum of Fine Arts, Boston
BPL	Boston Public Library
BS	The Bostonian Society
CHS	Connecticut Historical Society, Hartford
GEH	International Museum of Photography at George Eastman House, Rochester
LOC	Library of Congress, Washington, D.C.
MMA	Metropolitan Museum of Art, New York
MOMA	Museum of Modern Art, New York
SPNEA	The Society for the Preservation of New England Antiquities, Boston

ADAMS, S. F. Active ca. 1860–1880. New Bedford and Oak Bluffs, Mass. Stereos.
COLL. GEH; SPNEA; Whaling Museum, New Bedford.
BIBL. Darrah, *World*.

ALLEN, EDWARD L., and ROWELL, FRANK (1839–1889). Firm active ca. 1860–1880. Boston. Portraits.
COLL. BA; BPL; BS.

BEMIS, SAMUEL. 1789–1881. Boston and White Mountains, N.H. Amateur, ca. 1840.
COLL. GEH.
BIBL. *Boston Evening Transcript,* May 26, 1881 (obituary).
Kilbourne, Frederick W. *Chronicles of the White Mountains.* Boston, 1916.
Newhall, *Daguerreotype.*
Rudisill, Richard. *Mirror Image: The Influence of the Daguerreotype on American Society.* Albuquerque, 1971.

BENTLEY, WILSON A. Active ca. 1880–1930. Jericho, Vt. Scientific photographs.
PUBL. Bentley, W. A., and Humphreys, W. J. *Snow Crystals.* New York, 1931. Reprint, New York, 1962.

BIERSTADT, ALBERT, CHARLES, and EDWARD. Active New England, 1859–1865. New Bedford, Mass. Stereos, portraits, landscapes.
COLL. SPNEA; Whaling Museum, New Bedford.
PUBL. *Catalogue of Photographs, Published by Bierstadt Brothers, New Bedford, Massachusetts.* New Bedford, 1860. Copy at AAS.
Stereoscopic Views among the Hills of New Hampshire. New Bedford, 1862.
Gems of American Scenery. New York, Harroun and [Edward] Bierstadt, 1878.
BIBL. Darrah, *World.*
Hendricks, Gordon. *Albert Bierstadt.* New York, 1973.
Taft, *Photography.*

BLACK, JAMES WALLACE. 1825–1896. Boston. Portraits, landscapes, experimental work.
COLL. BA; BPL; BS; MMA; MOMA; Princeton Art Museum, Princeton, N.J.
PUBL. *Ruins of the Great Fire in Boston. November 1872.* Boston, 1873.
"Days Gone By." *St. Louis Practical Photographer,* 1877, p. 220.
BIBL. "Aerial Photography." *Photo-Miniature,* July 1903.
American Journal of Photography, n.s. 3 (1860–1861): 188.
Edidin, Stephen R. *The Photographs of James Wallace Black . . . of the Great Fire in Boston . . . 1872.* Williamstown, Mass., 1977.
King, Samuel. "The Late Balloon Photographic Experiment." *Boston Herald,* Oct. 16, 1860.
"Photographing from a Balloon" and "A Balloon Excursion from Rhode Island to New Hampshire." *Providence Journal,* Aug. 21 and Oct. 6, 1860.
Taft, *Photography.*
Welling, *Photography.*

CHAMBERLAIN, SAMUEL. 1895–1975. Marblehead, Mass. Architecture, landscapes.
COLL. BPL; MIT Historical Archives (camera and field equipment).
PUBL. *A Small House in the Sun.* New York, 1936.
Cape Cod in the Sun. New York, 1937.
Fair Is Our Land. New York, 1942.
Etched in Sunlight. Boston, 1968. Autobiography. Bibliography.

CHANNING, WILLIAM FRANCIS. 1820–1901. Boston. Experimental work, early 1840s.
PUBL. "Observations on Photographic Processes." *American Journal of Science and Arts* 43 (1842): 73.
BIBL. *Dictionary of American Biography.*
Taft, *Photography.*

CHILD, FRANK H. Active ca. 1900. Newport, R.I. Ships and yachts.
COLL. LOC.

CHURCH, ALBERT COOK. 1880–1965. New Bedford, Mass. Nautical photographs.
COLL. Whaling Museum, New Bedford.
PUBL. *Whale Ships and Whaling.* New York, 1938. Reissue, New York, 1960.
American Fisherman. New York, 1940.

BIBL. Purrington, Philip F. *Albert Cook Church: Photographs and a Biographical Sketch.* Old Dartmouth Historical Sketches, no. 76. New Bedford, 1969.

"Whaling Pictures." *The Month at Goodspeed's* 10 (Nov. 1938) : 70. Goodspeed's Bookshop, Boston, catalogue.

CLARK, ANSON. 1783–1847. West Stockbridge, Mass. Daguerreotype portraits.

COLL. Stockbridge Library.

BIBL. Newhall, *Daguerreotype.*

Resch, *Berkshire.*

CLOUGH, A. F. Active 1870s. Oxford and Warren, N.H. Stereos.

COLL. New Hampshire Historical Society.

PUBL. "Views Taken on Moosilauke during the Winter of '69 and '70 . . . by A. F. Clough, Warren, N.H." Set of 36 stereos.

"Views Taken on the Summit of Mount Washington, during the Winter of 1870–71, by Clough & Kimball, Concord, N.H." Set of 46 stereos.

Hitchcock, Charles. *Mt. Washington in Winter, or the Experiences of a Scientific Expedition upon the Highest Mountain in New England, 1870–71.* Boston, 1871. Part of the text is by Clough.

"Up Mt. Washington in Winter." *The Philadelphia Photographer,* 1871, p. 72.

BIBL. Darrah, *World.*

Kilbourne, Frederick. *Chronicles of the White Mountains.* Boston, 1916.

COBURN, ALVIN LANGDON. 1882–1966. Boston and England. Photo-Secessionist.

COLL. BMFA; GEH; Jewett Arts Center, Wellesley College, Wellesley, Mass.

PUBL. *Photo-Era,* Feb. 1902.

Camera Work. Ills. in nos. 3, 6, 8, 15, 21, 28, 32.

Henderson, Archibald. *Mark Twain.* New York, 1911.

Alvin Langdon Coburn, Photographer: An Autobiography. Ed. by Helmut and Alison Gernsheim. New York, 1966.

BIBL. Beaton and Buckland, *Magic Image.*

Camera, Dec. 1969.

Naef, *Collection of Stieglitz.* Bibliography.

Newhall, Nancy. *A Portfolio of Sixteen Photographs by Alvin Langdon Coburn.* Rochester, 1962. Bibliography.

COOKE, JOSIAH PARSONS. 1827–1894. Boston. Amateur, active ca. 1840–1845.

COLL. Nine talbotype negatives at Houghton Library, Harvard University.

BIBL. *Dictionary of American Biography.*

Taft, *Photography.*

COOLIDGE, BALDWIN. 1845–1928. Boston. Commercial work.

COLL. BPL; SPNEA (2,000 negatives).

PUBL. *Catalogue of Photographs of Painting, Sculpture . . . in the Museum of Fine Arts, Boston, Mass., U.S.A.: Published by Baldwin Coolidge . . . January, 1906.*

Coolidge's Souvenir Portfolio on Mount Washington. Boston, n.d. (ca. 1900). Twelve views.

BIBL. Reichlin, Ellie. "Double Exposure: Baldwin Coolidge and William Sumner Appleton." *Old Time New England,* Winter–Spring 1979, p. 34.

Sandler, *This Was New England.*

COUSINS, FRANK. 1851–1925. Salem, Mass. Architecture.

COLL. Essex Institute, Salem (over 5,000 original negatives).

PUBL. *Colonial Architecture.* Garden City, N.Y., 1912.

Fifty Salem Doorways. Garden City, N.Y., 1912.

Colonial Architecture of Salem. Boston, 1919.

BIBL. *Catalogue of the Negatives in the Essex Institute Collections.* Salem, 1925.

CURRIER, CHARLES H. 1851–1938. Boston. Commercial work.

COLL. LOC.

BIBL. American Heritage, *American Album.*

Rose Art Museum, Brandeis University. *Charles H. Currier: A Boston Photographer.* Waltham, Mass., 1964. Exhibition catalogue.

Sandler, *This Was New England.*

DAVIDSON, W. B. Active ca. 1887–1892. Wakefield, R.I. Landscapes, portraits.

COLL. Rhode Island Historical Society (summer mansions).

DAVIS, DANIEL, JR. 1813–1887. Active ca. 1840s. Boston. Experimental work.

BIBL. Newhall, *Daguerreotype.*

DAY, FRED HOLLAND. 1864–1933. Boston. Artistic photographs.

COLL. LOC; Norwood (Mass.) Historical Society.

PUBL. "Sacred Art and the Camera." *The Photogram,* Feb. 1899, p. 37.

"Photography As a Fine Art." *Photo-Era,* March 1900, p. 91.

BIBL. Beaton and Buckland, *Magic Image.*

Clattenburg, Ellen Fritz. *The Photographic Work of F. Holland Day.* Wellesley, Mass., 1975. Exhibition catalogue. Bibliography.

Gibran, Jean and Kahlil. *Kahlil Gibran: His Life and World.* Boston, 1974.

Hartmann, S. "A Decorative Photographer." *Photographic Times,* March 1900, p. 102.

"Massachusetts Photographers." *Photo-Era,* March 1900, p. 68.

Naef, *Collection of Stieglitz.*

Rollins, H. E., and Parrish, S. M. *Keats and the Bostonians.* Cambridge, Mass., 1951.

Taylor, H. W. "F. Holland Day: An Estimate." *Photo-Era,* March 1900, p. 77.

Thornton, *Masters of the Camera.*

DEVENS, MARY. Active ca. 1898–1905. Boston. Photo-Secessionist.

PUBL. *Camera Work.* Ill. in no. 7.

BIBL. Naef, *Collection of Stieglitz.*

DOUGHTY, JOHN G. Active ca. 1885. Winsted, Conn. Experimental work.

COLL. CHS (published prints); Winchester Historical Society, Winsted, Conn. (published prints, all published and unpublished negatives, and notes of all balloon ascensions).

PUBL. "Photography from a Balloon . . . Copyright 1886, by John G. Doughty and Alfred E. Moore, Winsted, Conn." Series of fourteen 5 x 7 inch photographs of 1885 balloon flight, mounted on cards with captions on back.

"Balloon Experiences of a Timid Photographer." *The Century,* Sept. 1886, p. 679.

BIBL. DeMars, Frank H., and Bronson, Elliott P. *Winsted and the Town of Winchester.* Winsted, Conn., 1972.

Duffy, Edward. "Three Miles High in a Balloon." *St. Nicholas,* Dec. 1887. The St. Louis ascension.

Moore, Alfred E. "Amateur Ballooning." *The Century,* Sept. 1886, p. 670.

DOUGHTY, T. M. V. d. 1911. Active ca. 1860–1890. Winsted, Conn. Portraits.
COLL. CHS; Winchester Historical Society, Winsted, Conn.
BIBL. DeMars and Bronson, *Winsted.* (See above entry.)

EDGERTON, HAROLD E. b. 1903. Cambridge, Mass. Experimental work.
COLL. MIT Historical Collections.
PUBL. *Flash! Seeing the Unseen by Ultra High-Speed Photography.* Boston, 1939.
Moments of Vision: The Stroboscopic Revolution in Photography. Cambridge, Mass., 1979.
BIBL. Beaton and Buckland, *Magic Image.*
Newhall, *History.*

EMMONS, CHANSONETTA STANLEY. 1858–1937. Roxbury, Mass., and Kingfield, Maine. Amateur.
COLL. Colby College, Waterville, Maine; Cutler Library, Farmington, Maine.
BIBL. American Heritage, *American Album.*
Péladeau, Marius B. *Chansonetta: The Life and Photographs of Chansonetta Stanley Emmons, 1858–1937.* Waldoboro, Maine, 1977.

EVANS, WALKER. 1903–1974. "Straight" photography.
COLL. Fogg Art Museum, Harvard University; MMA; MOMA; Smith College; Yale University Art Gallery.
PUBL. *Wheaton College Photographs.* Norton, Mass., 1941.
"Collins Co., Collinsville, Connecticut." *Fortune,* Jan. 1946, p. 110.
"In Bridgeport's War Factories." *Fortune,* Sept. 1941, p. 87.
"Homes of Americans." *Fortune,* April 1946, p. 148.
"Summer North of Boston." *Fortune,* Aug. 1949, p. 74.
"The U.S. Depot." *Fortune,* Feb. 1953, p. 138.
"Those Dark Satanic Mills." *Fortune,* April 1956, p. 139.
"Photography." In Kronenberger, Louis, ed. *Quality.* New York, 1969.
First and Last. New York, 1978.
BIBL. Baier, Lesley K. *Walker Evans at FORTUNE: 1945–1965.* Wellesley, Mass., 1977. Exhibition catalogue.
Kirstein, Lincoln. *Walker Evans: American Photographs.* New York, 1938. Reprint, New York, 1975.
Soby, James Thrall. *Modern Art and the New Past.* Norman, Okla., 1957.
Newhall, *Masters.*
Szarkowski, John. *Walker Evans.* New York, 1971. Bibliography.

FRAPRIE, FRANK ROY. 1874–1951. Editor, American Photographic Publishing Co., Boston.
COLL. Boston Camera Club; GEH.
PUBL. Chamberlain, Samuel, ed. *Fair Is Our Land.* New York, 1942.
Hammond, Arthur. *Pictorial Composition in Photography.* 3rd ed. Boston, 1939. Many ills.

GAGE, FRANKLIN B. Active 1850–1860s. St. Johnsbury, Vt. Portraits, stereos.

PUBL. Article in *Humphrey's Journal of the Daguerreotype and Photographic Arts,* June 1, 1858.

Theoretical and Practical Photography on Glass and Paper. St. Johnsbury, Vt., 1859.

BIBL. Fairbanks, E. T. *The Town of St. Johnsbury, Vt.* St. Johnsbury, 1914 (p. 488).

GARO, JOHN. 1870–1939. Boston. Portraits.

COLL. Carpenter Center for the Visual Arts, Harvard University; Smithsonian Institution.

PUBL. *The Photographic Times*: 1904, p. 289; 1905, p. 431.

Photo-Era: ca. 1900–1910. Numerous ills.

BIBL. Federal Writers Project. *Armenians in Massachusetts.* Boston, 1937.

Fraprie, Frank R. *Photographic Amusements.* 10th ed. Boston, 1931. Portrait of Garo, p. 139.

Hartmann, Sadakichi. *The Valiant Knights of Daguerre.* Berkeley, Calif., 1978.

Karsh, Yousuf. *In Search of Greatness.* New York, 1962.

GILBERT, R. A. Active ca. 1900. Concord, Mass. Amateur. Black cook and servant who photographed under the direction of his employer, ornithologist William Brewster (1851–1919).

COLL. Massachusetts Audubon Society, Lincoln (prints and 1,500 negatives).

GLEASON, HERBERT WENDELL. 1855–1937. Boston. Nature studies.

COLL. BA; BPL.

PUBL. "Winter Rambles in Thoreau Country." *National Geographic,* Feb. 1920, p. 165.

Writings of John Burroughs. Riverby Edition. Boston, 1905–. 23 vols. Gleason gravures.

Torrey and Allen, eds. *The Writings of Henry David Thoreau.* Boston, 1906. 20 vols. 120 Gleason ills. The trade edition consists of halftone illustrations; the "manuscript edition" consists of gravures, with a page from Thoreau's manuscripts bound in.

Thoreau, H. D. *Walden...with Mounted Photographs...by...Gleason.* Boston: Bibliophile Society, 1909.

Mt. Monadnock in Winter. N.p. N.d. Album, ca. 1915.

Through the Year with Thoreau. Boston, 1917.

"As to Ammonium Persulphate." *Photo-Era,* March 1918, p. 116.

"How I Beat the Official Photographer." *Photo-Era,* Nov. 1918, p. 230.

Scenes from Mt. Monadnock. N.p. N.d. Album, ca. 1920. Copy at BA.

Timlow, Elizabeth W. *The Heart of Monadnock.* Boston, 1922.

Herb Society of Boston. *A New Orchard and Garden.* Boston, 1935. Two mounted photographs.

BIBL. *Illustrated Maine Woods.* Princeton, N.J., 1974.

Illustrated Walden. Princeton, N.J., 1973.

Silber, Mark, ed. *Thoreau Country: Photographs...by Herbert W. Gleason.* San Francisco, 1975.

Thoreau's Cape Cod. Barre, Mass., 1971.

The Western Wilderness of North America. Barre, Mass., 1972.

GOURAUD, FRANÇOIS (or FRANCIS). d. ca. 1848. New York, Boston, and Providence. Daguerreotype promoter.

COLL. BMFA (daguerreotype).

PUBL. *Description of the Daguerreotype Process* . . . Boston, 1840. Copy at BA. Reprinted in *Image,* March 1960.

BIBL. "The Daguerreotype." *Boston Evening Transcript,* March 28, 1840.

"The Daguerreotype." *Providence Journal,* May 23, 1840.

"The Daguerreotype in Providence." *Providence Journal,* May 19, 1840. Advertisement.

Davis, Mrs. D. T. "The Daguerreotype in America." *McClure's* 8 (1896) : 10.

Newhall, *Daguerreotype.*

Taft, *Photography.*

HALE, EDWARD EVERETT. 1822–1909. Active ca. 1839–1840. Boston. Amateur.

PUBL. Clarke, James F. *Autobiography . . . by Edward Everett Hale.* Boston, 1891.

BIBL. C. W. Canfield, "Notes on Photography in Boston in 1839–40." *The American Annual of Photography,* 1894, p. 261.

Davis, Mrs. D. T. "The Daguerreotype in America." *McClure's* 8 (1896) : 10.

Taft, *Photography.*

HALE, LUTHER HOLMAN. 1821–1885. Boston. Portraits.

BIBL. Black, James Wallace. "Days Gone By." *St. Louis Practical Photographer,* 1877, p. 221.

Newhall, *Daguerreotype.*

Newhall, *History.*

The Photographic Art-Journal, 1851, p. 358.

HAWES, JOSIAH JOHNSON. 1808–1901. Boston. Daguerreotype and paper portraits, architecture, experimental work.

COLL. BA; BMFA; BPL; Massachusetts Historical Society; MMA; MOMA. (Architectural prints are in BA, BPL, and Massachusetts Historical Society.)

BIBL. (Note: There have been published a number of extensive works on Southworth and Hawes, most with exhaustive bibliographies. Therefore this bibliography lists only the major works.)

Homer, Rachel J. *The Legacy of Josiah Johnson Hawes.* Barre, Mass., 1972.

Moore, Charles Leroy. *The Careers and Daguerreian Artistry of Albert Southworth and Josiah Hawes.* Ann Arbor, Mich.: University Microfilms, 1975. Ph.D. diss., University of Michigan.

Newhall, *Daguerreotype.*

Newhall, *Masters.*

Romer, Grant B. "The Daguerreotype in America and England after 1860." *History of Photography* 1 (July 1977).

Sobieszek, Robert A., and Appel, Odette M. *The Spirit of Fact: The Daguerreotypes of Southworth & Hawes.* Rochester, 1976.

Stokes, I. N. Phelps. *The Hawes-Stokes Collection of . . . Southworth and . . . Hawes.* New York, 1939.

See also Southworth, Albert Sands.

HAYDEN, HIRAM WASHINGTON. 1820–1904. Active ca. 1851. Waterbury, Conn. Experimental work.

COLL. Mattatuck Museum ,Waterbury, Conn. (paper daguerreotype).

PUBL. "New Application of the Daguerreotype!" *Waterbury Republican,* Feb. 14, 1851.

HINE, LEWIS W. 1874–1940. Social documentary work.

COLL. BMFA; BPL; LOC.

PUBL. *Survey,* ca. 1909–1917. Numerous ills.

Davis, Philip. *Street Land.* Boston, 1915.

BIBL. Rosenblum, Walter, et al. *America & Lewis Hine: Photographs 1904–1940.* Millerton, N.Y., 1976.

Trattner, Walter. *Crusade for the Children.* Chicago, 1970.

HOLMES, OLIVER WENDELL. 1809–1894. Boston. Amateur, essayist, collector.

COLL. BMFA (Holmes's stereo view collection); Countway Medical Library, Boston; Oliver Wendell Holmes Library, Phillips Academy, Andover, Mass. (Holmes's original stereoscope; letter describing its invention).

PUBL. Bates, Joseph L., and Holmes, Oliver Wendell. *History of the American Stereoscope.* Boston, 1869. Reprint in pamphlet form of "History of the American Stereoscope," *The Philadelphia Photographer,* Jan. 18, 1869. Copies at AAS, Massachusetts Historical Society.

Soundings from The Atlantic. Boston, 1864. Contains reprints of all photographic articles written by Holmes for *The Atlantic Monthly*: "The Stereoscope and the Stereograph," June 1859; "Sun-Painting and Sun-Sculpture; with a Stereoscopic Trip across the Atlantic," July 1861; "The Human Wheel, Its Spokes and Felloes," May 1863; and "Doings of the Sunbeam," July 1863.

BIBL. Bowen, Catherine Drinker. *Yankee from Olympus.* Boston, 1944. Biography.

Taft, *Photography.*

HOMESTEAD VIEW COMPANY. Active ca. 1880s. 155 State Street, Springfield, Mass. Rural home "portraits."

COLL. Connecticut State Library.

HOWES, ALVAH and GEORGE. Active ca. 1890s. Ashfield, Mass. Rural occupations.

BIBL. American Heritage, *American Album.*

Sandler, *This Was New England.*

JOHNSON, CLIFTON. 1865–1940. Northampton and Springfield, Mass. Rural genre.

PUBL. (Note: Johnson published many books illustrated with his photographs of New England country life. Only two of the more interesting are listed here.)

The Country School in New England. New York, 1893.

A Book of Country Clouds and Sunshine. Boston, 1896.

"Photography and Art." *The American Amateur Photographer,* 1901, p. 78.

BIBL. Hartt, M. D. "Clifton Johnson and His Pictures of New England Life." *New England Magazine,* n.s. 24 (1901): 661.

JOHNSTON, FRANCES BENJAMIN. 1864–1952. Reportorial/artistic photography.

COLL. LOC.

BIBL. Smock, R. *A Talent for Detail: The Photographs of Frances B. Johnston, 1889–1910.* New York, 1974.

KILBURN, BENJAMIN WEST (1827–1909) and EDWARD (1830–1884). Littleton, N.H. Stereos.

COLL. SPNEA; Worcester Art Museum.

PUBL. *Kilburn Brothers, Littleton, N.H. Catalogue of Stereoscopic Views.* Littleton, 1868; ca. 1873; 1878.

"Mountain Photography." In *Wilson's Quarter Century,* p. 187.

BIBL. Adams, W. I. L. "Some Cloud Effects." *The Photographic Times,* 1909, p. 55.

Jackson, James R. *History of Littleton, N.H.* Cambridge, Mass., 1905.

The Philadelphia Photographer: 11 (1874): 138; 16 (1879): 601; 23 (1886): 256.

The Photographic Times: May 19, 1893, p. 256 (with portrait of Ben Kilburn); 1909, p. 75.

Reale, Paul J. "Why, It's Like You're Right There!" *Yankee,* May 1966.

KIMBALL, HOWARD A. Active ca. 1860–1880. Concord, N.H. Stereos, portraits.

COLL. New Hampshire Historical Society.

PUBL. Hitchcock, Charles. *Mt. Washington in Winter, or the Experiences of a Scientific Expedition upon the Highest Mountain in New England, 1870–71.* Boston, 1871. Part of the text is by Kimball.

"Views Taken on the Summit of Mount Washington during the Winter of 1870–71, by Clough & Kimball, Concord, N.H." Set of 46 stereos.

"New Hampshire State Prison." Set of 50 stereos, ca. 1880.

"Our Rooms . . ." In *Wilson's Quarter Century,* p. 442.

BIBL. Kilbourne, Frederick. *Chronicles of the White Mountains.* Boston, 1916.

KIMBALL, WILLIAM HAZEN, 1817–1892. Lowell, Mass., and Concord, N.H. Daguerreotype portraits.

KINGSLEY, ELBRIDGE. 1842–1918. Northampton, Mass. Wood engraver who used photographs as studies for his work.

COLL. Mt. Holyoke College, South Hadley, Mass.; Forbes Library, Northampton.

PUBL. Unpublished autobiography, Forbes Library.

The Picturesque Publishing Co., Northampton, published, ca. 1890s, a series of volumes on various cities and counties in Massachusetts, entitled *Picturesque —*; many contain Kingsley photographs.

BIBL. Jussim, Estelle. "The Syntax of Reality." *Image,* Sept. 1976.

———. *Visual Communication and the Graphic Arts.* New York, 1974.

LATIMER, HORACE A. d. 1931. Boston. Amateur.

COLL. Boston Camera Club; GEH.

LINCOLN, EDWIN HALE. 1848–1938. Boston and Pittsfield, Mass. Yachts, nature studies, flowers.

COLL. BA (*Wild Flowers*); Berkshire Athenaeum, Pittsfield (clipping file, *Wild Flowers,* photos of local buildings); Berkshire Museum, Pittsfield (ca. 200 nature studies); BPL (ca. 100 yacht photos, from negatives made 1883–1888); Lenox, Mass., Library (*Wild Flowers, Orchids,* collection of tree studies); Massachusetts Horticultural Society, Boston (*Orchids*).

PUBL. *Wild Flowers of New England.* Pittsfield. 1904: 3 vols. 75 plates. 1910–1914 (final edition): 8 vols. 400 plates.

Orchids of the North Eastern United States. Pittsfield, 1931. 2 vols. 84 plates.

BIBL. *Berkshire Eagle,* Oct. 17, 1938 (obituary).

"Flowers and Trees by Edwin Hale Lincoln." *U.S. Camera,* July 1942.

LUCE, WILLIAM BLAKE. Active ca. 1898. Hingham, Mass. Amateur. Experimental work.

PUBL. *Kites and Experiments in Aerial Photography.* Hingham, 1898.

McCARTHY, JOSEPH. Active ca. 1940. Providence. WPA photography.

COLL. Providence Public Library.

PUBL. "Rhode Island Mills and Mill Villages." A Federal Works Project, with 179 photographs. Providence Public Library.

BIBL. *Rhode Island Mills and Mill Villages: Photographs Made for the Nickerson Architecture Collection, Providence Public Library, by Joseph McCarthy, under the Auspices of the Federal Works Agency of the WPA, 1940.* 33 pp., mimeo. A catalogue of photographs, with chronological outline text by Samuel Green.

McCOOK, PHILIP. Active ca. 1893–1895. Hartford. Social documentary work.

COLL. Antiquarian and Landmarks Society of Connecticut, Inc., Hartford.

BIBL. French, Adela, ed. *The Social Reform Papers of John James McCook.* Hartford, 1977.

MANCHESTER, HENRY N. and EDWARD H. Active ca. 1840s–1870s. Providence. Portraits, stereos.

COLL. Rhode Island Historical Society.

BIBL. Newhall, *Daguerreotype.*

MOORE, ROSWELL A. and NELSON AUGUSTUS (1824–1902). Hartford. Commercial work, portraits, landscapes, architecture.

COLL. CHS; Connecticut State Library Museum.

PUBL. "A Photographer among the Last Men of the Revolution." *Hartford Daily Courant,* Aug. 11, 1864.

The Last Men of the Revolution. Hartford, 1865. Text by E. B. Hilliard. Reprint, Barre, Mass., 1968.

BIBL. French, H. W. *Art and Artists of Connecticut.* Boston, 1879.

The Connecticut Historical Society Bulletin: April 1973, p. 51; April 1977, cover.

NEWELL, EVA. 1845–1919. Southington, Conn. Amateur.

BIBL. Smith, Raymond. "Eva Newell." *American Art Review* 2 (Sept.–Oct. 1975).

NORTHERN SURVEY CO. Active ca. 1885–1890. Albany, N.Y. Rural home "portraits."

COLL. Connecticut State Library (ca. 2,600 photographs of New England homes).

NUTTING, WALLACE. 1861–1941. Framingham, Mass., Wethersfield and Southbury, Conn. Landscapes, colonial architecture, colonial interiors.

PUBL. *Wallace Nutting Pictures: Being Studies in America and Other Lands of Aspects in the Life of the Fathers and the Country Life of To-day.* Framingham, Mass., 1912. Catalogue of photographs for sale.

States Beautiful Series: *Connecticut Beautiful* (1923); *Maine . . .* (1924); *Massachusetts . . .* (1923); *New Hampshire . . .* (1923); *Vermont . . .* (1922); All Framingham, Mass.

Photographic Art Secrets. New York, 1927.

Wallace Nutting's Biography. Framingham, Mass., 1936. Also known as *My Life.*

PEABODY, CHARLES and JEANETTE. Active ca. 1890–1910. Cambridge, Mass. Photo-Secessionists.

PUBL. *American Amateur Photographer,* May 1907, p. 246.

Swann Galleries. *Photographica: Auction Sale #1099.* New York, April 20, 1978. Auction catalogue.

PEABODY, HENRY G. 1855–1951. Boston and various locales. Commercial work.

COLL. LOC; SPNEA.

PUBL. *The Photographic Times*: 1889, p. 14; 1891, p. 413.

Dartmouth College: A Collection of Thirty-Four Views. Boston, 1890. Gravure view book.

Representative American Yachts. Boston, 1891. Gravures.

Waldron, Holman D. *With Pen and Camera through the White Mountains.* Portland, 1907.

List of Photographs by the Detroit Publishing Co. Detroit, 1909.

BIBL. Massachusetts Audubon Society. *Man and Nature: Land Use.* Lincoln, Mass., 1975.

New York Times, March 28, 1951, p. 29 (obituary).

Weinstein, Robert A., and Booth, Larry. *Collection, Use and Care of Historical Photographs.* Nashville, 1977. Portrait of Peabody.

PICKERING, EDWARD C. 1846–1919. Cambridge, Mass. Astrophotography.

COLL. Harvard College Observatory.

PUBL. "Stellar Photography." *Memoirs of the American Academy of Arts and Sciences* 11 (1888): 180.

"Investigations in Astronomical Photography." *Annals of the Astronomical Observatory of Harvard College,* 1895.

PICKERING, WILLIAM HENRY. 1858–1938. Cambridge, Mass. Experimental work.

PUBL. "Measuring the Speed of Photographic Drop Shutters." *The Photographic Times* 14 (1888): 633.

Methods of Determining the Speed of Photographic Exposures . . . Description of Plates Illustrating Work Done with a Rapid Exposer. Cambridge, Mass., 1885. Extracted, in part, from the *Proceedings of the American Academy of Arts and Sciences.*

PLUMBE, JOHN, JR. 1809–1857. Boston. Daguerreotype portraits.

BIBL. Newhall, *Daguerreotype.*

POST, WILLIAM BOYD. 1857–1925. Fryeburg, Maine. Photo-Secessionist.

PUBL. *The Photographic Times*: 1889, p. 24; 1894, pp. 1, 104, 151; 1895, p. 1.

"Picturing the Pond-Lily." *Photo-Era,* Aug. 1914, p. 73.

Camera Work. Ill. in no. 6.

BIBL. Allan, Sidney [Sadakichi Hartmann]. "Winter Photography." *The Photographic Times,* March 1912, p. 85.

Naef, *Collection of Stieglitz.*

"Photography of the Snow." *Photo-Era,* March 1910, p. 113.

PRATT, FREDERICK H. Worcester. Photo-Secessionist.

BIBL. *Camera Work.* Ill. in no. 46.

RODGERS, H. J. Active ca. 1850s–1880s. Hartford. Portraits.

COLL. CHS; Mattatuck Museum, Waterbury, Conn.

PUBL. *Twenty-Three Years under a Sky-Light, or Life and Experiences of a Photographer.* Hartford, 1872.

RUOHOMAA, KOSTI. 1914–1961. Rockland and Rockport, Maine. Free-lancer. Genre and
landscapes.
COLL. Smithsonian Institution.
PUBL. Moore, Jim; Ruohomaa, Kosti; and Berry, Carroll. *Maine Coastal Portrait*. Rock-
land, Me., 1959.
Dietz, Lew. *Night Train at Wiscasset Station*. New York, 1977. Ruohomaa monograph.
ROWELL, FRANK. *See* Allen, Edward L., and Rowell, Frank.

SEARS, SARAH C. 1858–1935. Boston. Photo-Secessionist.
PUBL. *Camera Work*. Ills. in no. 18.
BIBL. Naef, *Collection of Stieglitz*.
SEELEY, GEORGE H. 1880–1955. Stockbridge, Mass. Photo-Secessionist.
COLL. Stockbridge Library.
PUBL. *The Photographic Times*, 1905, p .24.
"Photography: An Estimate." *The Photographic Times,* March 1905, p. 99.
Camera Work. Ills. in nos. 15, 20, 29.
BIBL. Edgerton, Giles [Mary Fanton Roberts]. "The Lyric Quality in the Photo-Secession
Art of George H. Seeley." *The Craftsman,* Dec. 1907, p. 298.
Green, Jonathan. *Camera Work: A Critical Anthology*. Millerton, N.Y., 1973. Biographi-
cal sketch.
Naef, *Collection of Stieglitz*.
Tape recorded interview with Laura Seeley (George's sister) made by Stockbridge Library,
1976.
SIPPRELL, CLARA. ca. 1880–1975. Manchester, Vt. Portraits.
COLL. Vermont Historical Society.
PUBL. *Moment of Light*. New York, 1966.
SOULE, JOHN P. 1827–1904. Boston. Stereos. Founder of large photographic firm pro-
ducing prints of art work, portraits, scenery, etc.
COLL. BPL; BS; Houghton Library, Harvard University (Boston fire); SPNEA.
PUBL. Wilder, E. *Wilder's Photographic Register*. Boston, ca. 1868. Mounted photographs.
"Ruins of the Great Fire in Boston. Nov. 9th and 10th, 1872." Series of stereo views.
Soule Photograph Co. Catalogue of Photographs of American Architecture. Boston, 1885.
*Soule Photography Company, Boston, Mass. Catalogue of Photographic Reproductions of
Works of Art*. 3rd ed. Boston, Jan. 1887. Lists 10,053 items.
Catalogue of Photographic Reproductions of Works of Art. Vol. 2. Boston: Soule Art
Company, ca. 1900. Lists items 10,054 through 15,597.
Illustrated Catalogue of the Soule Art Company. Boston, ca. 1900. Contains minute repro-
ductions of 3,700 photographs.
BIBL. Darrah, *Stereo Views*.
———, *World*.
Taft, *Photography*.
SOUTHWORTH, ALBERT SANDS. 1811–1894. Boston. Daguerreotype and paper por-
traits, experimental work.
COLL. *See* Hawes, Josiah Johnson.

PUBL. "An Address to the National Photographic Association of the United States, Delivered at Cleveland, Ohio, June, 1870." *The Philadelphia Photographer*, 1871, p. 315. Reprinted in *The British Journal of Photography*, 1871, pp. 530, 583.

"On the Use of the Camera." *The Photographic News* (London) 18 (March 6, 1874): 109.

Wilson's Photographics. Footnotes on pp. 58, 61, 63, and 183.

BIBL. *See* Hawes, Josiah Johnson.

STEBBINS, NATHANIEL L. 1874–1922. Boston. Yachts, ships.

COLL. BPL (street views); LOC; SPNEA (negatives).

PUBL. *American and English Yachts*. New York, 1887. Gravures.

Yachtsman's Souvenir. Gardner, Mass., 1888. Gravures.

Yacht Portraits of the Leading American Yachts. Boston, 1889. Gravures.

Illustrated Coast Pilot. N.p., 1891, 1896. 2 vols.

Yachtsman's Album. Boston, 1896.

The New Navy of the United States. New York, 1912.

BIBL. Bunting, William. *Portrait of a Port: Boston, 1852–1914*. Cambridge, Mass., 1971.

———. *Steamers, Schooners, Cutters and Sloops*. Boston, 1974.

STEELE, THOMAS SEDGWICK. 1845–1903. Hartford. Amateur.

COLL. CHS.

PUBL. *Canoe and Camera*. 2d ed., New York, 1880. Boston, 1882.

Paddle and Portage. Boston, 1882.

BIBL. French, H. W. *Art and Artists of Connecticut*. Boston, 1879.

STEINER, RALPH. b. 1899. "Straight" photography; commercial work.

PUBL. *Dartmouth*. Brooklyn, 1922. Pictorialist gravures.

Ralph Steiner: A Point of View. Middletown, Conn., 1978. Monograph.

STODDARD, JOHN T. 1852–1919. Northampton, Mass. Experimental work.

PUBL. "Composite Photography." *The Century* 33 (1887): 750.

"College Composites." *The Century* 35 (1888): 121.

STRAND, PAUL. 1890–1976. "Straight" photography.

COLL. BMFA; Fogg Art Museum, Harvard University; MMA; MOMA.

PUBL. *Time in New England*. New York, 1950. With Nancy Newhall.

BIBL. Newhall, *Masters*.

Newhall, Nancy. *Paul Strand: Photographs 1915–1945*. New York, 1945. Museum of Modern Art exhibition catalogue.

Paul Strand: A Retrospective Monograph. Millerton, N.Y., 1971.

Tomkins, Calvin. *Paul Strand: Sixty Years of Photographs*. Millerton, N.Y., 1976.

STYLES, A. F. Active ca. 1860s–1870s. Burlington, Vt. Stereos, portraits.

COLL. Bailey Library, University of Vermont; Vermont Historical Society.

PUBL. "Green Mountain Scenery. 500 Stereoscopic Views from All Parts of Vermont. Published by A. F. Styles, Burlington, Vermont. Catalogues sent to any address." Verso of Styles stereo card.

BIBL. Jackson, Clarence S. *Picture Maker of the Old West: William H. Jackson*. New York, 1947. Sketches of Styles's studio, ca. 1865, on p. 16.

Lipke, William C., and Grime, Philip N., eds. *Vermont Landscape: Images 1776–1976*. Burlington, 1976.

THOMPSON, WILLIAM H. Active ca. 1903–1918. Hartford. Commercial, Pictorialist work.

COLL. CHS (Pictorialist images); Connecticut State Library (street views).

TINGLEY, GEORGE EDWARD. 1864–1958. Old Mystic, Conn. Naturalistic photography; commercial portraits.

PUBL. Ham, Marion F. *The Golden Shuttle.* Brooklyn, N.Y., 1896.

Photo-Era, April 1902.

Studio-Light, Dec. 1916.

Unpublished autobiography. In possession of Mrs. Elsie Barstow, Mystic, Conn.

BIBL. *George E. Tingley ... An Exhibition of Photographs.* William Benton Museum of Art, University of Connecticut, Storrs, 1968.

Museum of Fine Arts. *Special Exhibition of Photographs Selected for Honor by the Photographers' Association of New England ... August ... 1901.* Exhibition list. Copy at BMFA.

WARREN, GEORGE K. Active ca. 1870s–1880s. Boston. Portraits.

COLL. BA; BPL; GEH.

PUBL. *Harvard College, Class of 1871.* Yearbook. 207 photographs.

WASHINGTON, AUGUSTUS. Active ca. 1847–1855. Hartford. Daguerreotype portraits.

COLL. CHS.

PUBL. "Daguerreotypes for 50 Cents." *Hartford Daily Courant,* Jan. 14, 1853. Advertisement.

BIBL. White, David O. "Augustus Washington, Black Daguerreotypist of Hartford." *The Connecticut Historical Society Bulletin* 39 (Jan. 1974).

WHIPPLE, JOHN ADAMS. 1822–1891. Boston. Portraits, experimental work.

COLL. BA; BPL; Harvard College Observatory.

PUBL. *The Photographic Art-Journal* (later *The Photographic and Fine Art Journal*), 1853 and 1854. Mounted crystallotypes by Whipple.

Homes of American Statesmen. New York, 1854. Mounted photograph.

Portraits of the General Court of Massachusetts. Boston, 1855. 4 vols. Copy at BPL.

BIBL. *American Annual of Photography for 1892,* New York, p. 242 (obituary).

Barnard, E. E. "The Development of Photography in Astronomy." *Popular Astronomy,* Oct. 1898, p. 425.

Bigelow, David. *History of Prominent Mercantile and Manufacturing Firms in the U.S.* Boston, 1857. Vol. 6, p. 362.

Bond, George. "Stellar Photography." In *The American Almanac and Repository of Useful Knowledge ... 1858.* Boston, 1857.

———. "Photography and Astronomy." In *The American Almanac and Repository of Useful Knowledge ... 1859.* Boston, 1858.

Boston Evening Transcript, April 13, 1891 (obituary).

Daguerreian Journal, 1851, part II, pp. 83, 114, and 210.

Dictionary of American Biography.

Ehrman, Charles. "Whipple's Crystalotypes. The First Negatives Made on Glass in America." *Photographic Times* 15 (1885): 216.

Hoffleit, *Some Firsts.*

Newhall, *Daguerreotype.*

The Photographic Art-Journal (later *The Photographic and Fine Art Journal*): 1851, p. 94; 1852, pp. 195, 271; 1853, p. 148; 1854, pp. 64, 321.

Root, *Camera and Pencil,* p. 364.

Taft, *Photography.* Portrait of Whipple.

Vancouleurs, G. de. *Astrophotography.* New York, 1961.

Welling, *Photography.*

Werge, John. *The Evolution of Photography.* London, 1890. P. 197.

WHITE, CLARENCE HUDSON. 1871–1955. Photo-Secessionist, teacher.

COLL. LOC; MOMA.

PUBL. Morris, Gouverneur. "Newport the Maligned." *Everybody's Magazine,* Sept. 1908, p. 311.

BIBL. Bunnell, Peter C., and White, Clarence H., Jr. "The Art of Clarence White." *Ohio University Review* 7 (1965): 40. Bibliography.

Moore, Henry Hoyt. "Photography with a Difference." *The (New) Outlook,* Sept. 1916, p. 97. Issue's picture section contains photographs of White School students at work.

WHITE, FRANKLIN. Active ca. 1858–1868. Lancaster, N.H. Stereos.

COLL. GEH; LOC.

PUBL. *Photographic Scrap Book, Containing Views of Mountain Scenery, Views of Boston, New York.* Lancaster, 1858.

Photographic Scrap Book (2nd Series) . . . Lancaster, 1859. 45 small photographs, mounted on 11 pages, mostly oval views of White Mountain and Quebec locales.

Photographic Views from Mount Washington and Vicinity and the Franconia Range. Lancaster, 1859. 24 views, approx. 5 × 8 inches each.

White's Photographic Views, for 1860, 2nd Series. Lancaster, 1860. Set of 25 half stereos.

BIBL. Chamberlain, Gary. "Franklin White." *Stereo World* 4 (Sept.–Oct. 1975).

Welling, *Photography.*

WYER, HENRY S. Active ca. 1885–1905. Nantucket, Mass. Local genre.

COLL. LOC.

PUBL. *The Photographic Times,* 1889, p. 466.

Nantucket: Old and New. Nantucket, 1895.

Nantucket: Picturesque and Historic. Nantucket, 1901.

Sea-Girt Nantucket. Nantucket, 1902.

Page numbers in *italics* indicate illustrations.